RESTAURANT GRAPHICS

RESTAURANT GRAPHICS /
GRANT GIBSON

LAURENCE KING PUBLISHING

CONTENTS

INTRODUCTION / GRANT GIBSON

The design and architecture critic Stephen Bayley wrote in *GQ* magazine: 'It's a truth not yet universally acknowledged that the success and enduring appeal of restaurants depend much more on their decor and ambience than on the food that they serve.' It's a quote I was reminded of when I started this book, because while I enjoy the drama and occasional spectacle inherent in restaurants, I've never really loved food. For this I blame my father.

Strictly speaking, it wasn't his fault. Only weeks after leaving the hospital (having fractured his skull trying to break up a fight), he realized his sense of taste had completely changed. Suddenly, he simply couldn't stomach meals he'd wolfed down in the past. It wasn't that food had become bland; its new taste was completely repugnant. I remember the sense of bewilderment and anxiety at mealtimes as my mother (a brilliant cook wasted in the Gibson household) put food on the table and my father attempted to reconcile himself to the fact that he couldn't recognize its flavour. The short-term solution was to pour curry sauce over everything. As a result, my formulative years were spent eating curry, and a love for the finer points of cuisine never truly developed. Nowadays, this means that when I go to a restaurant, I often find myself more interested in what others consider to be incidentals rather than the food. And one of the things I've always found fascinating is menu design.

Recently, there's been an explosion of interest in all things related to food. Cooking shows dominate our television schedules, recipe books (usually connected to the TV shows) hog the best-seller lists, and restaurant criticism has garnered more and more column inches in our newspapers. There are even tomes devoted to restaurant interiors. However, there is virtually nothing that investigates the role and importance of restaurant graphics. On the face of it, this is rather surprising, because (whether we like it or not) some of the most successful restaurant brands have used graphic design effectively to dominate shopping precincts and city centres around the globe. McDonald's, of course, is the most obvious and – recent poor publicity not withstanding – most successful example. It opened its first restaurant, under the aegis of Ray Kroc in Des Plaines, Illinois, in 1955. Currently, the company has more than 30,000 restaurants in over 100 countries and has become an emblem of the USA.

Why? Well, obviously speed and a standardization of service and food across continents are important reasons, as is its aggressive franchaising policy. But none of this would have worked without a simple, easy-to-remember and appealing marque. The way the food is packaged, the Golden Arches, Ronald McDonald himself... all were pitched perfectly at the brand's demographic: children. And whatever one thinks of the food it serves or its strong-arm court tactics, it's hard not to admire the craft behind the graphic design. After all, it helped turn the simple hamburger into an icon.

Interestingly, where McDonald's has led, a new generation of fast-food restaurants and sandwich bars have followed. The reason for this is relatively simple: bright, eye-catching, often pop-inspired graphics are an easy and relatively cost-effective way of making you stand out on the street. Also, of course, if things aren't working out financially, it's much simpler to change a restaurant's graphic design than it is to change its architecture. During the course of my (arduous) research compiling this book, I had lunch with a graphic designer friend of mine, R&D&Co's Rob Andrew, at a restaurant where he'd created the menu.

The Real Greek in London serves well-cooked, relatively cheap Greek food, in a tapas style. But it had problems, as Rob was keen to explain. 'We were invited by the restaurant's owner, Mark Yates, to have a look at their graphics and the brief was pretty much this: "We have a menu at the moment that people don't understand. They don't understand that the food we sell is like tapas, in that you take a little bit from here and a little bit from there..." The original menu had three sections: one page looked like starters, one like mains and another like desserts but it didn't really work like that,' he told me. This confusion meant that customers simply couldn't grasp what was on offer, and more than a few left disappointed – including, on one occasion, me. As Rob pointed out, 'If people weren't getting it when they were inside, they sure as hell weren't getting it when they stood outside the restaurant.'

His solution was to make the concept completely clear at the same time as being 'fun, lively, happening, and full of noise'. The brash new design turned the notion of the traditional menu on its head. Instead of reading it from top to bottom and from outside to in, customers were encouraged to go from inside to out and from the middle to the outer edges. Positively bursting with energy, Rob's menu is full of illustrations, anecdotes about the staff, and, frankly, type that makes your eyes hurt if you stare at it for too long. But as he said to me between mouthfuls of kebab, 'The typography isn't stylish, but it's quite immediate. Let's look at it this way: it certainly doesn't look like Helvetica.' The proof is in the pudding, however, and at the time of writing the owner estimates that The Real Greek's turnover haS increased by 12–15 per cent – or 20,000 extra covers – in the eight months since the new menu was published. For all kinds of reasons it's the kind of project that will never grace the pages of the style press, but it sure was effective and proves, beyond any doubt, that graphic design matters.

One of the interesting themes that has emerged from this book is how important graphics are becoming to upmarket restaurant interiors. Indeed, so vital has it become that, on more than one occasion, it's the two-dimensional design that has led the interior and not the other way around, suggesting that the boundaries between disciplines are dissolving.

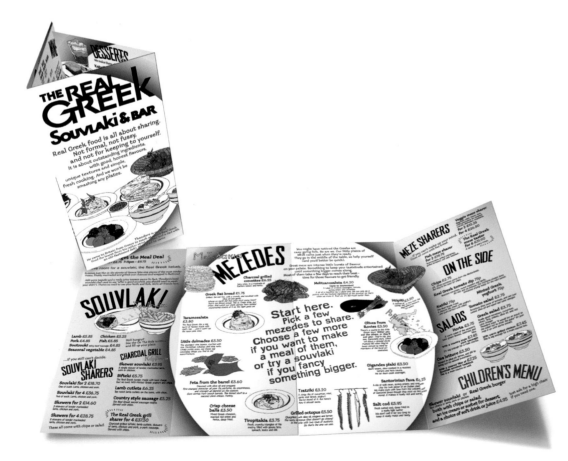

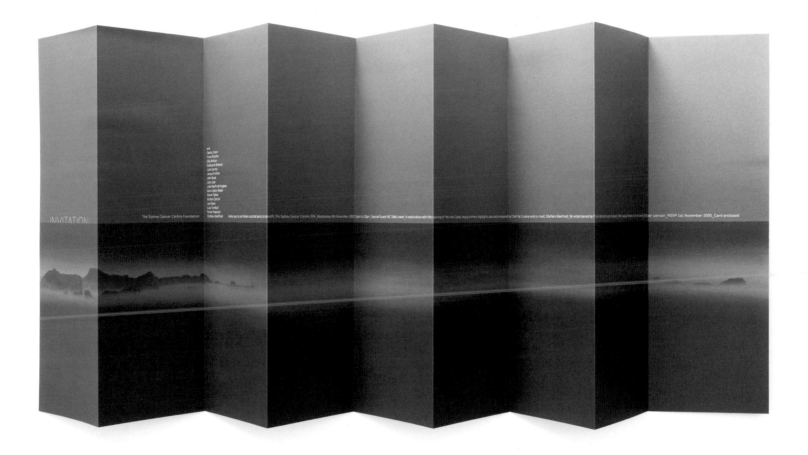

At Coast in Sydney, Australia, for example, designer Vince Frost recreated the city's coastline in 60m (197ft) of yellow acrylic and hung it from the ceiling. Likewise, Cayenne in Belfast, Ireland, is dominated by Peter Anderson's playful, typographically based artwork, including a Corian wall that features a broken-up city map with all its residents' names jumbled together. On one level, diners can have fun trying to find themselves, but on another it means that, in this most divided of cities, Protestant names suddenly find themselves next to Catholic ones – which, as Anderson points out, 'in the shape of the country doesn't happen very often'.

Restaurants are about fusing a set of elements to create an experience. Traditionally, it has always been thought that they were food, service and architecture, but I like to think this book is evidence that graphic design needs to be part of that equation as well. The point of *Restaurant Graphics* has been to be eclectic and look at the whole gamut of restaurants from, yes, the McDonald's on London's Oxford Street to the Operakällaren restaurant in Stockholm's opera house, and from the punky White Trash in Berlin to the classy Craft in New York. Have discernible aesthetic trends emerged? Well, if they have, then I've missed them. It's always tempting for journalists to come up with handy catch-all tags that neatly sum up a new design movement, but it ain't going to happen here. I've made no distinction in restaurant type or design genre. Let the chips fall where they will, is what I say – as long as they land in alphabetical order.

Finally, it's important to make clear that this book isn't intended as a restaurant *guide*; rather, think of it as a survey of the graphic possibilities restaurants provide. A number of the establishments featured here have already closed and, such is the speed of the market, more will almost certainly be shut by the time you read this. If you, therefore, turn up to one expecting a great night out and are greeted by a locked door, it's vital that you don't blame the publisher. Or, more importantly, me.

Grant Gibson

FACING PAGE / Where McDonald's led, others, including London's The Real Greek Restaurant, have followed – with an impressive rise in turnover.

ABOVE / One of the elegant invitations to Sydney, Australia's Coast, created by Frost Design. Restaurant graphics today consist of much more than menu and logo typography.

F: 212.343.0918 WWW.PUBLIC-NYC.COM

AVROKO / PUBLIC / USA

Owned and designed by New York practice AvroKO, there's more than a touch of the municipal about PUBLIC. In the interiors this manifests itself in the bank of mailboxes that line the entry hall but, in many respects, it's the graphic design that gives the clearest indication of the thinking behind the scheme. 'Everything stemmed from the food,' says AvroKO partner William Harris. 'The cuisine is really first for us whenever we do a restaurant design, and it had a very global approach. It was eclectic – hence we started to consider the idea of the global community, which in turn led us to the global public, and then just "public".'

Using this notion of public as its foundation, AvroKO became fascinated by typical municipal institutions such as libraries, courts, police stations and schools, seeking inspiration from their graphic language. 'We were looking at library design, materiality and other design themes,' Harris says. 'We certainly didn't want to make a theme restaurant by any means, but just provide subtle hints from certain institutions.'

Some hints, it has to be said, are more subtle than others. Certainly the heavy vanilla paper, reminiscent of old records stock, is a bit of a give-away. And the utilitarian clipboards used for the menus are highly evocative of municipal-type employees. Indeed, AvroKO even went to the trouble to source the brass clips separately, hand-burnishing them to the required finish. 'We researched everything: from old library materials to old office memorandum and accountancy ledgers from the twenties and thirties,' Harris explains. 'We started to note some of the consistencies and create our own language.'

The designer elected to use a Courier font on the menus to give the sense that they'd been produced by an old typewriter, while the underline colours reinforce the organized, institutional feel. Harris believes the bold, almost architectural, sans serif logo is very generalized. 'It's strong,' he adds, 'but it doesn't have a lot of inherent style.'

ABOVE / A seal of approval. PUBLIC has a deliberately municipal feel.

FACING PAGE, ABOVE AND RIGHT / The restaurant's new stationery and soap. Both the Courier font and the clipboard – complete with brass clip – evoke a feeling of office days gone by.

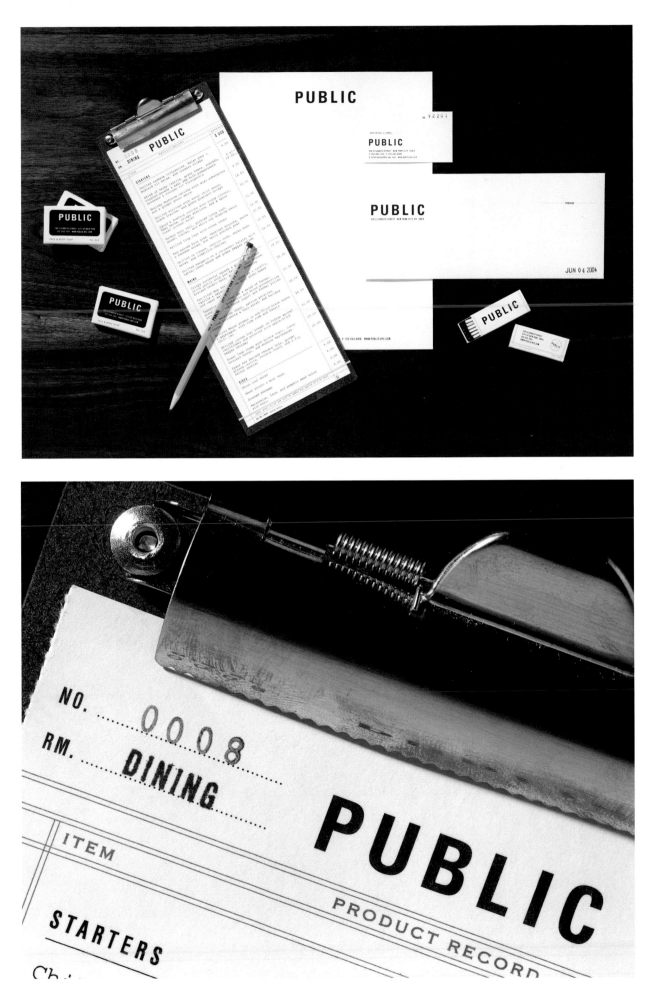

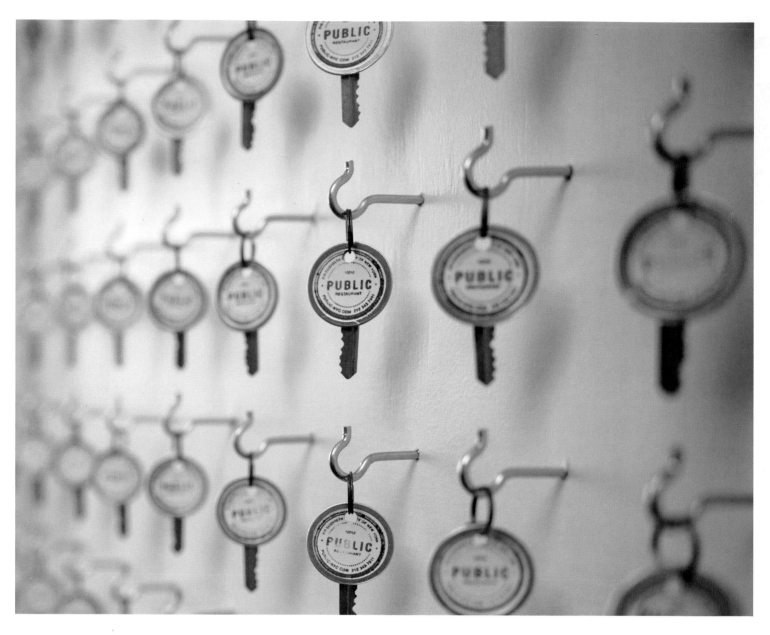

ABOVE / The restaurant features a series of mini-installations, including this collection of keys and a set of mailboxes in the entrance.

FACING PAGE / A view of the interior that neatly encapsulates the brief. According to AvroKo's William Harris: 'When we explored the idea of "public", it tended to lead us towards a kind of municipal scheme. There are certain institutions that every civilized society tends to have. We tend to have a library, courts, police stations and schools. It's about the idea of what makes a happy and healthy civilized community. We also thought it would be a great design challenge to take something as potentially cold and ugly and warm it up.'

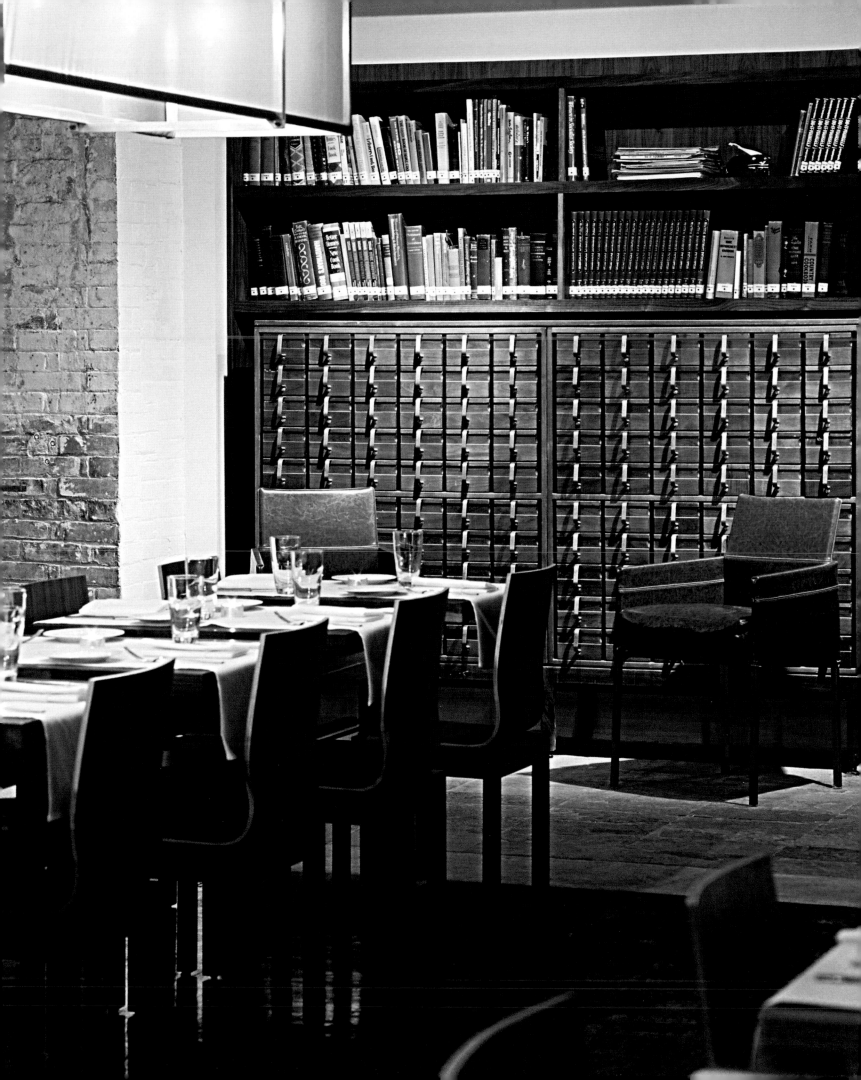

BARKLEY EVERGREEN & PARTNERS /
40 SARDINES / USA

When discussing his work at 40 Sardines in Kansas City, Kansas, there's one thing Craig Neuman, creative director at Barkley Evergreen & Partners, needs to clear up. 'A lot of people ask about the name…' he begins. This isn't especially surprising, given that the restaurant doesn't just sell fish. Owned by chef couple Debbie Gold and Michael Smith, it evolved, explains the designer, from a wager that they made. 'When they were in the South of France,' Neuman says, 'they made a little bet about how many sardines Michael could consume.' The answer would appear to be self-explanatory. Sadly, client confidentiality means that Neuman refuses to reveal what Smith actually won as a result.

With the issue of the restaurant's monicker resolved, the challenge for the designer was, in Neuman's words, to convey the chef-owners' personalities ('which are pretty divergent at times') while at the same time representing their food through the branding. 40 Sardines has a smart but casual feel which is very much reflected in the backgrounds of the owners. 'Debbie Gold tends to be more exquisite, pushing the upscale side of the restaurant,' explains Neuman. 'Michael Smith is a very frenetic personality. He arguably holds down the casual aspect of things.'

As far as the restaurant's logo is concerned, it looks as though the sophisticated side won out. The font used is called Mrs Eaves, which, Neuman believes, is 'somewhat reminiscent of a French country label'. Interestingly, though, rather like a sports team, 40 Sardines also has a secondary (and perhaps more immediate) motif applied to press kits and chef hats.

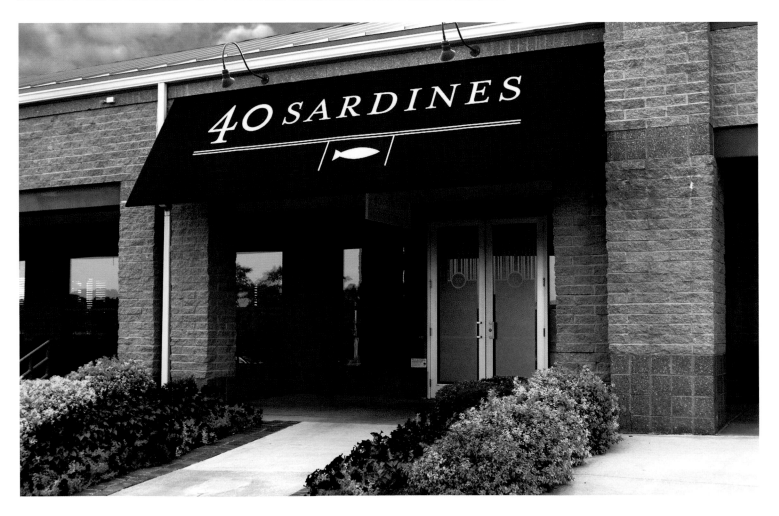

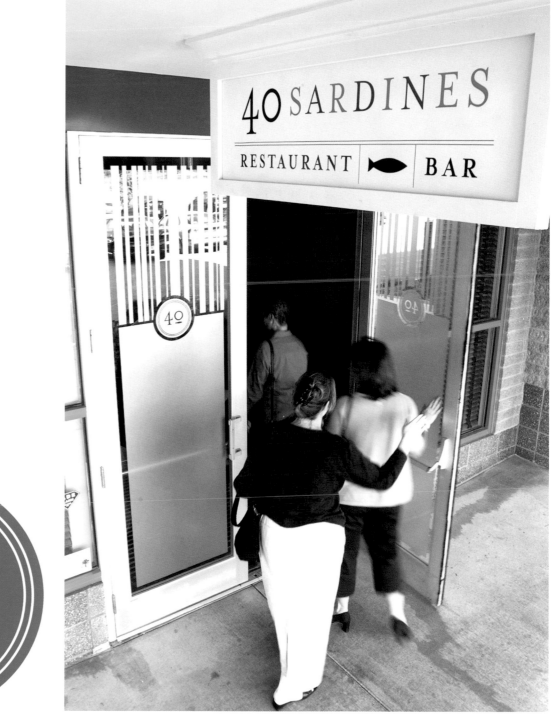

FACING PAGE LEFT, AND ABOVE RIGHT / The tidy, if unprepossessing, entrance of 40 Sardines.

ABOVE / The restaurant's logo. Interestingly, the fish-related name refers to a bet once struck by the owners rather than the food.

'It's more of a symbol for the times where we need a quick read,' says Neuman. 'When we need to get across the position of the restaurant, we use the full name. Then, for the times where it's intended to be more of an accent or an addition, we use the symbol.' The secondary motif also happens to be easier to reproduce in embroidery, which is extremely useful.

Perhaps what really sets the restaurant apart, in a graphic sense at least, is the menu, which is bound between chipboard covers. Barkley Evergreen & Partners decided to use the material because of the interior's low lighting levels. Rather than sticking with the established logos, it created a new marque from letterpress at the bottom left-hand side of the cover, using four different colours and picking up the zero in the restaurant's name as well as the fish from the branding. At the top right, '40 Sardines' is also letterpress-printed with a varnish finish.

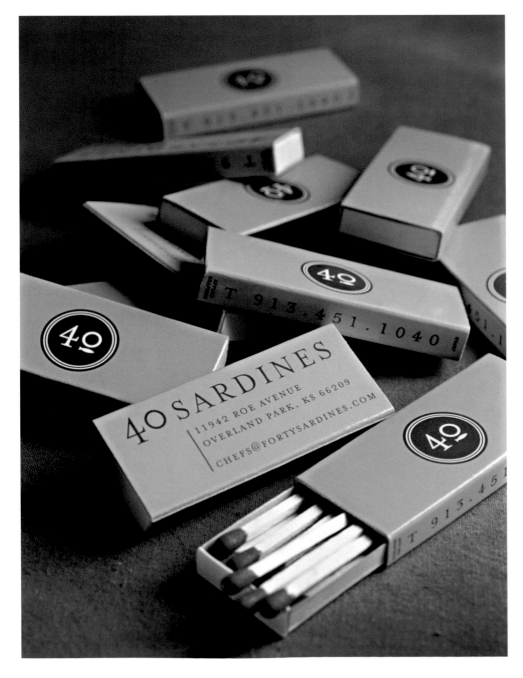

LEFT AND FACING PAGE / The restaurant's stationery and matchboxes. All the graphics attempt to reflect the personalities of the owners – a cross between the exquisite and frenetic.

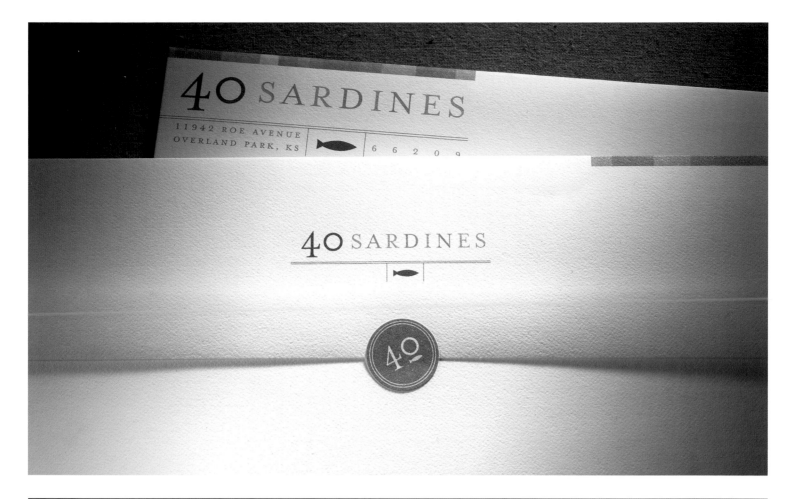

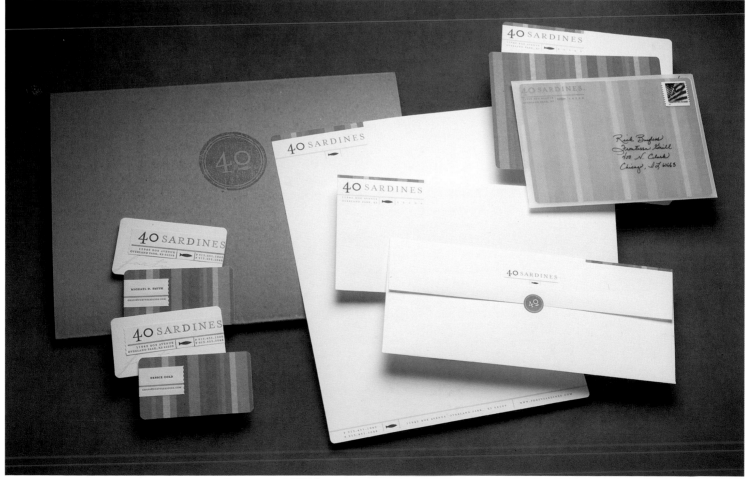

BOB'S HAUS / CRAFT / USA

Opened in 2001 by award-winning chef Tom Colicchio, Craft has established itself as a bit of a New York classic. However, not content with running a single, high-end eaterie, Colicchio has set about spreading the restaurant's tentacles and transforming it into a brand. Craftsteak, for example, opened at the MGM Grand, Las Vegas in 2002, followed by Craftbar (a sort of more informal version of its older sibling), and 'wichCraft, an upmarket sandwich joint. The graphic designer behind all these ventures is Bob Dahlquist of Bob's Haus.

Dahlquist was commissioned after the client saw a ten-page splash (entitled 'No commercial value') of his personal work using a blueprint machine, which was published in the now sadly defunct *Emigre* magazine. For Craft, the designer used similar techniques and typefaces. Futura, for example, was employed for the restaurant logo because, says Dahlquist, 'It is still one of my favourite typefaces.'

'Another favourite is Centaur,' he continues in an amiably, laid-back, West Coast kind of way. 'To me, it's the quintessential, renaissance book font. And I thought, "Here's a classy restaurant, so it's perfect for that." Futura and Centaur are fonts I'm really intimate with. I'm real comfortable with the typefaces, and I went with what I felt good about. It all stemmed from the personal work.'

Elsewhere in the restaurant Dahlquist used a photogram technique to create the images of the onion-skin and the whisk which hang in the private dining rooms and also adorn a book of recipes based around the restaurant, published by Random House. The same method of laying glass plates and spoons on blueprint paper before exposing them to light was used to produce the menus.

When it came to extending the brand, the designer recalls that the process was organic. 'I already knew the people I was working with, and they knew me,' he says. 'We had a visual compatibility, so from there it was really informal.' It was important that the new ventures contained a feel of the original Craft, but also managed to communicate to potential customers that there was a distinct difference. 'I had a fine line to walk,' Dahlquist explains. 'All these things should be aesthetically related, but I had to make sure not to muddle the identities.' So Craftbar, for instance, contains colours that are 'a little stronger, a little brighter' and 'wichCraft uses an Ionic typeface in its logo.

The font was selected because of its 'friendly, informal' quality. 'If you look at Craft,' Dahlquist adds, 'you've got this hardcore Germanic, modernist type and then this equally hardcore Italian renaissance type. And so if those are two legs of the typographic identity, then the third leg for 'wichCraft would have to be different from those but still be a strong graphic type.'

A three-legged table? It's an unusual metaphor, admittedly – but an effective one.

FACING PAGE AND RIGHT / Craft started as a restaurant
and has turned into a brand. Pictured are examples of
Bob Dahlquist's work from the various different branches.

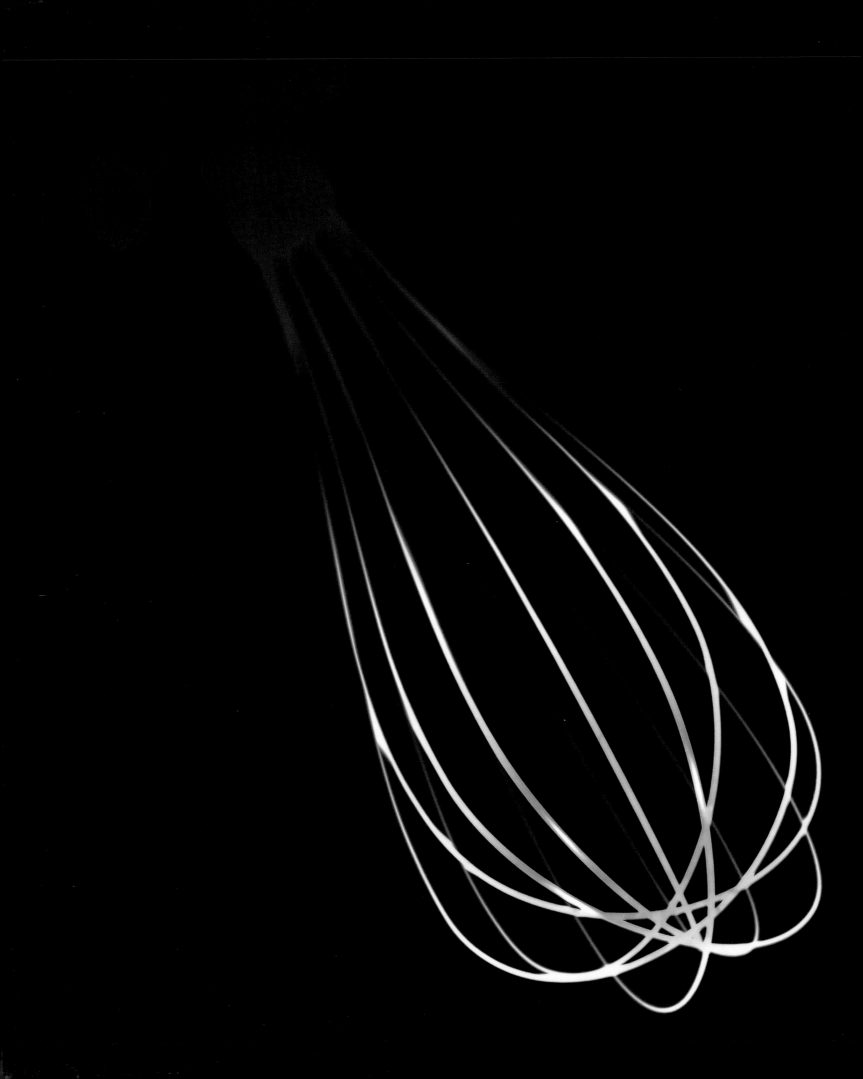

pantry

8.

'wichcraft

FACING PAGE AND TOP / The photographs of the onion skin and the whisk adorn the Craft book and the restaurant's private room.

ABOVE / The 'wichcraft logo is designed to make it clear that it belongs to the Craft stable but offers something rather different.

BRINDFORS ENTERPRISE IG /
OPERAKÄLLAREN / GOOH! / SWEDEN

Stockholm's Operakällaren has been a feature of the city's opera house since it opened in 1787. However, it began to take a more recognizable form in 1865, when a larger, baroque-style venue was built to replace the original. While the last restoration of the main building happened way back in 1961, the restaurant had a makeover, courtesy of architectural firm Claesson, Koivisto and Rune in 2005. And along with a new interior came some refashioned graphics by Brindfors Enterprise IG.

According to the design firm's Oskar Bostrom, the initial brief was to create a distinct and strong graphic identity which, much like the interior, effectively added a contemporary touch to a Swedish classic. The practice was also tasked with designing a marque for Veranda, the new bar concept, which had to be tied seamlessly to the restaurant.

Everything to do with Operakällaren had to ooze class, yet feel completely modern at the same time. Interestingly, it was English fashion designer Paul Smith who became something of a role model; his pin-stripped textiles used on the restaurant chairs provided the initial spark of inspiration. 'We modernized the "OK" monogram, and combined it with tasteful typography, exclusive materials and papers,' Bostrom explains, 'and had all the binding and production made to get a unique feel.'

For fonts, Brindfors used only Garamond, Bostrom says, because of 'its beautiful classical letterforms, multipurpose usability and the fact that it is a very large family', while the colour scheme was kept as simple as possible: black, white, silver and hints of bright green to provide contrast. In the restaurant, this essential feeling of exclusivity was bolstered with the use of heavy-grained paper stock, complete with hand-torn edges, for the menus. In the younger, more obviously hip Veranda, the designer tried to lighten the tone a little by specifying a lighter grade paper such as the oystershell: shimmering paper that was used on the inside of the cocktail menu.

OPERAKÄLLAREN

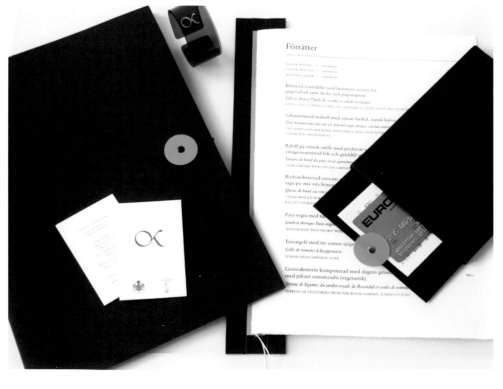

FACING PAGE AND LEFT Tasteful is the watchword at Operakällaren. It's all about exclusive materials and the 'classical' Garamond font. Brindfors Enterprise IG apparently took inspiration from the work of fashion designer Paul Smith.

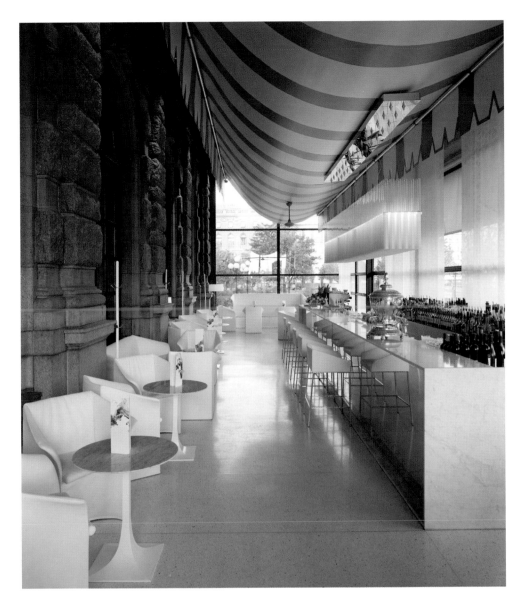

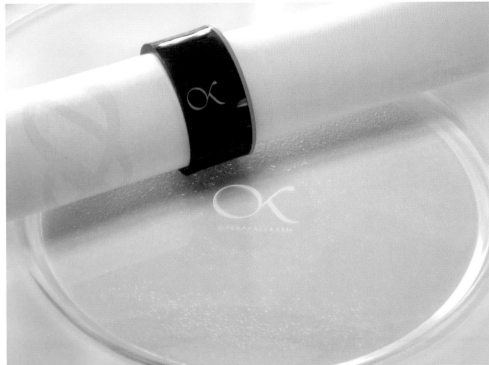

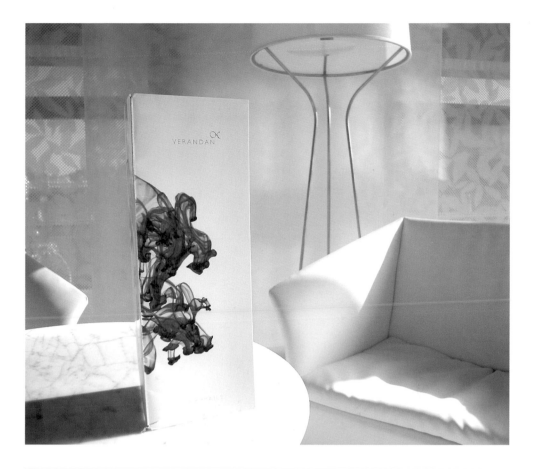

The whole thing is tied together with the logo. 'The old Operakällaren monogram was starting to look dated, and we wanted to create something a bit more timeless and simplified than the previous one,' says Bostrom. 'We liked this solution best because of its ability to look exclusive, timeless and yet simple at the same time.'

And to show the practice's range, Brindfors Enterprise IG was also responsible for Gooh!, a restaurant aimed at a completely different sector of the market. Owned by Operakälleren and Lantmannen, one of Sweden's farming cooperatives, Gooh! produces fast food that also happens to be healthy. According to Brindfors, its concept can be summed up in a string of words: good taste, healthiness, affordable prices, easier, faster and easy to understand. There's plenty of playfulness in the restaurant, both in the interiors, which feature a floor designed by Sweden Graphics, and in the obviously pop-influenced branding.

While the logo is handcrafted, the designer didn't want to overcomplicate the visuals and decided to use a relatively conservative collection of graphics. The basic fonts are Franklin Gothic and Caslon Italic, and Helvetica Neue also makes a cameo appearance on some of the packaging.

The colour palette was designed to support the array of products that Gooh! stocks. Dishes are divided into colour categories: blue for fish, dark red for meat, green for vegetarian. There are also different shades to differentiate desserts and drinks.

ON THESE PAGES / Verandan, Operakällaren's younger, hipper bar, lightens the tone a little, even using a shimmering paper on its cocktail menu.

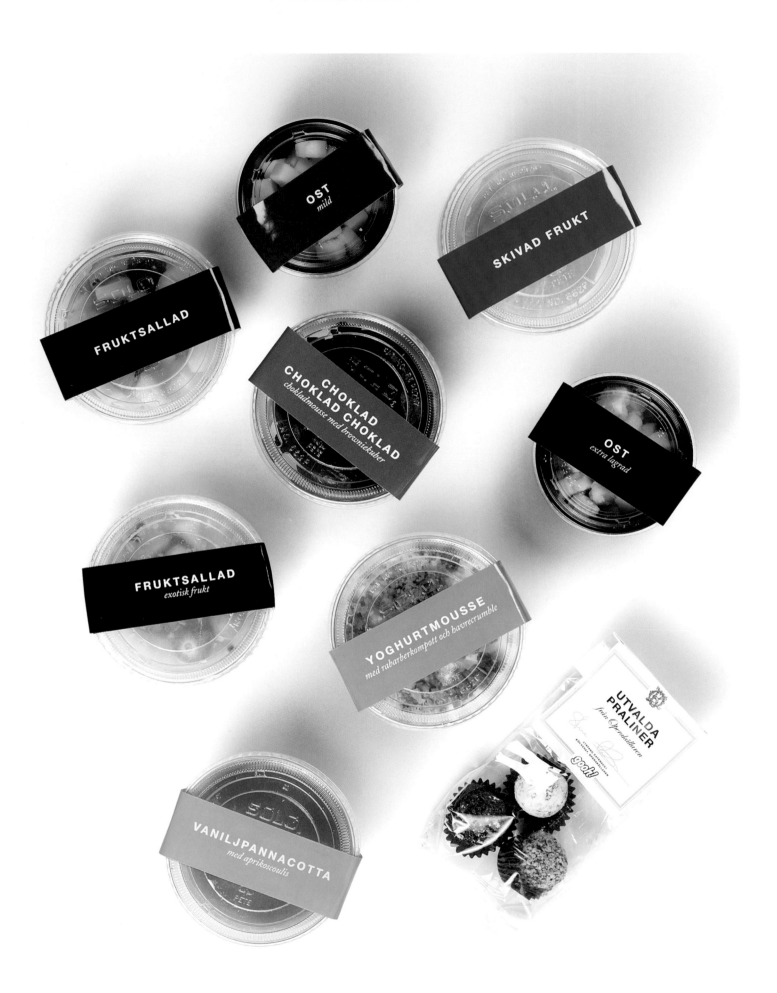

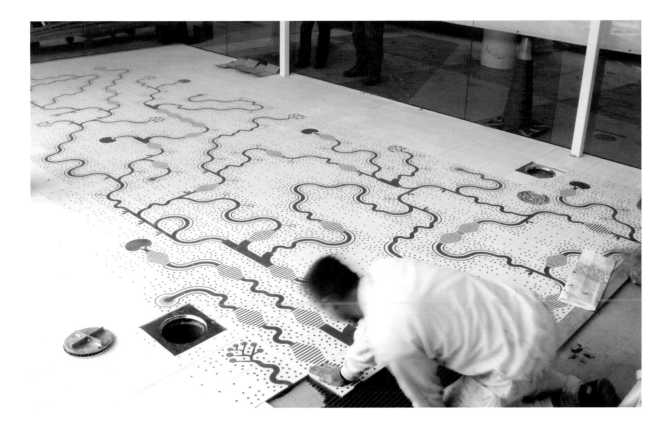

ON THESE PAGES / Where Operakällaren is slow and classical, Gooh! is fast and pop (and very healthy). Here, dishes are divided into colour categories: blue for fish, red for meat, etc. Incidentally, the floor (TOP RIGHT) was designed by Sweden Graphics.

DUFFLET

BRUCE MAU DESIGN INC /
DUFFLET / CANADA

Dufflet and its eponymous owner, Dufflet Rosenberg, are something of an institution in Toronto. Rosenberg started selling pastries in 1975, and became so successful that in 1980 she opened a bakery on Queen Street West which went on to become a retail outlet and café. After concentrating on supplying pastries to specialist retailers, in 2002 she expanded again, opening another outlet on Younge Street designed by Kohn Shnier Architects, with graphics by her long-standing collaborator, Bruce Mau Design Inc.

According to Senior Design Associate Kevin Sugden, the brief for the new store was based on his firm's history with the client. 'We've had a relationship with Dufflet that goes back a long time,' he says. 'They [Mau and Rosenberg] are old friends, and, in fact, for a number of years, when [Mau] first started the practice, his apartment was on top of the café in Toronto.' Indeed, Mau was responsible for Dufflet's original identity in the early eighties, which Sugden now describes as 'kind of funky, a little ironic and happy, and involving the kind of typography that was sort of appealing at that time'.

In 2001, the graphic designer was asked to examine the identity once again, when, in Sugden's words, Dufflet Rosenberg decided that she needed a 'real, proper, brand architecture'. It was shortly after work began that she revealed her intention to open another outlet-cum-café, this time in partnership with Rosemary Little, a floral designer and proprietor of Quince Flowers. As Sugden says, this meant the job entailed 'doing a full-out identity so we could cover everything from napkins and sugar dispensers to outlet graphics and exterior signage'. In hindsight, he describes it as a bit like tweaking a recipe: 'Where you're always looking at the ingredient list and wondering which thing you can change and which you retain. If you change something too much, it ends up not being recognizable any more.'

For the logo, the practice elected to use Tray Gothic Narrow Bold, and the Dufflet colour palette was adapted from (chocolate) brown and white. 'We figured chocolate is probably a pretty good colour to have in the palette, but we maybe needed to stabilize it with one other colour consistently,' says Sugden. Hence the acidic green. Meanwhile, the spiral-effect logo that's prominent on items such as the coffee cups and the website harks back to the design of the doilies that Mau had done for Rosenberg years before. And the reason for its prominence? 'It's the one piece of brand product that always travels with the pastry,' Sugden explains.

ON THESE PAGES / Bags, cups, sugar packets and logo from Dufflet, an upmarket pastry brand-cum-café. While chocolate-brown plays an important role in the colour scheme, it's balanced (and perhaps usurped) by an acidic green.

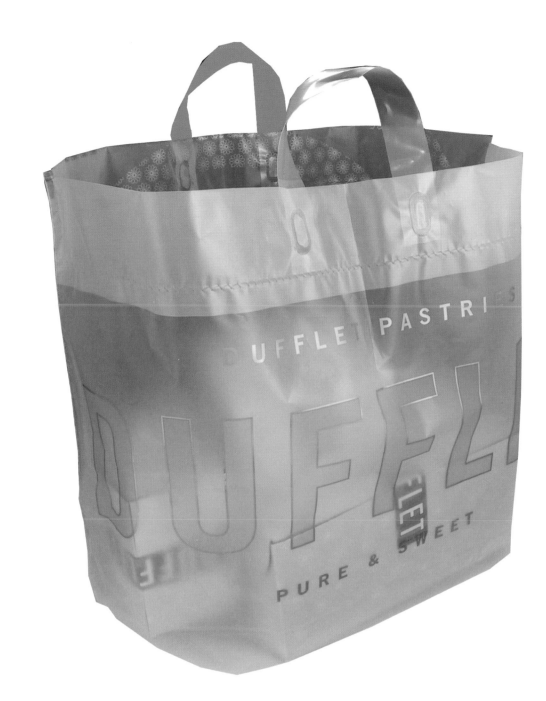

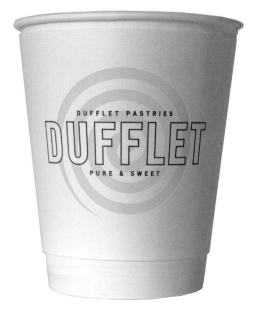

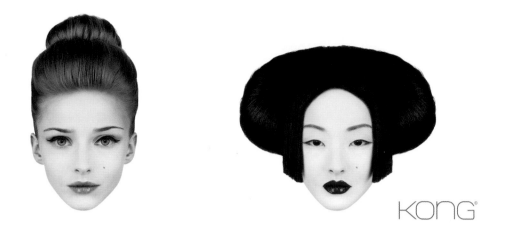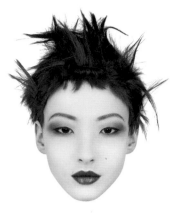

CAKEDESIGN / KONG / BACCARAT / KATSUYA / LO-SUSHI / FRANCE

Oddly, many of the reviews of the Parisian restaurant Kong barely mention the food. Jean-Jacques Ory's architecture, which allows diners a fantastic view across Paris, crops up occasionally, although rather less often than the word 'hip'. But really this is a project centred around one singular talent: designer and showman extraordinaire Philippe Starck.

Located above the Kenzo flagship store on rue du Pont Neuf, Kong is Starck at his most bombastic, offering what one critic described as 'a jumble of eighteenth-century-inspired aluminium chairs, spindly-legged, sixties-style sofas, maple rocking chairs with plastic backs and holograms, walls painted to resemble flaking plasterwork, a pebble-motif carpet and Japanese prints'. According to the scheme's graphic designer, Thibaut Mathieu of cakedesign, Starck and owner Laurent Taieb took the mythology surrounding the Kenzo brand as their initial starting point. Together they came up with the idea of creating a restaurant that depicted the encounter of Japan and Europe.

To illustrate this as provocatively as possible, Starck wanted to commission three distinct female portraits which would embody the idea: a geisha, a modern Japanese woman from Tokyo's Omotesando shopping district, and a European woman. Mathieu proposed making three faces, each created by mixing up the features of six different women. 'This idea allowed us to create unique and different characters, yet belonging to the same family,' the designer explains. 'Surprisingly, these characters look alike. They are sisters from different countries with different origins.' These images dominate the restaurant, from the 12m (39ft) long (and charming) geisha on the ceilings to the films displayed on flat screens, as well as the printed photos on the tables.

Elsewhere, the Kong logo (which includes a 'K' rotated around ninety degrees to resemble a Martini glass) was self-made, and the accompanying text used Trade Gothic. The colours – silver, pink and black and white – were created to fit in snugly with the interior. 'Philippe Starck had a very precise idea of the environment he wanted to see,' concludes Mathieu. 'We worked so that the visual identity would perfectly fit with the restaurant and give the impression that when a customer leaves with one of its shopping bags, business cards, or its CDs, he takes with him a part of Kong.' Certainly the combination seems successful. Besides Kong, Starck and cakedesign have worked together on other projects, including Baccarat, Larousse, Starck's own exhibition at the Pompidou Centre, and the Katsuya restaurant in Los Angeles.

ABOVE / Kong is dominated by three distinct female portraits which embody cultural encounters between Japan and Europe.

FACING PAGE / How the portraits work with the interiors.

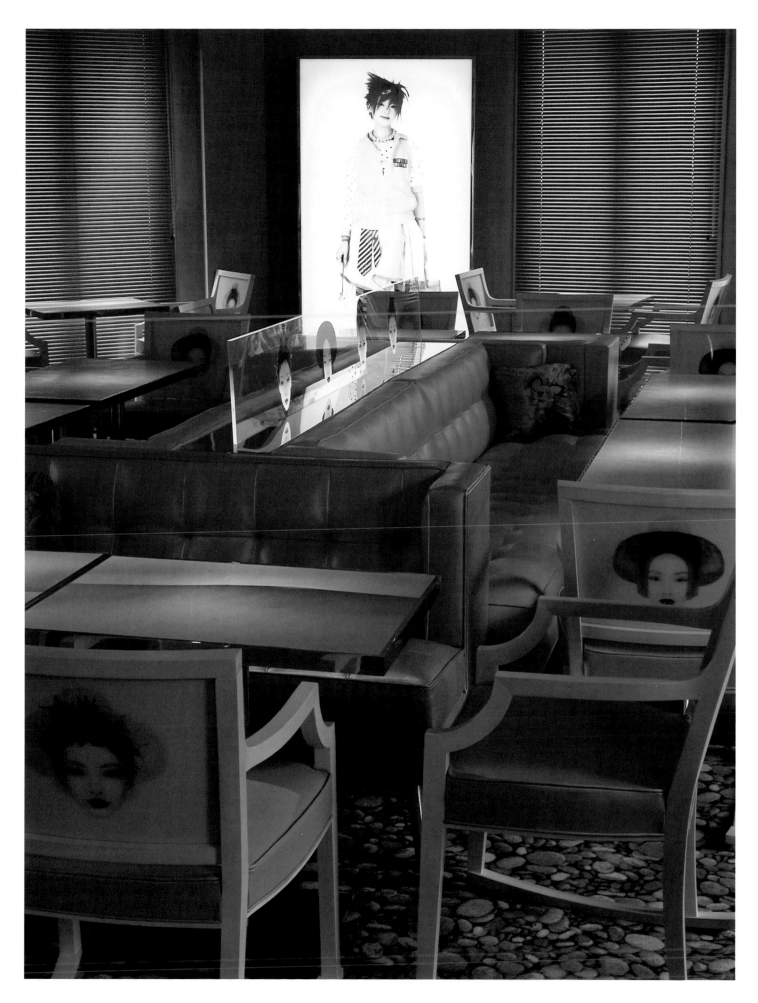

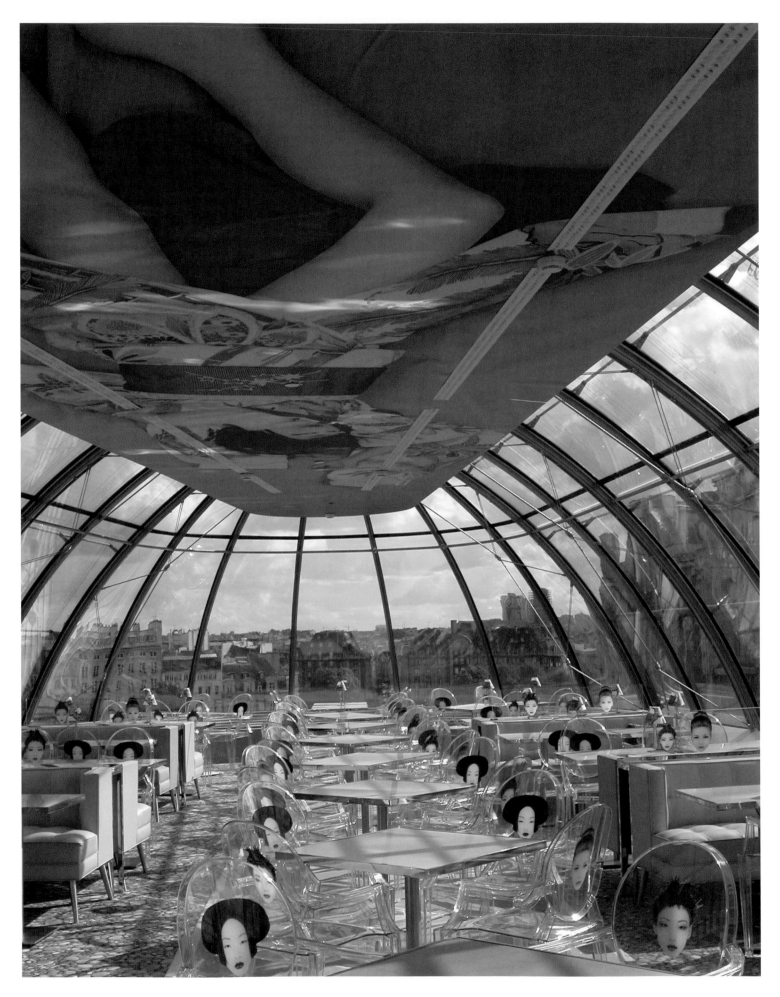

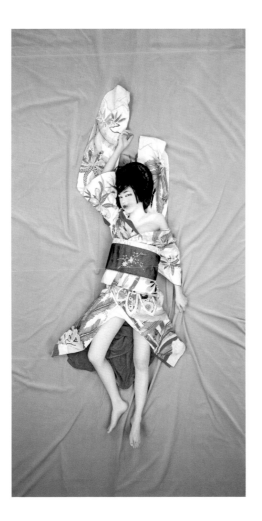

At Baccarat (*see* page 35), Starck has taken the mansion once owned by Marie-Laure de Noailles – a great patron of the arts who financed films for the likes of Cocteau and Man Ray – on the Place des Etats-Unis and transformed it into a typically extravagant palace for the classic crystal company. It includes a showroom, museum and, of course, fashionable restaurant, set in Noailles' Louis XIV dining room and replete with gigantic crystal chandeliers, panels that reveal the original brickwork, tables covered by Porthault cloths, and the designer's own furniture. Cake was brought in to do the identity and wisely thought it shouldn't attempt to compete with the interior. 'We decided then to create a graphic identity with a slight sense of nostalgia in reference to the monogram of the 1930s, while still using a contemporary type face: the Metsys,' confirms Mathieu. The silver and powder tones, meanwhile, are a clear reference to Starck's work.

Most recently the dynamic duo has joined forces again at Katsuya in Los Angeles (*see* page 35). Based around the traditional Japanese *robata* (or barbecue), it sees Starck in a restrained – well, almost reflective mood. Designed like a huge *bento* box, the wooden interior is occasionally punctuated by illuminated close-up shots of Japanese women – which is where Cake came in. Working with photographer Julien Oppenheim, it 'imagined a series of photos with a very subtle atmosphere', choosing teasingly beautiful elements of the face and body and tempting the customer to try and create a complete picture. The finished results also ran through all the restaurant's graphics. On the inside of the menu, business cards and bills, Mathieu reflected the interior by using a veneered wood effect, while the logo was drawn 'to come close to the effect of a Japanese ideogram'.

But just to prove that the practice is capable of working on a restaurant scheme without Philippe Starck, it has also done the graphics for Lo-Sushi (*see* page 34). Another restaurant owned by Laurent Taieb, it has two branches in Paris designed by Andrée Putman; both feature an enormous conveyor belt as a centrepiece, along with banks of computer screens. The task, says Mathieu, was to create a visual identity that was 'modern, light, pure – really "design" with just a zest of humour'.

Inspired by the belts, Cake created a logo using rounded fonts – Neue Helvetica in extra light and Gravure bold which was redrawn – that was to be read vertically as it would be in Japan. In another nod to the fascinating contradictions of that particular nation, it also developed a little character Mathieu thinks is like a crossing of a traditional kabuki mask and a *manga* pictogram. The menu, which unfolds like a do-it-yourself house-paint colour chart, is 'practical and fun', according to the designer, allowing customers to understand the concept of the conveyor belt. Each colour corresponds to a certain dish and price range, which means that it's a little bit easier to work out how much that plate you pick out is going to cost.

FACING PAGE/ Diners at Kong get a great view of Paris from the windows – as well as of the 'ravished' 12m (39ft) geisha on the ceiling.

ABOVE AND RIGHT / A more detailed view of the geisha, and examples of the restaurant's menus.

THIS PAGE / Lo-Sushi's graphics were inspired by the restaurant's conveyor-belt centrepiece, featuring rounded fonts that have to be read vertically. The menu resembles a house-paint colour chart.

FACING PAGE ABOVE / The sumptuous interior and graphics of the Baccarat restaurant.

FACING PAGE BELOW / The graphics at Katsuya include close-up shots of Japanese women that challenge customers to try and piece together the complete picture.

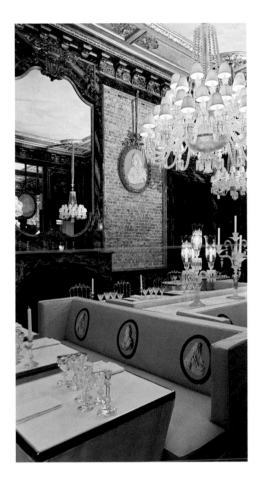

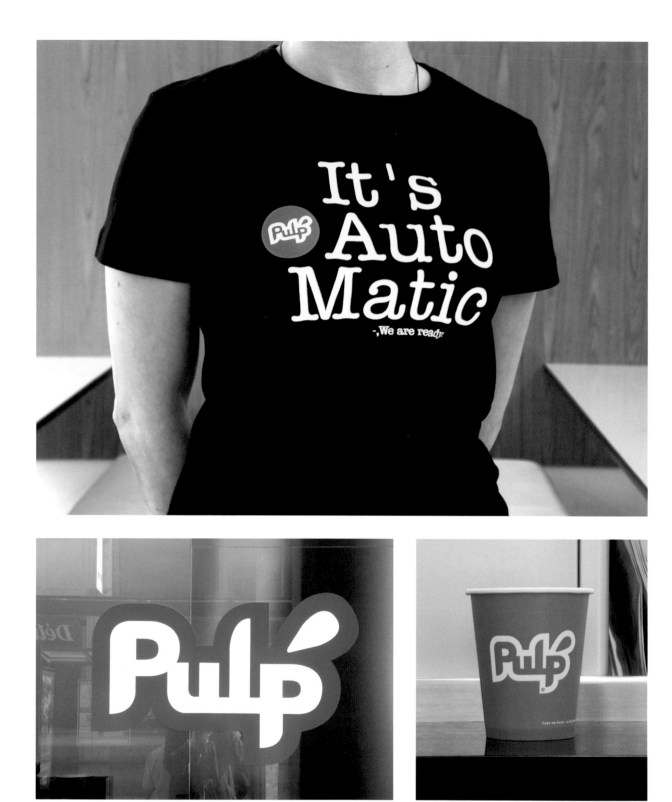

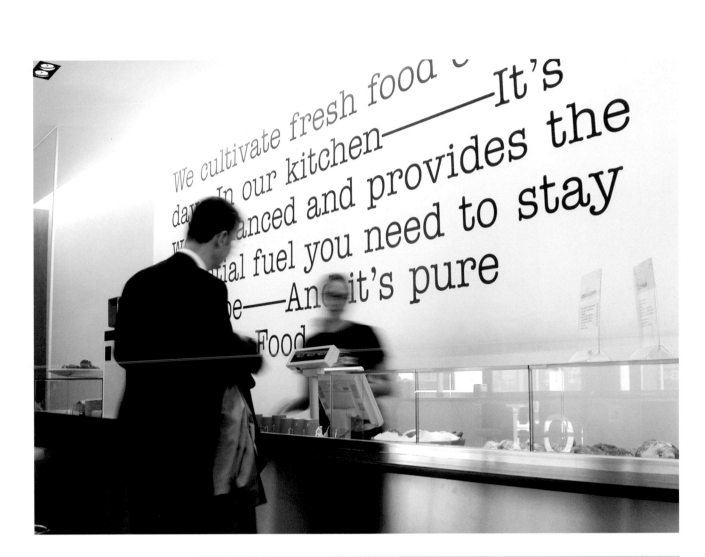

COAST / PULP / BELGIUM

On first inspection there's something slightly askew about Pulp. *We cultivate fresh food everyday – In our kitchen – It's well balanced and provides the essential fuel you need to stay in shape – And it's pure. Mmmmh Food* says the text on the back wall. There's nothing wrong with the sentiment (although if you're being picky, you could find fault with the punctuation). But what's really odd about this rather smart chain of sandwich bars and cafés is that all six branches are located in Brussels.

'In Brussels we speak different languages,' explains Frédéric Vanhorenbeke, art director of the scheme's graphic designer, Coast. 'The areas where Pulp is located are near EU business places, so we decided to go straight to the point. We only use English.' It's the kind of comment that would no doubt have French President Jacques Chirac choking on his baguette.

Coast has been working with the healthy-eating chain since 1998, when the client came in with an initial, if sketchy, concept for the restaurant. 'The brief was quite simple,' says Vanhorenbeke – perhaps a little ironically. 'They were just looking for a company to provide a new name, attitude and all the graphics.' After much debating, the two sides alighted upon the name 'Pulp' because it referred to food and freshness. 'The name was aiming to get young European customers – not only Belgians but people working in a business environment who might be going abroad to England or France.' The idea of freshness was reinforced in the logo, which has a pip coming off the final 'P'.

ABOVE / Don't be fooled by the English text that dominates Pulp's interior. This sandwich bar is located in Belgium.

FACING PAGE ABOVE / Music plays an important role at the sandwich bar. The text on the waiting staff's T-shirt apparently derives from a song lyric.

FACING PAGE BELOW / The name 'Pulp' refers to the freshness of the food, and the accent above the final 'p' actually represents a pip.

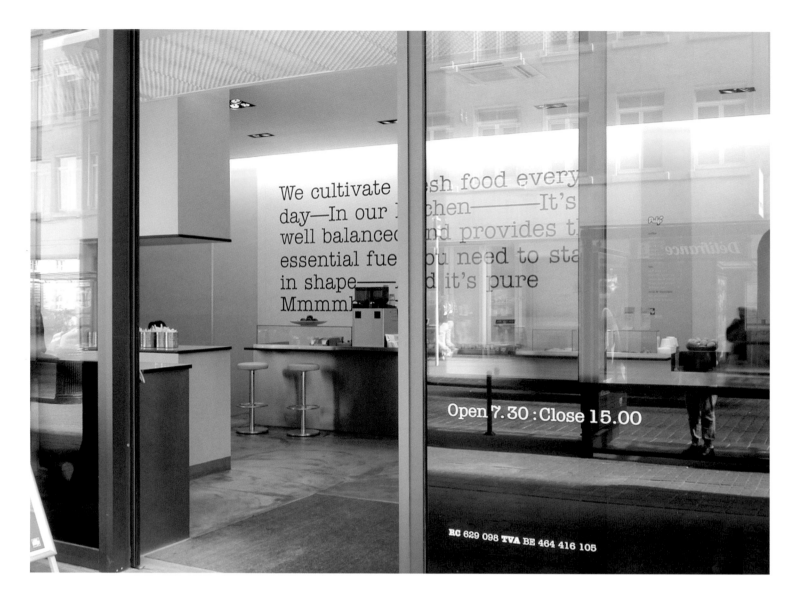

In the image: "We cultivate [fre]sh food every day—In our [kit]chen———It's well balanced [a]nd provides t[he] essential fue[l y]ou need to sta[y] in shape———[an]d it's pure Mmmm[h]."

"Open 7.30 : Close 15.00"

"RC 629 098 TVA BE 464 416 105"

When Coast first started working on the project, it used a colour palette of red, black and white; however, over the years this has been expanded with the addition of green and orange. Vanhorenbeke believes the newer colours bring more natural elements to the visual identity. For the font on the walls, the practice chose America Typewriter in an effort to differentiate itself from larger brands. 'We didn't want our typographics to make us look like McDonald's,' the designer says. 'We wanted to be close to the people and not a brand that's aloof.' The typeface, he adds, is more traditional. 'It looks like it has been hand-drawn, so it doesn't look like it has come from a big company but from a shop next door.'

The restaurant's final touch is the staff T-shirts, emblazoned on with 'It's Auto-matic' in large, unforgiving type and 'We are ready' below. The slogan is derived from a Zoot Woman song and is designed to assert the importance of music to the restaurant, while at the same time letting customers know that they can expect hyper-efficient service.

ABOVE / A view through the front door of the sandwich bar's interior.

FACING PAGE / Even the bags are used to reinforce the Pulp brand's message.

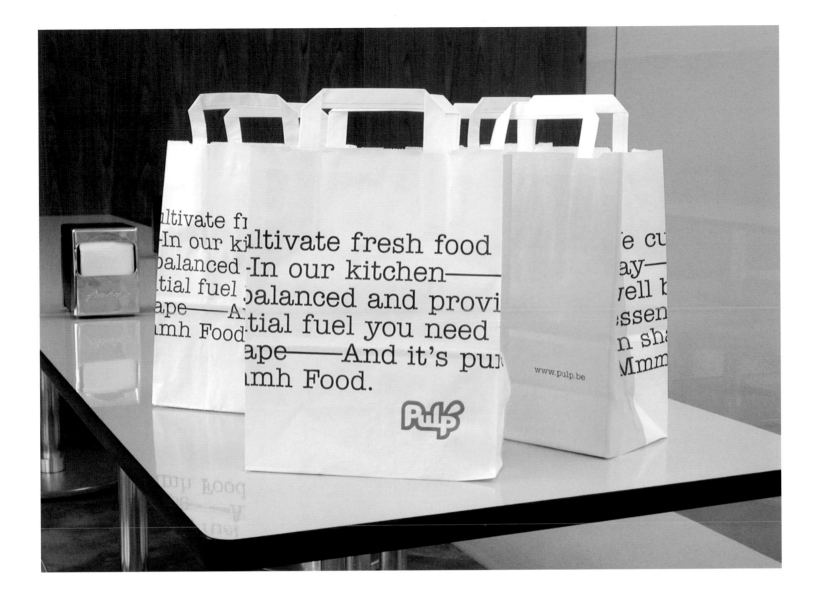

DESIGNRICHTUNG /
MENÜ 1 / SWITZERLAND

Traditionally, the sandwich shop is functional rather than delightful, relying on the quality of the fillings rather than tricky branding to build a reputation. With the odd exception, such shops are rarely the province of the contemporary designer. However, when the new owner of Zurich's Menü 1 (formerly known as Gourmetinseli) commissioned the young, up-and-coming firm designrichtung to rebrand the shop, he was taking something of a calculated risk – particularly as he didn't give the designer a specific brief.

'The situation was [that] the owner was changing and the new owner wanted to refresh the whole thing but in a very low-budget way,' confirms designrichtung partner Christof Hinderman. 'It's as always: you don't really have a brief. It's like, "Keep the costs very low and show me something". So it was really a *carte blanche* for us but with a really small budget.'

With €6,000–€8,000 (about $7,667–$10,222) to spend, the designer was forced to make a little go the length of a marathon. The interior is notable for the wooden, canteen-style trays that run along the back wall onto the ceiling and the spoon curtain that hides a small office on the left-hand wall. According to Hinderman: 'It was something that was shiny and glamorous, and it was important to have the main theme connected to food. It's only on the second glance that you notice the spoons. First of all, it has to work as a curtain.'

While the interior has the most obviously eye-catching elements, the importance of Menü 1's graphic design should not be underestimated. The process started with the shop's new name and the urge to avoid creating an anonymous, American-style outlet. 'It was important that we weren't talking about take-away [take-out] or sandwiches because we wanted to keep it very local,' explains Hinderman. 'You have take-aways everywhere, so we wanted to make it more Swiss-like.' By the same token, everyone was determined to make a break from the past. As the designer points out: 'Before, the store was called Gourmetinseli, but it really had no connection to gourmet. It serves sandwiches all day so it was important to have that explained.' To balance these two desires, designrichtung developed a playful logo where the 'N' and the 'U' merge into one, while using a Courier typeface that Hinderman believes is connected to old-fashioned menu cards.

The relationship between the graphic and interior design was genuinely symbiotic. The menu card picks up on the spoon curtain, and the keyline around the '1' in the logo is a reference to the trays. But Hinderman is keen to point out that it wasn't all one-way traffic. 'We had the name first, then the logo,' he says. 'Then we came up with the interior concept. This used the trays and the spoons, which we then added to the graphics.'

iklämmti zum mitneh •• menü 1

FACING PAGE / The spoon curtain that covers Menü 1's left wall is also the inspiration for its, er, menu.

LEFT / The relationship between Menü 1's graphics and interior was genuinely symbiotic. For example, the keyline around the logo is a reference to the trays that run across the ceiling.

40 / DESIGNRICHTUNG / MENÜ 1

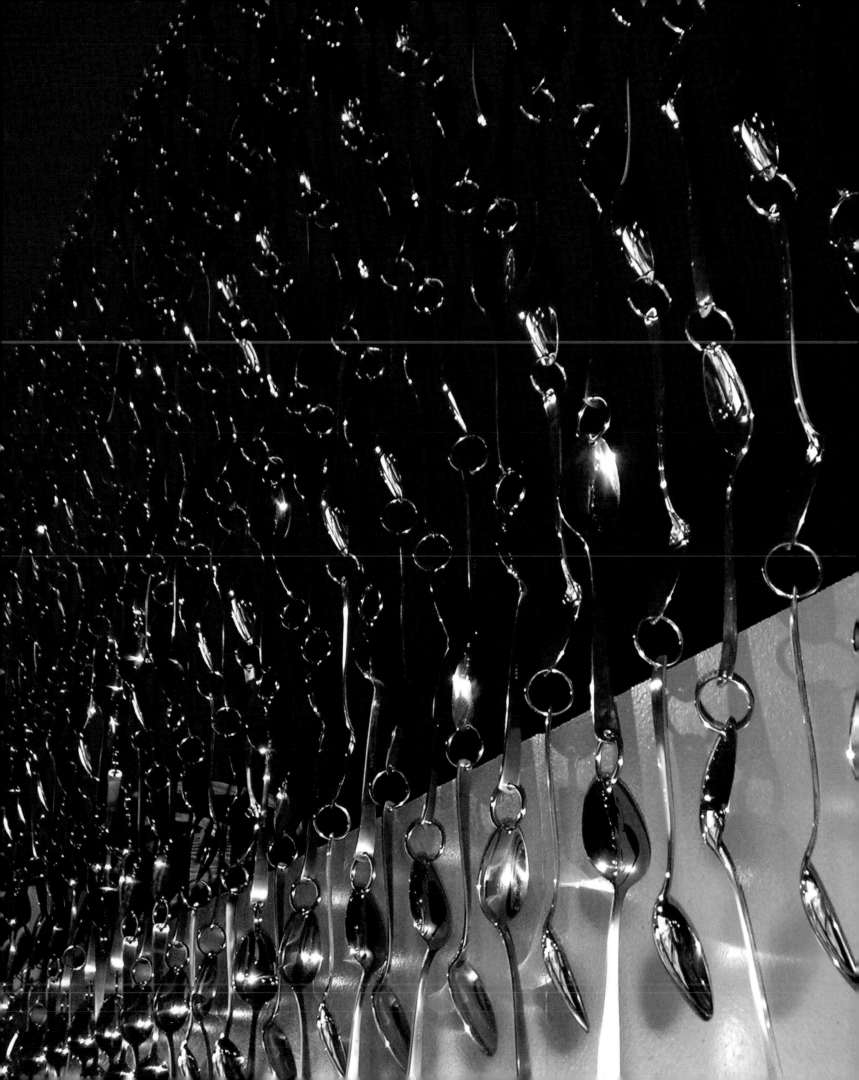

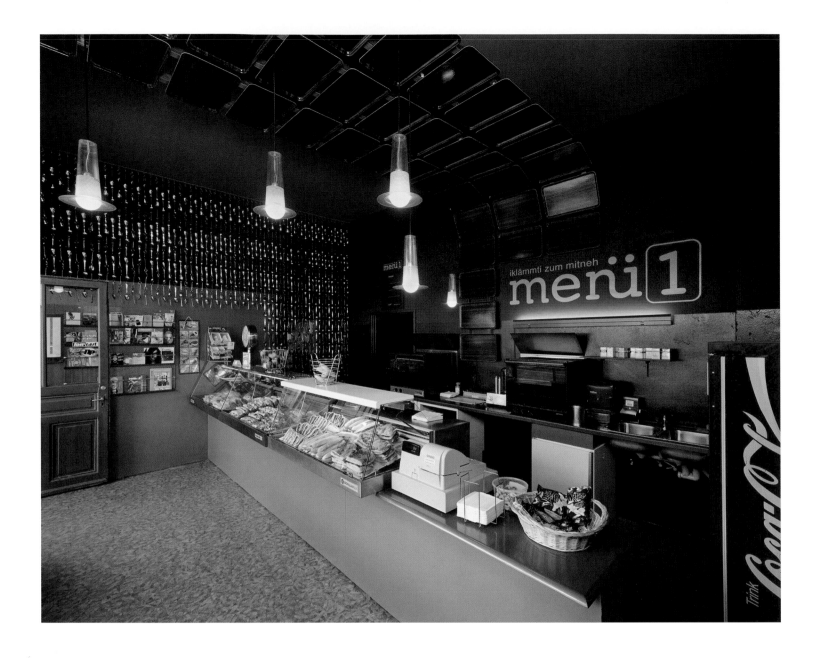

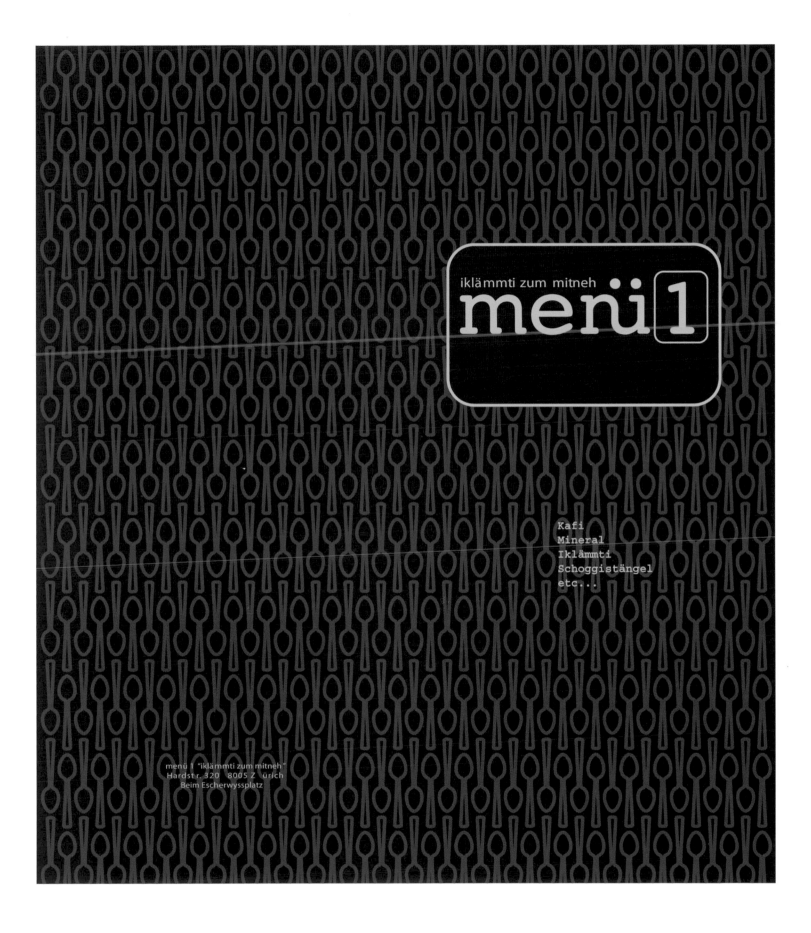

iklämmti zum mitneh **menü 1**

Kafi
Mineral
Iklämmti
Schoggistängel
etc...

menü 1 "iklämmti zum mitneh"
Hardstr. 320 8005 Z ürich
Beim Escherwyssplatz

FACING PAGE / Menü 1's interior: small, inexpensive,
but cool.

ABOVE / The menu, boasting its spoon-curtain-
inspired pattern.

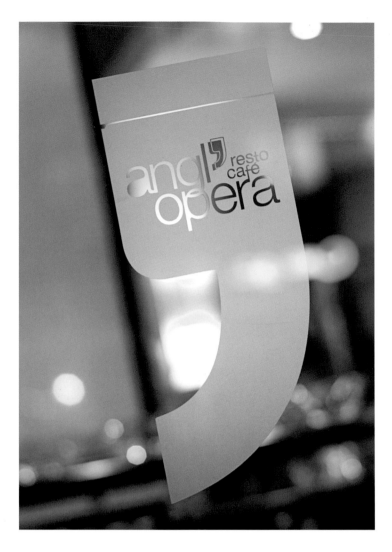
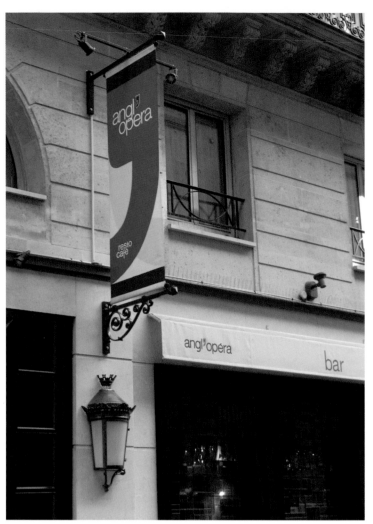

EDO / ANGL'OPERA / FRANCE

The Parisian communications consultancy edo has worked with family-owned Corbel Property for a decade. Indeed, its first scheme for the company was to rebrand the four-star Hotel Edouard VII, which now houses Angl'Opera. Other projects have included the Corbel identity itself and the graphic palette for another three-star hotel.

Angl'Opera has been based around the fusion cooking of up-and-coming chef Gilles Choukroun, a man who thinks nothing of combining a main course of salmon with lemon risotto and a shot glass of hot coconut milk. According to edo, the project began with a meeting of minds: Christina Corbel tasted the 'incredible and almost indefinable' cuisine of Gilles Choukroun and introduced it to Frédéric Blanc, edo's creative director. The pair then set about trying to work out how Choukroun's food could best be captured in two dimensions.

'The identity had to be built on a proper foundation, or the brand would suffer,' a spokesperson at edo explains. 'It was essential to be true and authentic in its development, to talk to Gilles about his approach to his craft, his goals and his results; to be direct and effective; and to charm without pandering. Like Gilles, it was necessary to go right to the heart of the matter without embellishing. Just two words, two colours and one typeface.'

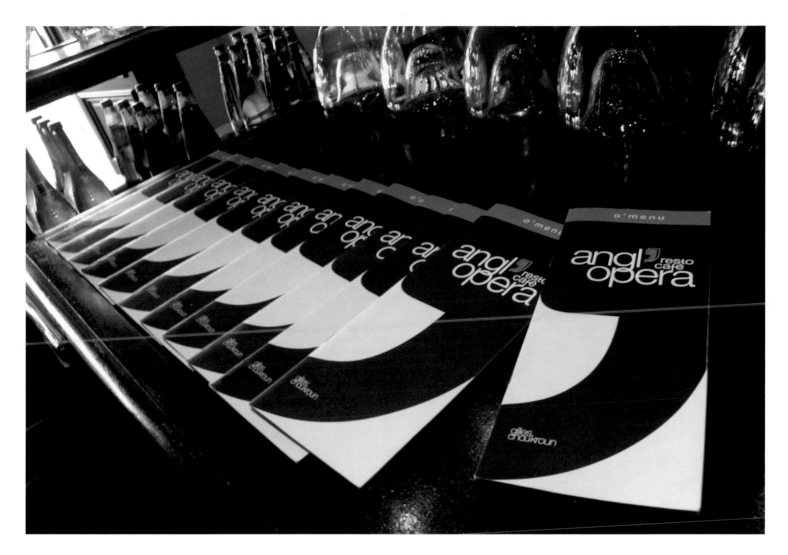

ACROSS THESE PAGES / Examples of how the restaurant's branding is used – on the door and as external signage as well as on its menus. The logo was designed to echo the shape of the building's architecture, while edo fiddled with the spelling of Angl'Opera in an attempt to create 'an indivisible whole, broken by a pause of clam and respite'. Helvetica was used to keep the identity looking 'elegant, modern and timeless'.

To do this, the practice elected to tweak the restaurant's name, originally called Angle Opera; edo dumped the 'e' and added an apostrophe, making Angl'Opera. Apparently, according to the company, this 'created an indivisible whole, broken by a pause of calm and respite'. More importantly, perhaps, it gave the restaurant an easy-to-identify symbol, while its shape echoed the architecture.

For the identity and other graphic material, edo decided to keep things simple in terms of fonts, using Helvetica because 'It is elegant, modern and timeless'. But the practice got quite playful with the way it was used, superimposing the letters on top of one another in an effort, it says, 'to create a unity of ideas and tastes'. 'The split apostrophe,' edo declares, 'allows it to be read on two levels, just like Gilles Choukroun's cuisine.'

Finally, the colour palette of orange and blue was lifted directly from the hotel itself, while edo says the brown was added to convey 'a chic, elegant, comfortable edge without distancing itself too much from the hotel'.

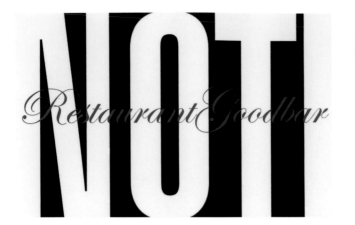

ROGER DE LLURIA, 35-37 08009
BARCELONA + 34 933 426 673
WWW.NOTI-UNIVERSAL.COM
NOTI@NOTI-UNIVERSAL.COM

ELENA BARTA / NOTI / SPAIN

Located in the former offices of the famous but now defunct Spanish newspaper *El Noticiero Universal,* NOTI has become one of Barcelona's hotspots. Serving Mediterranean, French-style cuisine, this restaurant-cum-nightclub is the brainchild of Christian Crespin and Elena Barta, who had previously owned a *chiringuito* (beach bar) at Sitges beach. Their aim with the new site, says Barta, was 'to reach a wider audience than just tourists and holiday-makers'.

For the interior, the pair decided to commission renowned Catalan designer Francesc Pons who, inspired by *el toreo* ('the bullfight'), created an extravagant cocktail of red velvet, linoleum, black glass, silk wallpaper and plenty of brass. According to Barta, who did the graphic design herself, 'It was my intention to be serious and modern without overshadowing any other element of the restaurant. I was also keen to respect the past as much as possible.'

So while Pons concentrated on bullfighting, Barta harked back to the building's former life, specifying the same font that *El Noticiero Universal* had used for its headlines, Swiss 911 BT Ultra Compressed, in the restaurant's logo. While 'NOTI' itself is printed in white on a red background, Barta has also included the rest of the paper's name in magenta on the menus. To soften this bold type – or, as Barta says, 'to add character and tenderness' – she ran the words 'Restaurant Goodbar' in Snell Roundhand over the top on much of the stationary, giving the graphics an extra pinch of decadence. The rest of the text in the menu is in easy-to-read uppercase DIN. The hints of colour were picked up directly from Pons interiors, although black and white predominate on much of the stationery.

The results, says Barta, are 'modern, elegant, simple, refined and functional, while at the same time being lively, warm, cosy, enjoyable, cheerful, likeable, professional and effective' – which just about covers it.

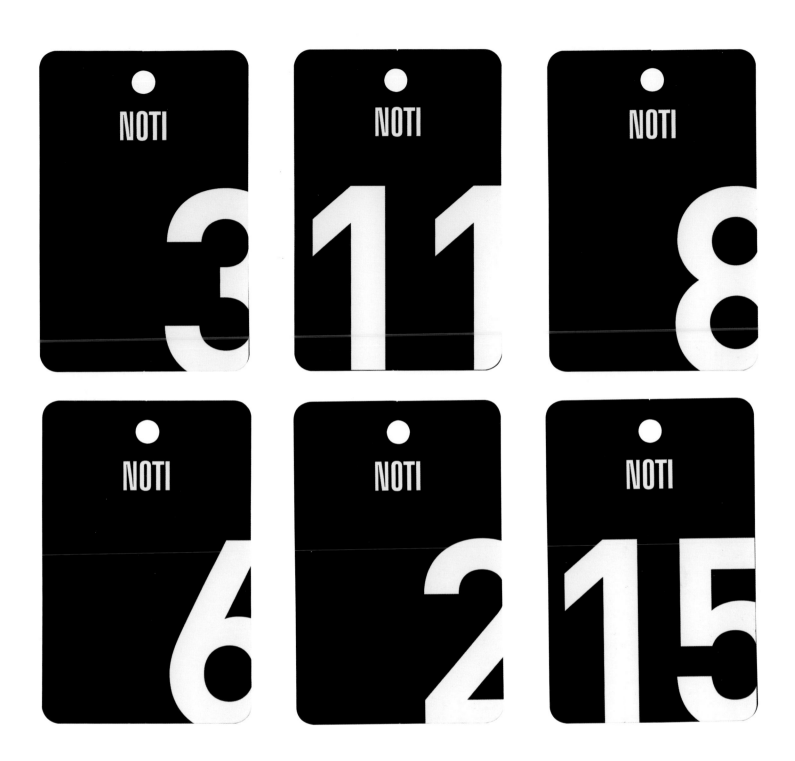

FACING PAGE / Business cards from Noti,
which use a combination of Swiss 911 BT
Ultra Compressed and Snell Roundhand.

ABOVE / The restaurant-cum-nightclub's coat tags.

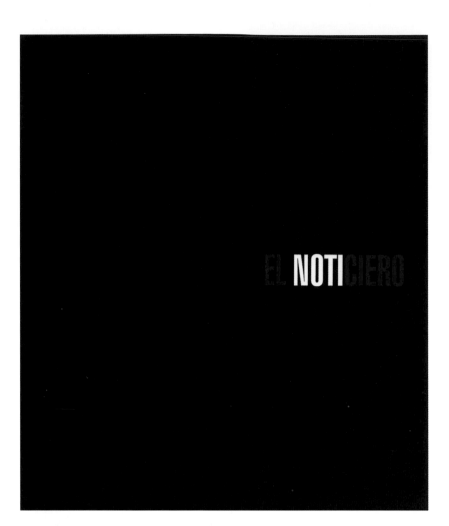

EL NOTICIERO

cold starters

HOMEMADE FOIE DE CANARD, TUB, GELATIN OF "FINO". TOASTS
SHORTBREAD SABLÉE OF SARDINES AND GOAT'S CHEESE, BALSAMIC VINEGAR REDUCTION
MESCLUN SALAD, TINY SLICED IDIAZÁBAL CHEESE, MUSTARD AND TOASTED PINE NUT VINAGRETTE SAUCE
TUNA FILLET IN TATAKI SOY SAUCE, WASABI
PRAWN AND SALMON CARPACCIO, LITTLE FRIED VEGETABLES, SEAWEED OIL

hot starters

NOTI'S FISH SOUP WITH NOODLES AND PRAWNS
RICOTTA CHEESE RAVIOLI AND IBERIAN HAM CREAM
CREAMY RISOTTO OF ROCKET SALAD AND MONKFISH
GRILLED SEASON VEGETABLES, VIRGIN OLIVE OIL
GRILLED GREEN ASPARAGUS AND POACHED EGG. GOOSEBERRY VINAIGRETTE

fish

RAW SEARED TUNA STEAK IN ITS OWN JUICE, SMOKED OIL
CONFITTED COD, TOMATO CONCASÉ IN THYME, ROSEMARY AND BLACK OLIVES, MEAT SPICE
GRILLED MONKFISH TAIL WITH GARLIC SHOOTS, LIGHT BACON CREAM
FISH FROM "LA BOQUERIA"

meat

TARTAR OF BEEF SIRLOIN AND "PONT NEUF" POTATO
CURRIED CHICKEN, COCONUT MILK, BASMATI RICE AND GRANNY SMITH APPLE CHUTNEY
NATURE BEEF SIRLOIN, VEGETABLES AND GRATIN DAUPHINOIS
BEEF SIRLOIN, ASIAN SPICES REDUCTION, PARMENTIER OF POTATOES
PAN FRIED LAMB SKEWER, COUSCOUS OF VEGETABLES AND RAISINS, HARISSA SAUCE
MAGRET OF DUCK, SWEET AND SOUR HONEY SAUCE. PUMPKIN MOUSSELINE

SELECTION ON FRENCH CHEESES
BRIE DE MEAUX + SAINT NECTAIRE + SAINTE MAURE DE TOURAINE + COTTAGE ROQUEFORT

CHEF CHRISTIAN CRESPIN. SPRING 2006
PVP IN EUROS. IVA NOT INCL.

entrantes fríos

TERRINA DE FOIE DE PATO, GELATINA DE 'FINO', TOSTADAS PAN INGLÉS 19,85
SABLÉ DE SARDINAS MARINADAS Y QUESO DE CABRA. REDUCCIÓN DE BALSÁMICO 14,50
MESCLÚN DE ENSALADA, VIRUTAS DE IDIAZÁBAL. VINAGRETA DE MOSTAZA Y PIÑONES TOSTADOS 11,50
LOMO DE ATÚN EN TATAKI, SALSA DE SOJA, WASABI 15,00
CARPACCIO DE SALMÓN Y LANGOSTINOS, VERDURITAS FRITAS. ACEITE DE ALGAS 18,70

entrantes calientes

SOPA DE PESCADO NOTI CON FIDEOS Y LANGOSTINOS 11,50
RAVIOLI DE RICOTTA, CREMA DE JAMÓN IBÉRICO 12,75
RISOTTO CREMOSO DE RÚCCULA Y RAPE 19,20
PARRILLADA DE VERDURAS DE TEMPORADA, ACEITE DE OLIVA VIRGEN 16,00
ESPÁRRAGOS TRIGUEROS A LA PLANCHA, HUEVO POCHÉ. VINAGRETA DE GROSELLA 14,10

pescados

STEAK DE ATÚN, SEMICRUDO Y EN SU JUGO. ACEITE DE HUMO 17,50
BACALAO CONFITADO, CONCASÉ DE TOMATE AL TOMILLO, ROMERO Y OLIVAS NEGRAS. ESENCIA DE CARNE 19
COLITA DE RAPE A LA PLANCHA, AJOS TIERNOS. CREMA LIGERA DE BACON 19,80
PESCADO DE LA BOQUERÍA 26,00

carnes

TARTAR DE SOLOMILLO DE BUEY, PATATA PONT NEUF 19,85
CURRY DE POLLO, LECHE DE COCO, ARROZ BASMATI, CHUTNEY DE MANZANA GRANNY SMITH 14,82
SOLOMILLO DE BUEY NATURE, HORTALIZAS, GRATÍN DAUPHINOIS 19,85
SOLOMILLO DE BUEY, REDUCCIÓN DE ESENCIAS ASIÁTICAS, PARMENTIER DE PATATAS 22,90
BROCHETA DE CORDERO A LA SARTÉN, COUS COUS DE VERDURAS Y PASAS. SALSA DE HARISSA 18,00
MAGRET DE PATO, AGRIDULCE DE MIEL. MUSELINA DE CALABAZA 17,50

SURTIDO DE QUESOS FRANCESES
BRIE DE MEAUX + SAINT NECTAIRE + SAINTE MAURE DE TOURAINE + ROQUEFORT ARTESANAL 13,00

PRIMAVERA 2006. CHEF CHRISTIAN CRESPIN
PVP EN EUROS. IVA NO INCL.

...unos aperitivos para empezar / ...canapes

TOSTADA DE TERRINA DE FOIE GRAS DE PATO. REDUCCIÓN DE GARNACHA
TOAST OF FOIE GRAS WITH GRENACHE REDUCTION

PECHUGA DE POLLO AHUMADO Y CAVIAR SOBRE BLINIS
SMOKED CHICKEN BREAST WITH CAVIAR AND BLINIS

CONSOMÉ DE LANGOSTINOS. RAVIOLI ABIERTO DE BOGAVANTE
PRAWNS CONSOMME. OPEN RAVIOLI OF LOBSTER

DORADA A LA PLANCHA. TEMPURA DE VERDURA. INFUSIÓN DE CITRONELA
GRILLED 'DORADA'. TEMPURA OF VEGETABLES. LEMON GRASS INFUSION

COCHINILLO ASADO CON FRUTA EXÓTICA TAITI' ARROZ MADRAS. SALSA AGRI-DULCE
ROASTED SUCKLING WITH FRUITS TAHITIAN WAY. MADRAS RICE. SWEET AND SOUR SAUCE

ESPUMA DE CREMA CATALANA
ESPUMA OF 'CREMA CATALANA'

COULANT CREMOSO DE CHOCOLATE CUBA. BANANITO CARAMELIZADO. CREMA HELADA DE VAINILLA BOURBON
CREAMY CUBA CHOCOLAT TART. CARAMELICED BABY BANANA. BOURBON VANILA ICE CREAM

...y a las 12. las UVAS DE LA SUERTE
...at midnight THE GRAPES OF LUCK

FELICIDADES CHEERS

Restaurant &GoodBar
NOTI
Roger de Llúria, 35–37
08009 BARCELONA
933 426 673
933 426 674 fax
noti@noti-universal.com
www.noti-universal.com

NOTI

FACING PAGE / The NOTI menu. The graphics combine a sense of the building's history with a touch of decadence.

RIGHT / Some of the restaurant's striking promotional material.

FROST DESIGN / COAST / AUSTRALIA

Coast, one of a clutch of upmarket restaurants that occupy Sydney's increasingly buzzing harbours, is another example of how a graphic designer can profoundly influence an interior – in this case, with a huge (and definitely three-dimensional) intervention.

Frost Design's brief was to create something quintessentially about the Sydney coast without relying on the usual clichés. To meet this challenge, the practice came up with the idea of creating an actual coastline and suspending it from the ceiling. This dramatic overhead installation of Sydney's coast stretches the length of the restaurant and was constructed from translucent yellow acrylic, then down-lit with LEDs.

The sculpture is composed of three groups of curvilinear forms made from 60m (197ft) of purpose-moulded translucent yellow acrylic. The forms themselves were created by making a one-to-one contour model which was then photographed and traced to form the cutting line for the acrylic mould. Frost worked with a lighting consultant to test different light sources and how they reacted with the acrylic ribbon; LED lighting was selected because it was long-lasting and relatively easy to maintain in a lively environment.

During the day, the sunlight penetrates the acrylic to bathe the space in a golden glow. Together, the lighting and the coastal forms help to create greater intimacy in what was quite a large, impersonal space. The lighting feature's visibility through the full-height glazing helps to promote the restaurant in a busy dining and entertainment precinct.

Meanwhile, running along the entire length of the restaurant is a giant 30m (98ft) image of Clovelly Beach at dusk taken by Stephen Ward. Commissioned especially for the project, Frost's aim was to capture the beauty of the beach at twilight. Rather than looking *at* the coast, the photograph is a view *from* the coastline. The shot is also used on the menus and other livery, including business cards, invitations and even its in-house wine label; in fact, it sets the tone for the restaurant's entire colour palette.

Announcing the restaurant at the entrance is a huge 1.2m (4ft) yellow curve: the top half of the letter 'C'. It is completed by its reflection in a shallow pool of water. Reflection is also the theme for the restaurant's logo; it's as if the word 'coast' is disappearing over the horizon. At night, the inside of the curve is up-lit, creating an alluring gradient of colour and light. To echo the handmade logotype, Frost elected to use Foundry Monoline for its 'clean, minimal lines'.

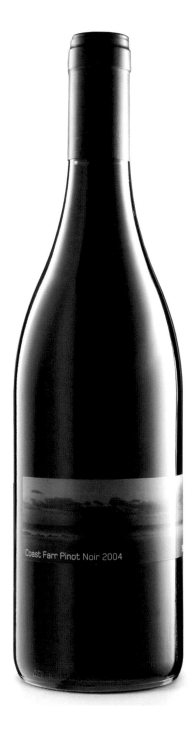

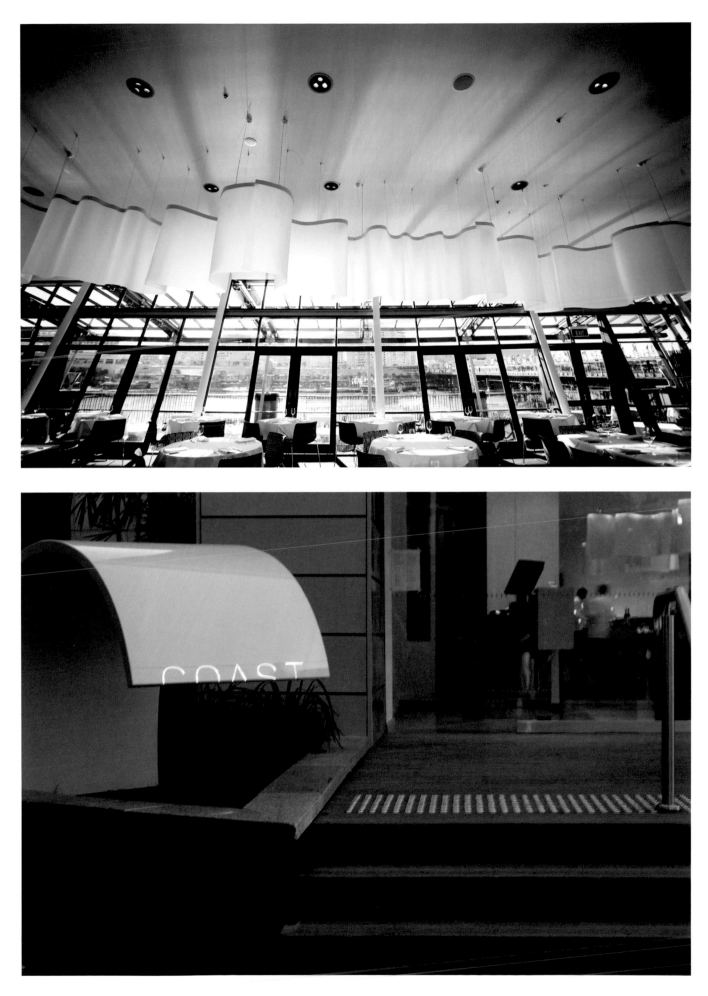

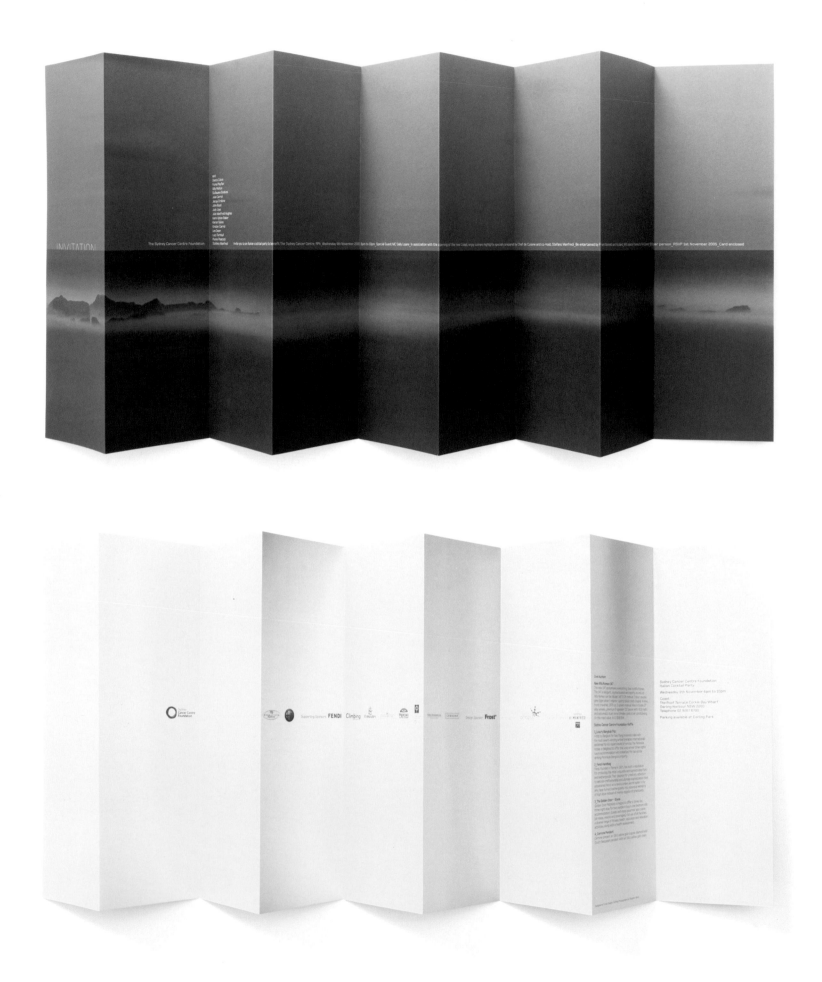

FACING PAGE / Examples of invitations to the restaurant.

BELOW / Some business cards, using photography to
further the restaurant's coastal theme.

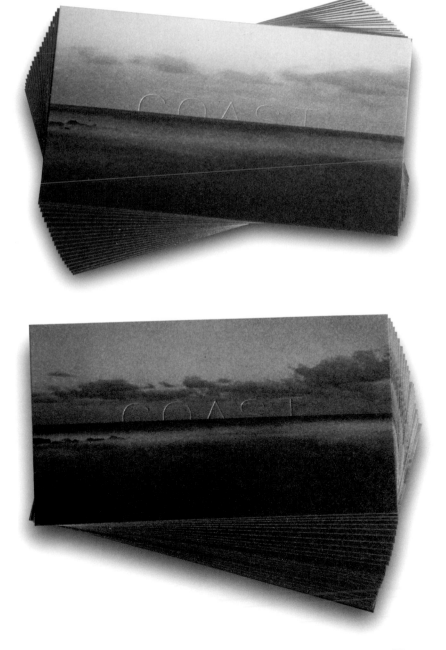

GRAFICA / OVEN / SPAIN

The design of Barcelona's Oven has two strong but contrasting influences: geometry and Mexico. Owned by Greek minimalist architect Minos Digenis and colourful Mexican DJ Professor Angel Dust, the restaurant-cum-nightclub mixes both their backgrounds to telling effect. At Oven, cool straight lines meet rather bizarre South American artefacts. According to the scheme's graphic designer, Pablo Martin of Grafica, the initial 'brief' was scant, to say the least. 'There wasn't a brief,' he says. 'I got involved six months before it was opened, so I was able to work closely with the architect for a while. There was this thing about "the mix of cultures", but they wouldn't brief me.'

Evidence of the close working relationship between architect and graphic designer can be seen in the graduated hues of red on the menus and the business cards (what Martin describes as the 'quieter graphics'), which have been picked up directly from the interior. 'Everything was very warm. Everything was very red, like an oven,' explains Martin. 'There was a richness to the red inside; the lighting was very interesting. And I thought it would be very boring, or not as rich, if we used just a flat red.' Martin describes the restaurant's logo as a 'typographic anecdote', explaining that he wanted to create something that was a symbol yet still a logo. The idea was that it should be geometric while also being slightly enigmatic at the same time; he happily admits it's hard to read, but believes that, once you know what it says, it becomes a marque you'll always remember.

Elsewhere, the designer has introduced some neat flourishes. The logo, for example, is die-cut into the flyers, which also show fragments of a larger, Mexican-inspired image created to encourage customers to collect the entire set. As an aside, the restaurant's head chef uses the die-cut to recreate the logo on plates with herbs before sending them out to the customers.

The central notion of geometry meeting Mexico came together most obviously in the monthly brochures Martin also designed for the restaurant. For these, he photographed some of Professor Angel Dust's eclectic collection of Mexican objects before superimposing a technical drawing on them. With all this strong imagery going on, the designer elected to use a single font, Vectora, throughout. 'We just needed a sans serif typeface,' he says. 'It was something quite new and it could gives us something that Helvetica couldn't. Helvetica is used and very abused.' Oven, he concludes, is a project more about images and colour than typography.

FACING PAGE AND ABOVE / The menu cover for Oven, and its business card, front and back. The graduated red hues reflect the name of the restaurant, while its designers describe the logo as a 'typographical anecdote'.

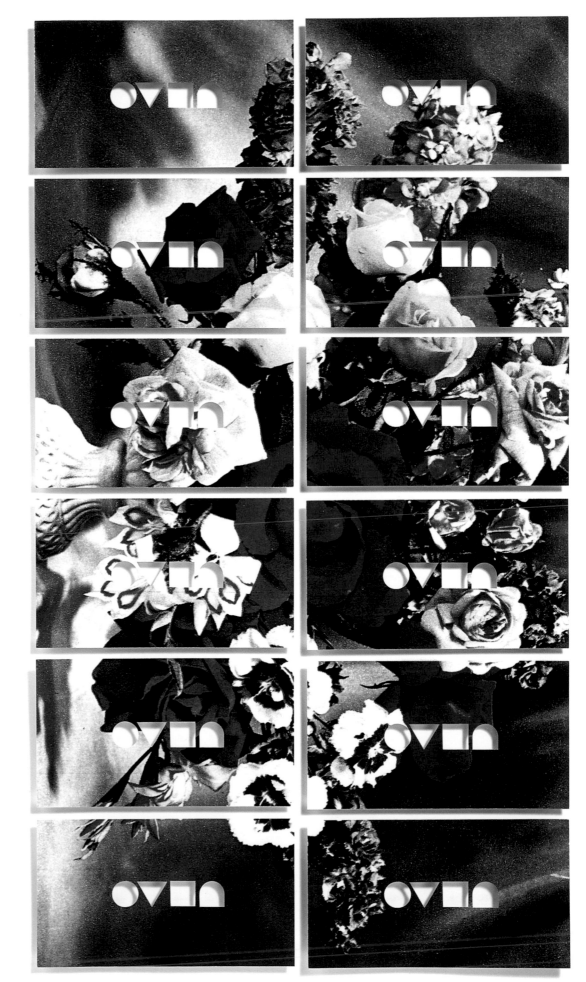

FACING PAGE / More examples of the menu and wine list (ABOVE), as well as drinks mats (BELOW).

RIGHT / Flyers for the restaurant show fragments of a larger Mexican-inspired image. The logo, meanwhile, has been die-cut.

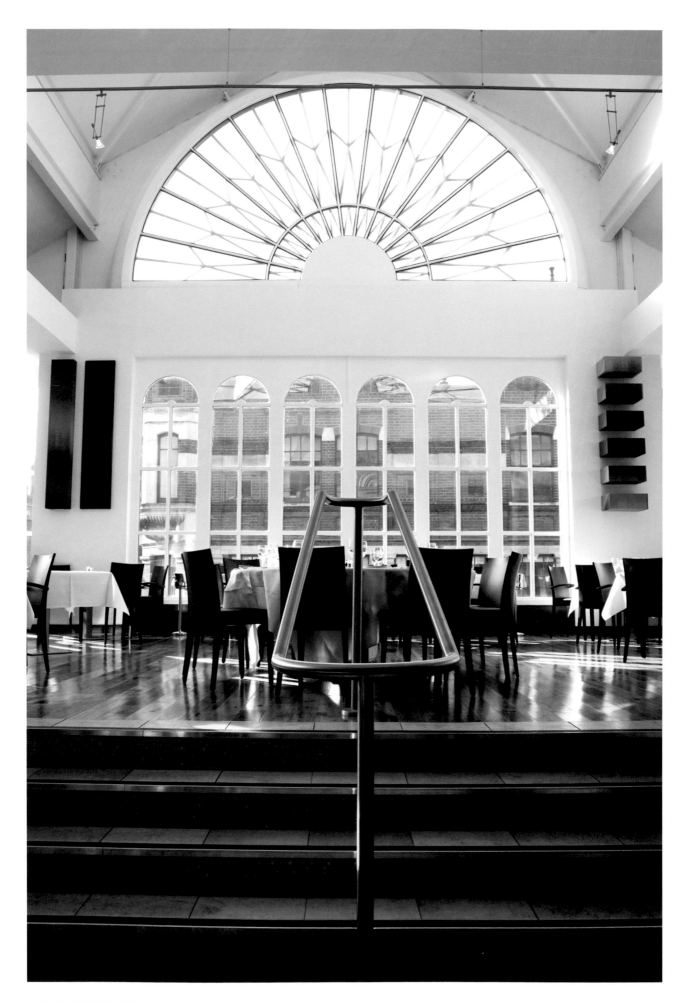

The Floral Hall Borough Market Stoney Street London SE1 1TL
T 020 7940 1300 F 020 7940 1301 E info@roast-restaurant.com
www.roast-restaurant.com

roast

roast
BILL

HGV / ROAST / UK

Roast is an intriguing idea that relies heavily on a sense of place. Thanks to the likes of style and food guru Terence Conran, the UK has undergone a food revolution in the past two decades. However, the notion of what constitutes British cuisine has become clouded along the way. Owned by former journalist (and founder of London's The Cinnamon Club, in Westminster) Iqbal Wahhab, Roast is located in the famous Floral Hall, once situated in Covent Garden, but recently rebuilt in Borough Market, one of the oldest markets in London. The restaurant aims to encourage diners to rediscover seasonal British food by buying its ingredients from the market itself. It was this concept that influenced the restaurant's interior and graphics.

Designed by David Gabriel, the interior, which has a spit-roasting oven as its focal point, uses natural materials, including plenty of wood. According to Wahhab: 'We didn't need elaborate design. We just need effective functional design that works well with the building. It's like cooking with salt: you can always put more in later.'

When hgv's Pierre Vernier came to do the restaurant's graphics, it made sense to follow suit. 'The idea behind the restaurant was to come back to a British, seasonal type of food and cooking,' he explains. 'So then, with the identity, they wanted to reflect the traditional aspect and natural theme. And to evoke the name "Roast" we came up with a roasting motif.'

Initially, the various menus for the different applications look the same. It's only on closer inspection that you notice that the grain in the cross-section of wood is very slightly different. So in the bar menu it's possible to make out a stick of rhubarb, the dessert menu contains a pear, while the bill wallet has an onion. Meanwhile, the word 'Roast' has been hand-drawn, because the practice didn't want to use a run-of-the-mill typeface.

Since the restaurant opened, the motif has found an array of applications. For example, the cover of the staff brochure, which deals with the nature of the brand and the need for a tight-knit operation, uses peas in a pod. Clever, eh?

FACING PAGE / Roast is located in Floral Hall, directly above London's Borough Market.

THIS PAGE / All the menus and stationery riff on the same theme: subtly playing with woodgrain to get their message across.

roast
WINE LIST

FACING PAGE / The Roast wine list continues the theme of images in wood-grain: look closely and you can make out the outline of a wine bottle, with a reflection on the left side. Other designs (ABOVE) in the graphic pack are more obvious…

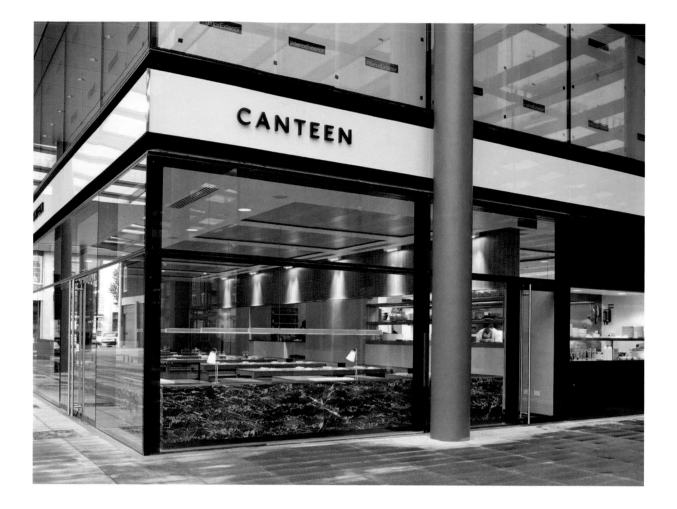

HUDSON POWELL / CANTEEN / UK

There's something very evocative about the name of this London restaurant. The word 'canteen' comes positively loaded with connotations, conjuring mental images of noisy, smelly spaces, of plastic trays, formica-topped tables replete with cigarette burns, cheap cutlery, and, in the UK, sugary tea, baked beans and men in hats. Canteens were places that existed before McDonald's invaded the British high street.

But while this east London eatery acknowledges the refectories of old – by including 'mushy peas' on its menu, for example – its sights are set somewhat higher. According to its owners, Canteen is 'committed to providing honest food, nationally sourced, skilfully prepared and reasonably priced'. In design terms, this has been translated into a broadly modernist, democratic-feeling interior by Universal Design Studio, with large oak tables at its centre and more intimate booths decked out in a green Bute fabric running around the circumference.

ABOVE / The Canteen interior was designed by Universal Design Studio.

FACING PAGE / Canteen's address card. Hudson Powell's graphics draw inspiration from English canteens of the 1960s.

If the interiors take their cues from the interwar years, then Hudson Powell's graphic palette has taken inspiration from a rather different era. 'The brief was to do with sixties English canteens, really,' admits Luke Powell. 'The client was really interested in colours from that period – the kind of muted blues and beiges – as well as the font styles. They wanted to capture the feeling of that era but make it completely modern at the same time. They also wanted to keep it simple.'

The results are quiet and undoubtedly elegant without being in any way elitist. Much of this is down to the sugar paper the designer chose for all the stationery, including the menus. According to Powell, the reasons for this were twofold: it's a cheap paper stock but also a very practical one, in the sense that it does 'soak stuff up'. That it also happens to bring back memories of childhood art classes is probably not a coincidence.

For the restaurant's logo, Powell decided on Johnston, a font best known for its use on the London Underground system. 'It's basically similar to Gill, but the weights are very slightly different,' Powell explains. 'When we compared them, the middle weight that Johnston gave us was exactly what we were after.' The main body text on the menu, meanwhile, is in Garamond which was chosen 'because we love it as a font and it was relevant to that era'.

However, perhaps the most intriguing element of the scheme is the restaurant's logo – or marque, as Powell prefers to call it. After researching medieval heraldry, Powell took two triangles – one red, the other blue – and joined them to create a square in a symbol that's designed to represent the connection between the restaurant and its various partners, from customers to suppliers. In many respects it's a 'non-logo', designed to be used as a seal on envelopes rather than the key element of the brand and, as such, sums up much of the work on this restaurant: simple, reserved and effective.

CANTEEN

Canteen is committed to providing honest food, nationally sourced, skillfully prepared and reasonably priced. We believe in good produce provenance. Our meat is additive free sourced directly from producers practicing good animal husbandry and our fish delivered fresh from day-boats on the south coast. All dishes are cooked to order and the menu changes seasonally to accommodate the best and freshest national produce.

2 Crispin Place 0845 686 1122
Spitalfields London info@canteen.co.uk
E1 6DW UK www.canteen.co.uk

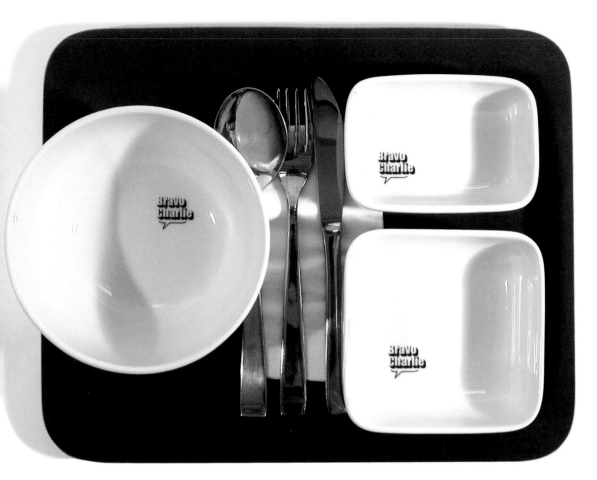

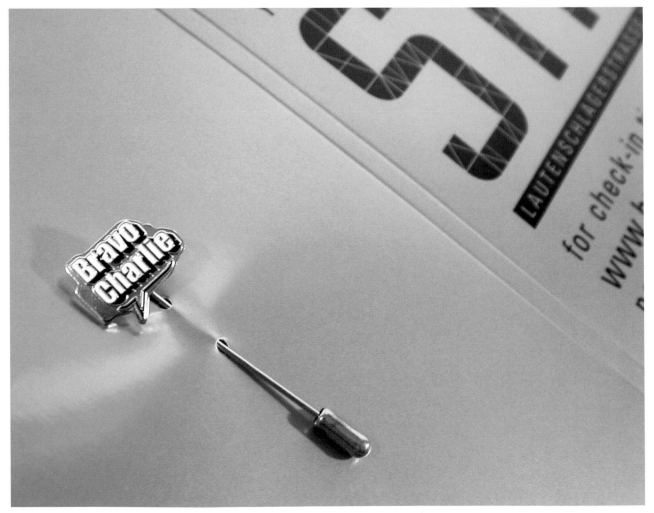

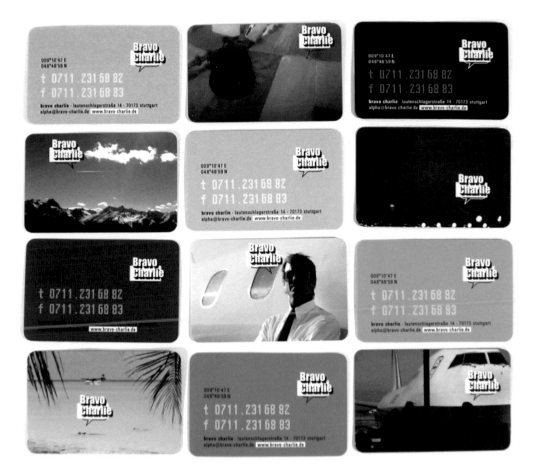

I_DBUERO / BRAVO CHARLIE /
RUBIROSA / GERMANY

Located in a former Lufthansa airport terminal in Stuttgart, it's absolutely impossible to get away from airport paraphernalia in Bravo Charlie. With graphics by German design house i_dbuero, the brief, says the practice's Oliver-a Krimmel, was to 'create a comfortable restaurant and bar/club with delicious international food where people can feel at ease, but in the meantime create a special atmosphere with a unique environment'.

'Because of the former history, it soon became clear that we wanted to refer to the aerial world,' explains Krimmel. 'The owner wanted to call it "Terminal", which in our opinion was too technical and common. So i_dbuero came up with the idea of basing the name on the international pilot's alphabet.' Hence Bravo Charlie – which, as the designer points out, could also stand for 'bar and club'.

Flight, of course, conjures up a host of associated images and emotions but, according to Krimmel, the real challenge was to use these common pictures and moods in a completely new way, 'without being retro or too close to the subject'. Central to this were the huge collages hung from the walls and the neat appropriation of aeronautical language: L-00, for example, was used to indicate the basement level (or Level 00) which also happened to house the toilets (or 'loos', in British English). Geddit?

ON THESE PAGES / In keeping with its airport terminal location, Bravo Charlie picks up on the paraphenalia of flight, using the familiar Gateway font as well as that old favourite, Univers. The Bravo Charlie font itself was specially created.

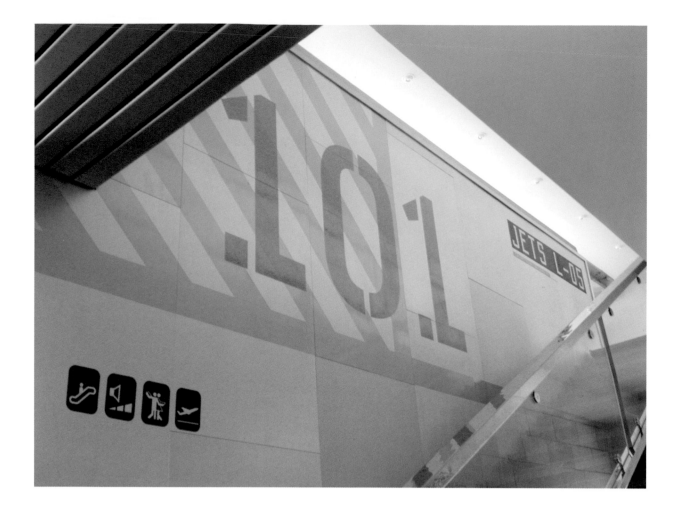

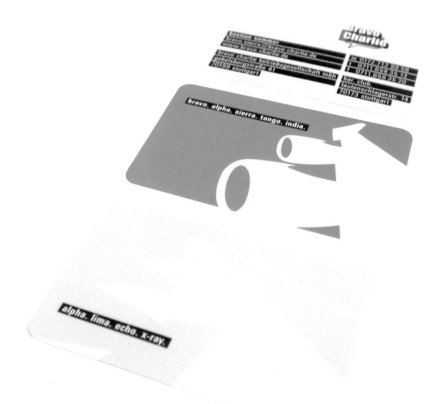

Staying with the airport theme, i_dbuero chose to use Univers, a font designed by Adrian Frutiger, the typographer behind France's Charles de Gaulle International Airport signage, throughout the scheme, combining it with the familiar airport Gateway type and the self-made Bravo Charlie font which, says Krimmel, 'adds more glamour and emotion'. For the logo, the designer selected Impact so that the branding had – well, impact. In terms of colour, the scheme is full of olives, greys, bright yellows, and soft beiges: shades Krimmel believes are associated with flight. It's just as well for Bravo Charlie's customers that he doesn't take charter flights too often…

Ultimately the graphic concept became so strong that the furniture in areas such as the upstairs Tigerlounge was specified to match the graphic designer's approach.

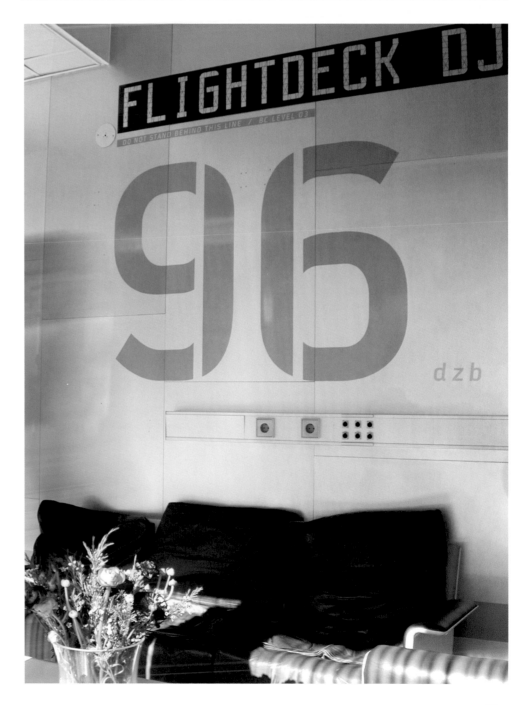

ON THESE PAGES / More examples of Bravo Charlie's flight-driven graphics. In the end, the graphic design proved so strong that the furniture in many areas of the restaurant was designed to match it.

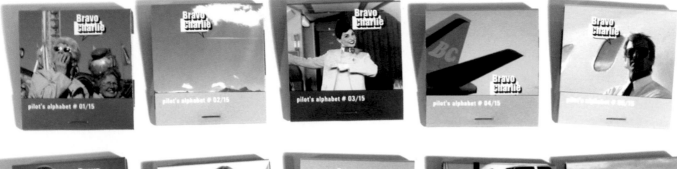

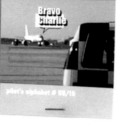
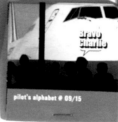
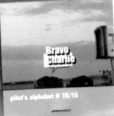
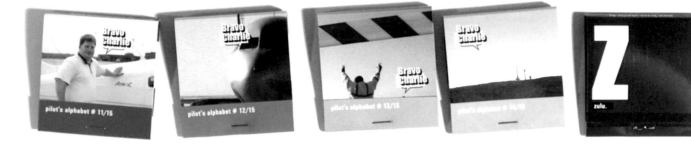

pilot's alphabet # 01/15
pilot's alphabet # 02/15
pilot's alphabet # 03/15
pilot's alphabet # 04/15
pilot's alphabet # 05/15
pilot's alphabet # 06/15
pilot's alphabet # 07/15
pilot's alphabet # 08/15
pilot's alphabet # 09/15
pilot's alphabet # 10/15
pilot's alphabet # 11/15
pilot's alphabet # 12/15
pilot's alphabet # 13/15
pilot's alphabet # 14/15

Z
zulu.

ABOVE AND FACING PAGE / Bravo Charlie's matchboxes
present a nostalgic, pre-9/11 view of aeronautics, while
the shape of the bar menu echoes that of aircraft windows.

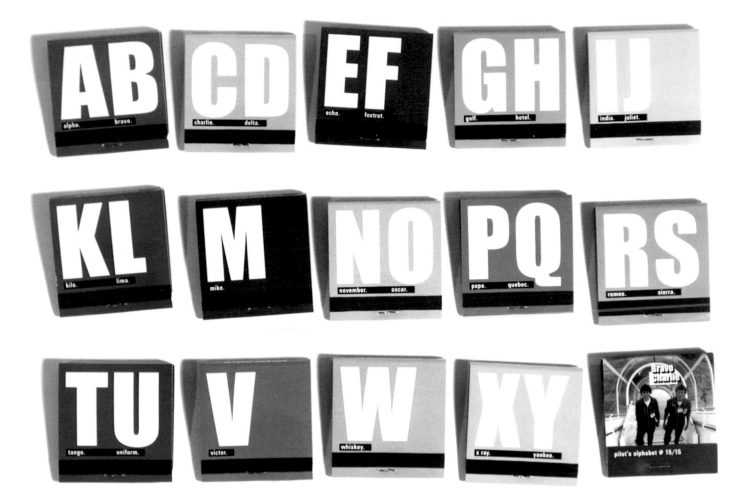

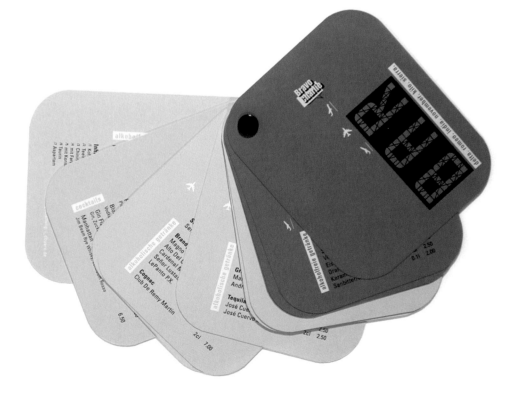

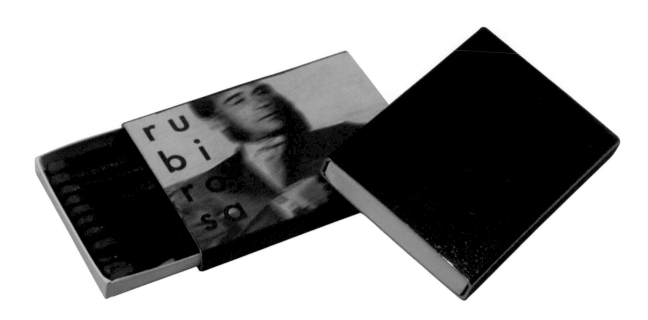

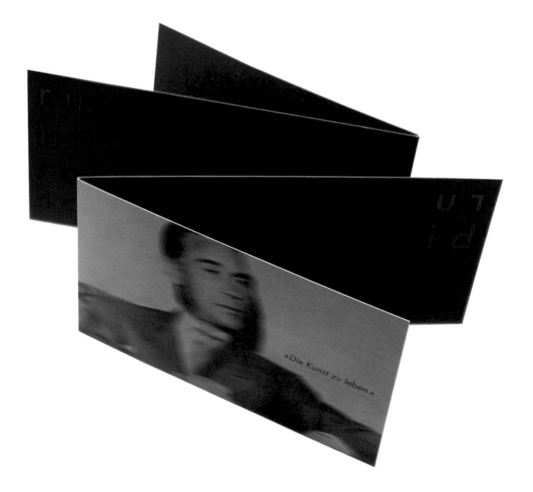

ACROSS THESE PAGES / Both the interior and graphic material at Rubirosa possessed a luxuriant, decadent feel, that was completely in keeping with the man himself.

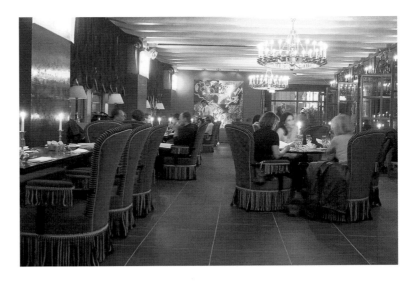

To prove the practice is anything but a one-trick pony, it also did the two-dimensional work for a now sadly closed restaurant called Rubirosa in the same city. As befits its name, very little about Rubirosa was understated. 'Our concept was to give the restaurant a real personality,' explains the scheme's designer, Oliver-a Krimmel of i_dbuero. And they did: literally. After learning that the restaurant's owner drove a Ferrari that had once been in the possession of the Dominican playboy Porfirio Rubirosa, it was decided to base the whole restaurant around his lifestyle.

Rubirosa died in 1965, when the Ferrari he was driving smashed into a tree; the 56-year-old had been celebrating vigorously after winning a polo match and was travelling with his fifth wife, Odile Rodin. Over the years he had become known for his womanizing – managing to coax the likes of Marilyn Monroe, Zsa Zsa Gabor, Ava Gardner and Eva Peron into his bed – as well as for being an adventurer. At various times he had been a jewel thief, a forger, a shipping magnate, a treasure hunter and, last but by no means least, a politician.

Once the practice had found its man, the working process, according to Krimmel, entailed 'lots of cigars and wine' and experiencing 'quite a bit of the Rubirosa lifestyle – except the polo-playing, for budget reasons'. Rubirosa means 'ruby-red' in Spanish, so the choice of colours directly reflected this, while when it came to selecting fonts, Krimmel says he was after something that was both classic and high-class; Paul Renner's Futura was an obvious choice.

The relationship between architect and graphic designer was crucial. Rather unusually, perhaps, architect Gasser/Wittmer was working to a concept drawn up by a graphic designer, and the interior is peppered with references to Rubirosa himself. The columns had the names of his numerous lovers written on them, while the doors leading to the back of house were marked with Hollywood-style stars and characters that played an important part in his life. Meanwhile, the ceilings were plastered with items relating to his hobbies, which included flying, cigars and polo. And there was a final neat touch on the exterior, where the sign took a typical Rubirosa quote: 'To work? I don't have the time to work.'

Certainly Krimmel believes it would have made the old bounder himself very proud, describing it as a 'worthy memorial of his life and "work"'. And, one suspects, he might be right.

INTERFIELD DESIGN /
CAYENNE / ROSCOFF /
RAIN CITY / CAFÉ PAUL RANKIN / UK

Cayenne, located in the middle of Belfast and owned by restaurateurs Paul and Jeanne Rankin, is unusual in the sense that it's dominated by an extremely rich graphic language. Created by Interfield Design's Peter Anderson, the interior plays second fiddle to the two-dimensional design. Anderson, a Belfast native, was commissioned after the success of the couple's upmarket Roscoff restaurant. 'They always wanted Roscoff to be a relaxed, vibe-y place,' he explains, 'but it ended up being rather posh.' 'Posh' or not, it still put the Rankins on the culinary map – and yet, the pair wanted a new challenge. 'They basically said to me: "We want to turn everything upside down and do something new",' says Anderson.

Which is exactly what he did. Cayenne is awash with ideas. Its centrepiece is the 10.7m (35ft) lightbox on the ceiling that is rigged up with microphones and responds to sound by very slowly changing colour. When diners go to the toilet, they are followed by a lenticular piece of artwork. Elsewhere, a fluorescent sculpture reads 'He opened his mouth and swallowed the truth'. According to Anderson, in Irish folklore 'truth' means food. However, it's an expression with several layers of meaning when one realizes that this is also a hangout for many of the city's businessmen doing lunchtime deals.

Perhaps most impressive is the 18.3m (60ft) wall at the back of the restaurant. Here Anderson took the Belfast street map, broke it up and rearranged it. Then he took all the names from the Northern Ireland phone book and dumped them onto this new design. On one level diners can have fun trying to find themselves, but on another it means that, in this most divided of cities, Protestant names suddenly find themselves rubbing shoulders with Catholic ones, which, as Anderson points out, doesn't happen very often here. 'I thought about the whole experience of being in a restaurant and tried to recreate that as art,' he declares. Patrons might not understand (or even perhaps notice) what's going on around them, but sometimes that's beside the point.

ABOVE / A detail from a new artwork in the restaurant's recent extension.

FACING PAGE / Cayenne's impressive corian wall features a disjointed Belfast street map together with all the names from the Northern Ireland phone book.

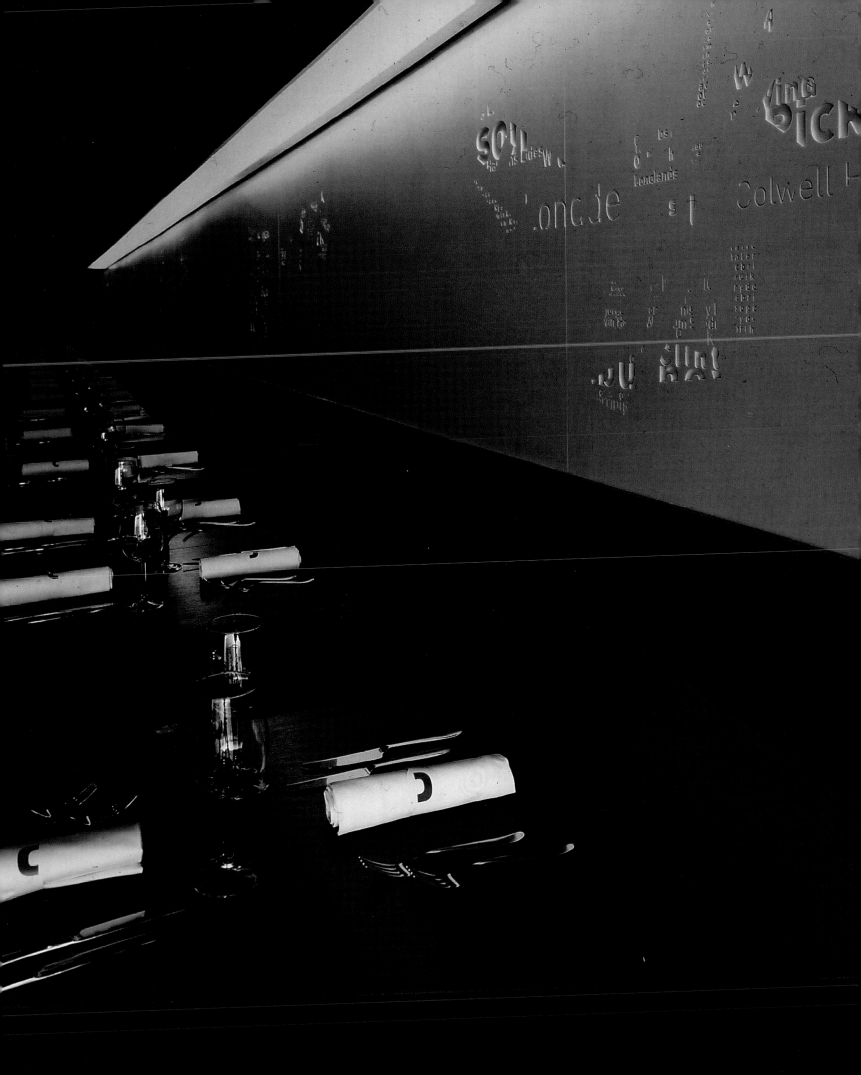

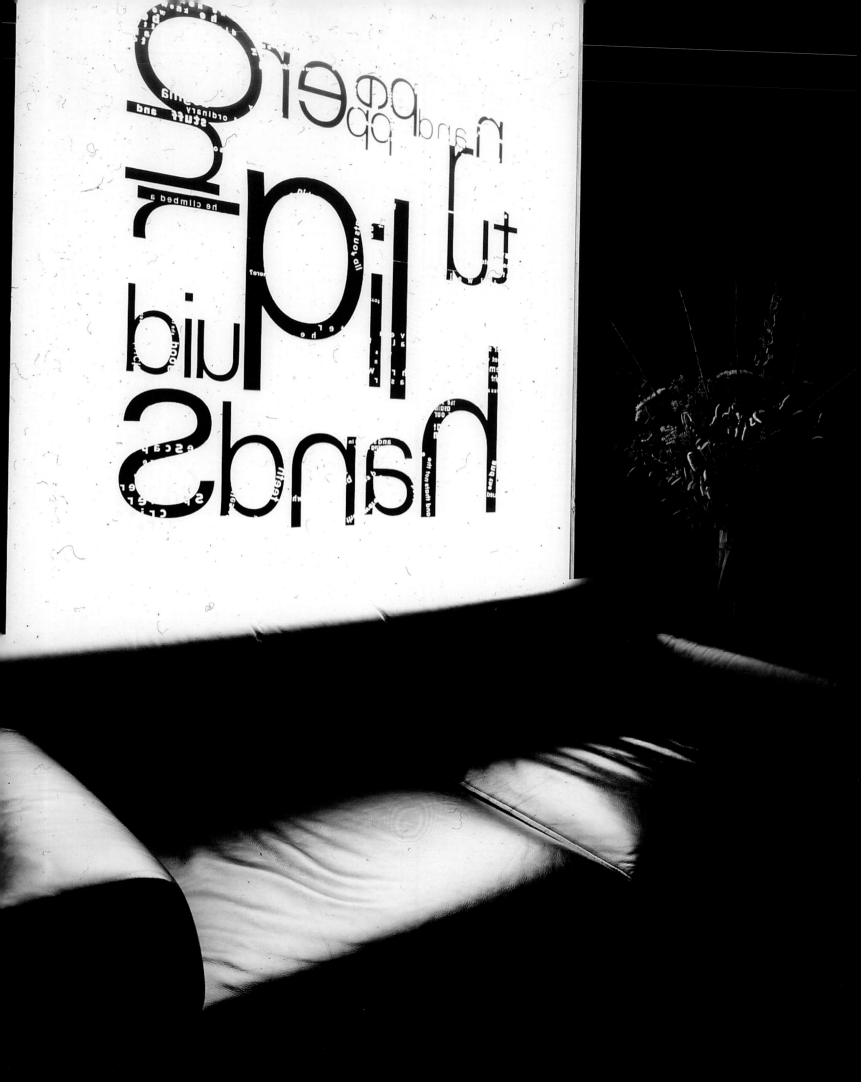

Cayenne, located in the middle of Belfast and owned by restaurateurs Paul and Jeanne Rankin, is unusual in the sense that it's dominated by an extremely rich graphic language. Created by Interfield Design's Peter Anderson, the interior plays second fiddle to the two-dimensional design. Anderson, a Belfast native, was commissioned after the success of the couple's upmarket Roscoff restaurant. 'They always wanted Roscoff to be a relaxed, vibe-y place,' he explains, 'but it ended up being rather posh.' 'Posh' or not, it still put the Rankins on the culinary map – and yet, the pair wanted a new challenge. 'They basically said to me: "We want to turn everything upside down and do something new",' says Anderson.

Which is exactly what he did. Cayenne is awash with ideas. Its centrepiece is the 10.7m (35ft) lightbox on the ceiling that is rigged up with microphones and responds to sound by very slowly changing colour. When diners go to the toilet, they are followed by a lenticular piece of artwork. Elsewhere, a fluorescent sculpture reads 'He opened his mouth and swallowed the truth'. According to Anderson, in Irish folklore 'truth' means food. However, it's an expression with several layers of meaning when one realizes that this is also a hangout for many of the city's businessmen doing lunchtime deals.

Perhaps most impressive is the 18.3m (60ft) wall at the back of the restaurant. Here Anderson took the Belfast street map, broke it up and rearranged it. Then he took all the names from the Northern Ireland phone book and dumped them onto this new design. On one level diners can have fun trying to find themselves, but on another it means that, in this most divided of cities, Protestant names suddenly find themselves rubbing shoulders with Catholic ones, which, as Anderson points out, doesn't happen very often here. 'I thought about the whole experience of being in a restaurant and tried to recreate that as art,' he declares. Patrons might not understand (or even perhaps notice) what's going on around them, but sometimes that's beside the point.

Cayenne, though, is only the tip of the burgeoning Rankin restaurant empire. Anderson has also been commissioned to work on a new version of the upmarket, mature Roscoff, the family-friendly Rain City and the immediate (as opposed to fast) Café Paul Rankin. As Anderson explains: 'All the artwork is me; all the branding for the most part is me; but they're all aimed at a completely separate target market.' What they all share is attention to detail. Where Cayenne is all celebrity chic, Roscoff, the Rankins' oldest brand, is designed for the more low-key, mature diner. Anderson may have created all the art, but here it comes traditionally framed, while he also decided to adapt some elements of the original identity and add a few quirks of his own. The menu, for example, has a spoon on the back and a fork on the front cover made from a poem that pays homage to Rankin's food. The

FACING PAGE / Text on the outside windows gives Cayenne a huge presence on the street.

ABOVE / A detail from the ceiling lightbox installation.

ACROSS THESE PAGES / The interior and graphics from
the more mature Roscoff. The spoon and fork on the
menus are made from a poem that pays homage to
Rankin's food. The latter utensil also repsents the fork in
the road where the restaurant is located.

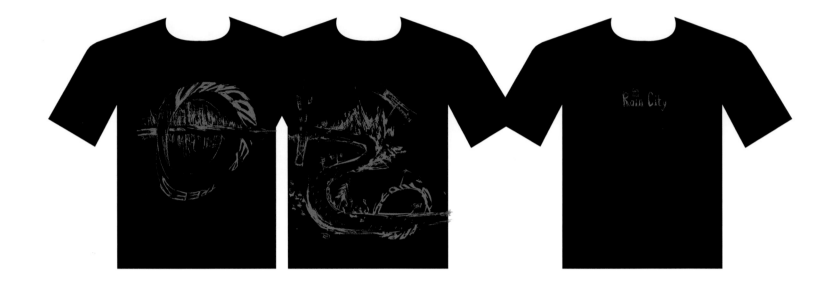

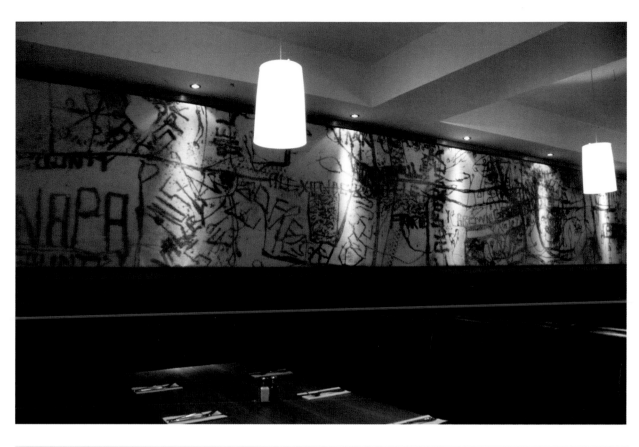

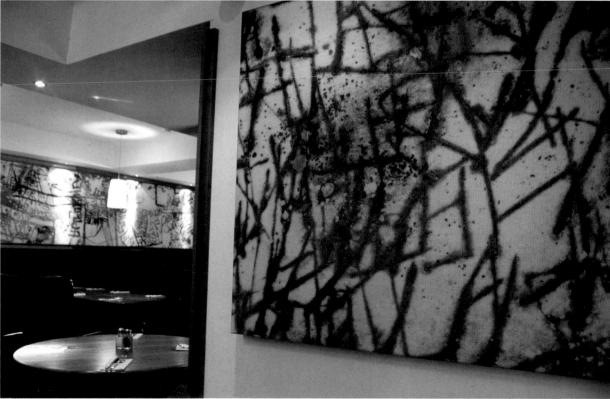

ACROSS THESE PAGES / Rain City has sites in both Belfast and Antrim in Northern Ireland. Here Interfield's Peter Anderson created drawings based on the Rankins' lives. The T-shirts are specifically 'male- and female-designed'. When waiting staff brush past each other, they create a complete drawing.

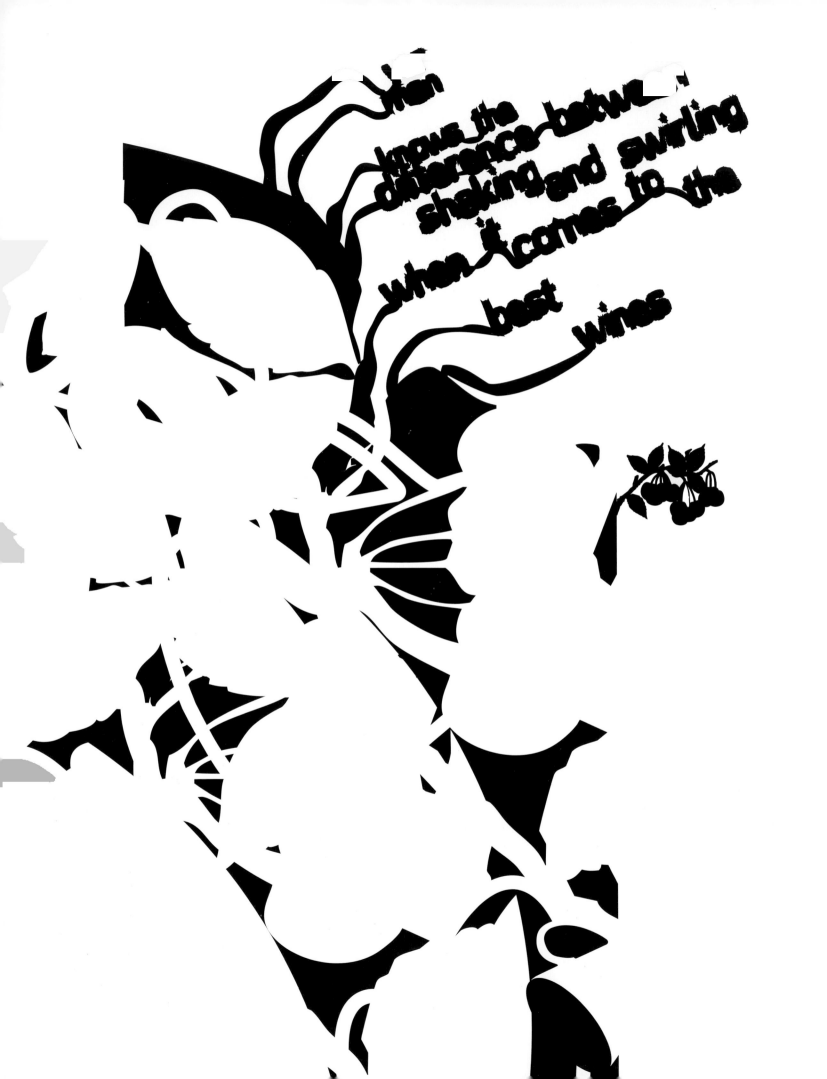

FACING PAGE / Graphics from Café Paul Rankin,
which Anderson describes as 'a brand in transition'.

ABOVE AND BELOW / Coasters and vinyl for the
wine refrigeration.

ABOVE / More of Paul Anderson's signature artwork that was designed for Café Paul Rankin.

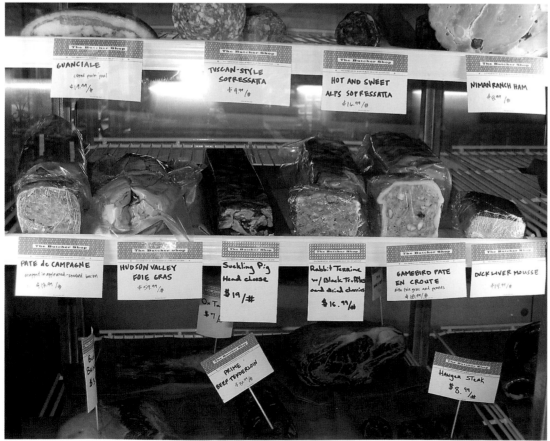

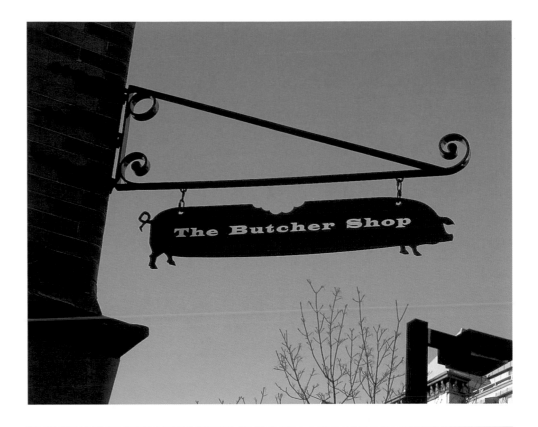

JAMES BARONDESS / THE BUTCHER SHOP / B&G OYSTERS / USA

Although located in Boston, The Butcher Shop pays homage to European *boucheries,* being both a restaurant and a retail butcher. Owned by Barbara Lynch, it is described on its website as a 'love letter' to her soujourns in Europe:

A place to have a glass (or bottle) of wonderful wine, perhaps a charcuterie plate of homemade morsels or something more substantial, such as a gnocchi with spicy sausage ragu.

While its interior was created by Bentel Associates, the real star of the show is the restaurant's graphic palette created by Boston-based designer James Barondess. A former teacher of graphic design and design history at Harvard University, he describes the central motif of his work as 'an exploration of patterns created using Zuzana Licko's beautiful decorative "Whirligig" font'. The patterns turn up on menus, letterheads, business cards, labels and gift vouchers. Possibilities of the forms it creates are fully explored – meaning, for example, that there are dozens of different business-card variations, as well as different versions of letterheads, labels and cards. For the colour palette, Barondess went back to basics, using a traditional black and red scheme which he describes as 'appropriate for such a carnivorous place'.

Signage is another important element of the restaurant. The Butcher Shop windows, on which Barondess collaborated with Matt Meyer, are gilded in four different colours of gold leaf, and have various black pattern screens which echo the Whirligig and filter light during the day while providing an intriguing optical effect at night. 'These pattern screens bear some resemblance to decorative ironwork, which is a fixture in this historic Boston neighbourhood,' explains the designer. The copy on each pane advertises the restaurant's specialties and gives it even more presence on the street. From the outside, as Barondess indicates, 'One sees an effect somewhat reminiscent of curtains in saloon windows.'

FACING PAGE TOP, AND ABOVE / The Butcher Shop type is evocative of another age. For the logo, James Barondess selected Latin Wide, partly because of its knife-blade serifs.

FACING PAGE BELOW / How the graphics work with the food.

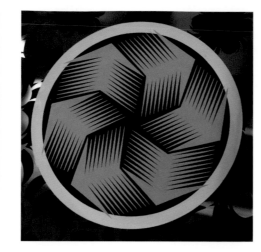
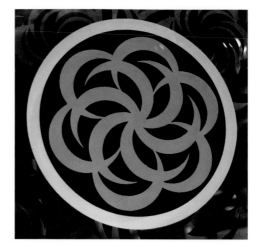
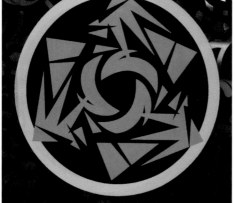
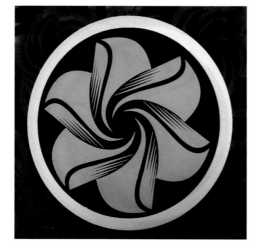
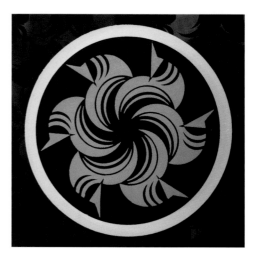
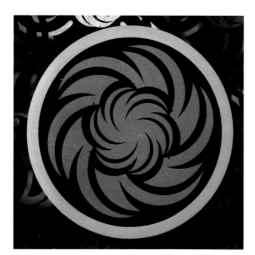
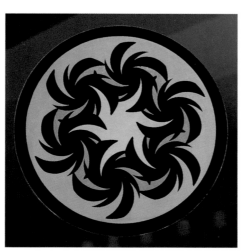
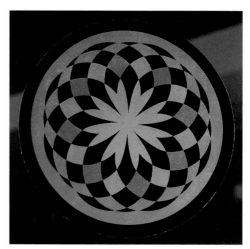

ABOVE / Variations of the 'whirligig'. The patterns turn
up on menus, letterheads, business cards, labels and
gift vouchers.

FACING PAGE / On the restaurant's windows, Barondess
collaborated with Matt Meyers to create patterns that
echoed the whirligig.

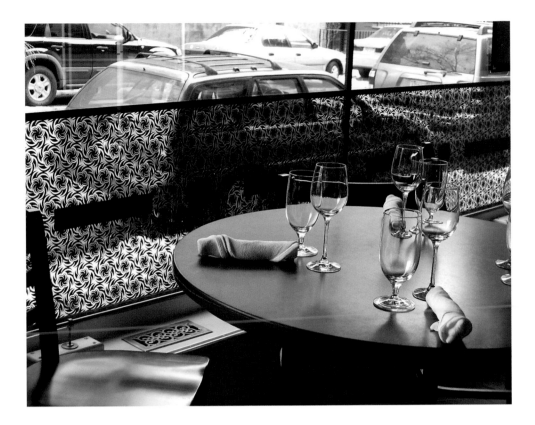

Like the rest of the scheme, the restaurant's type is also evocative of a different age. For the logo, the designer selected Latin Wide, which he describes as 'an early nineteenth-century design with seemingly appropriate knife-blade serifs characteristic of the "Latins" of that period'. Interestingly, one of the body faces is Clarendon, a slab serif, whose origins also come from that period; the fact that the restaurant sits just off a street with the same name can hardly be a coincidence.

However, not content with this, Barbara Lynch also opened another restaurant, B&G Oysters, next door. Serving refined versions of New England classics like clam chowder and lobster roll, the restaurant used the same design team to create a simple, pared-down interior. According to Barondess: 'The graphics were conceived to reflect this aesthetic of simplicity and refined high quality.' Hence a colour palette that plays off both the interior and the produce. For his typeface, the designer chose DIN Neuzeit Grotesk, a mid-twentieth-century German face known for its clean, modernist forms.

Other references to oysters can be seen, most obviously in the signage, which uses various colours of Japanese silver leaf and gold, but also in the paper of the printed material, which contains what Barondess describes as small, white oyster-shell flecks. Like The Butcher Shop, the designer used the restaurant business cards as an excuse to experiment, starting with three-colour printing (black, blue and yellow) and then overprinting with different spot-colour tints to produce a variety of different shades. 'There are 16 different business-card variants on two different paper colours, or a total of 32 different business cards,' he explains. Meanwhile, menus and wine lists are printed out daily by the restaurant itself on offset-printed sheets with the logo in colour.

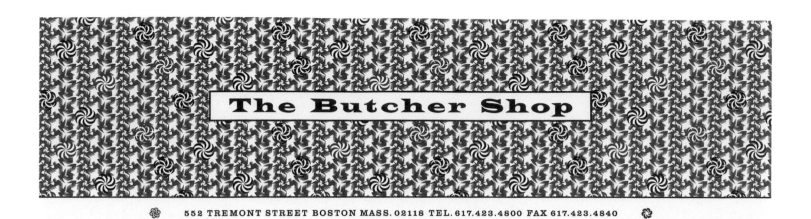

The Butcher Shop

552 TREMONT STREET BOSTON MASS. 02118 TEL. 617.423.4800 FAX 617.423.4840

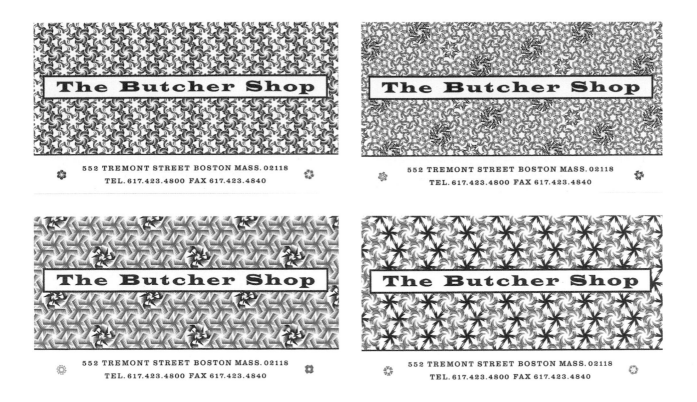

The Butcher Shop

552 TREMONT STREET BOSTON MASS. 02118
TEL. 617.423.4800 FAX 617.423.4840

The Butcher Shop

552 TREMONT STREET BOSTON MASS. 02118
TEL. 617.423.4800 FAX 617.423.4840

The Butcher Shop

552 TREMONT STREET BOSTON MASS. 02118
TEL. 617.423.4800 FAX 617.423.4840

The Butcher Shop

552 TREMONT STREET BOSTON MASS. 02118
TEL. 617.423.4800 FAX 617.423.4840

ON THESE PAGES / Business cards, letterheads and
placemats come in a huge number of variations.

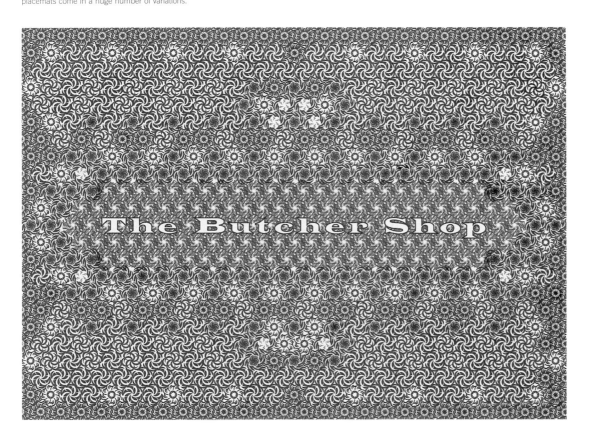

The Butcher Shop

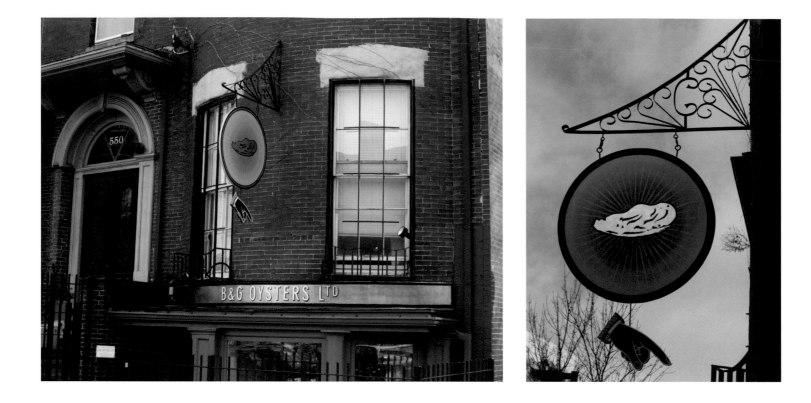

ON THESE PAGES / Barondess also created the graphics for owner Barbara Lynch's other restaurant, B&G Oysters, which is located next door to The Butcher Shop. The designer chose a clean, modern typeface as well as a colour palette that played off the interiors.

JNL GRAPHIC DESIGN / AVEC / USA

'The mission of Avec is quite simple,' states this Chicago-based restaurant's website. 'Excellence. The architecture provides us with a clean palette to present our concept of dining, community and lifestyle.' It seems that traditional public space has been eroded to such a degree that it is now down to restaurants to provide a similar function – at least if Jason Pickleman of JNL Graphic Design, the man responsible for Avec's daring graphics, is to be believed.

'We started thinking of the word with as a conjunction,' he explains. '"With" is a word that brings a multiple of things together – and in a way, that's exactly what the restaurant is. It's that hinge: that conjunction. Once I started to understand that as a thematic concept to the restaurant, the idea of crossing off words – getting rid of everything except the word *avec* – became a graphic conceit that I was trying to flush out.'

It's a brave, perhaps even arrogant, move, but Pickleman would argue that a restaurant with a stark, almost Donald Judd-esque interior (note the austere benches running along all the walls) required a dash of colour. 'Actually, the thing we're crossing out everywhere is the actual menu. I mean, it's the food itself,' he continues. 'Even though the food is really great, people just need a place, outside of their homes and outside of their business, to be that place of meaning. So the crossing out is kind of like a graphic gesture.'

If the designer's explanation of his concept is convoluted, the thinking behind his selection of fonts for the restaurant's logo and menu is more straightforward. 'I never have a rationale with fonts,' Pickleman admits. 'I believe in the random. I believe everything can be designed in Helvetica.'

The logo font is The Mix, complete with a bold underlining that is supposed to represent the restaurant's solid-wood benching. 'I don't know where it came from or what it was about,' Pickleman says. 'I just thought the density of the letterforms – the density of the stroke – had a solidity, a slab-like quality, that was very much in keeping with the architecture of the restaurant.' It's an idea he has taken up far more literally in the letterhead and envelope that come with a photographic image of a strip of lumber.

Meanwhile, he chose a typewriter font on the menu 'just to be as casual as possible', although in a brief moment of retrospection Pickleman concedes: 'It's anachronistic to use a typewriter typeface in the digital era. It becomes a mannerist gesture, even though I was actually trying to do the exact opposite.'

ABOVE / An Avec business card. The bold underlining echoes the restaurant's solid-wood benching.

FACING PAGE / On Avec's menu, Pickleman used a typewriter-style font to lend it a casual feel.

avec

small plates

house-marinated mediterranean **olives** 5

roasted organic **beets** with burrata, basil,
extra virgin and fine herbs 7

fresh shell **bean crostini** with baby arugula,
reggiano, lemon and extra virgin 7

grilled chicories with shaved fennel,
pecorino, lemon juice and extra virgin 7

heirloom **apples, celery**, marcona **almonds**, shaved
manchego and apple cider vinegar 8

basa escabeche with roasted tomatoes, caramelized
fennel, crispy potatoes and arbol chilies 13

crushed tomato and olive oil-braised **octopus**, baby
spinach, onion salad and pancetta vinaigrette 12

pan-fried **sardines** with crispy jamon serrano
and picholine olive tapenade 12

chorizo-stuffed **medjool dates** with smoked
bacon and piquillo pepper-tomato sauce 8

whipped **brandade** 7

marinated and roasted **chicken** thigh panzanella salad
with preserved lemon, parsley and natural juices 8

duck cassoulet with house made garlic sausage,
flageolet and fresh herbs 13

housemade **chorizo** and **mussel stew** with
potatoes, piquillos and parsley 10

spicy **meatballs** with chick peas, rapini and orzo 8

crispy **hanger steak** with celery salsa verde,
radishes, fresh herbs and extra virgin 11

braised beef **short rib** with red beans,
onion, bacon and fresh herb salad 13

large plates

bourride: poached fish stew with fennel,
garlic, saffron, aioli and croutons 22

pissaladiere with caramelized onion,
anchovies, nioise olives and thyme 13

"deluxe" **focaccia** with taleggio
cheese, truffle oil and fresh herbs 14

shaved **jamon serrano** with persimmon,
queso fresco de oveja, extra virgin and mint 16

wood oven roasted prairie grove farm **pork shoulder**
with green chili sofrito 19

bucatini with crispy guanciale, parmiggiano reggiano,
eggs and cracked black pepper 16

daily selection of salumi

with garniture

one 8 assortment 15

avec blends

coffee 2
espresso 2.5
cappuccino 3
avec latte 4
camomille / prppermint / green / assam teas 2.5

blended by intelligentsia coffee roasters

cheese from our cave

any 3 cheese selections 14

italia

cademartori **taleggio**
(cow's milk)

pecorino foglie di noce
(sheep's milk)

parmiggiano reggiano vecchi rossi
(cow's milk)

antonio carpenedo **ubriaco**
(cow's milk)

robiola langhe
(cow, sheep, goat's milk)

gorgonzola piccante d.o.p.
(cow's milk)

espana

picon
(cow's milk)

cabra de murcia
(goat's milk)

garrotxa
(raw goat's milk)

manchego in e.v.o. with rosemary
(sheep's milk)

torta del casar
(raw sheep's milk)

france

banon **chevre**
(goat's milk)

fourme de **montbrison**, fourez
(cow's milk)

caprin
(goat's milk)

st. felicien
(cow's milk)

accompaniment

quince paste

date cake

marcona almonds

fig mostarda

6

03.04.04

	sparkling	bottle	250 ml
	FRANCE		
001	nv **Charles de Fere**, Brut Reserve, Blanc de Blancs	26	9
	Vernay (chardonnay, chenin blanc, ugni blanc)		
	ITALIA		
002	nv **Le Colture**, "Cruner" Prosecco di Valdobbiadene	44	
	Veneto (prosecco valdobbiadene)		
003	nv **Mionetto**, "Sergio" Spumante	35	12
	Valdobbiadene (prosecco valdobbiadene, etc)		
004	nv **Ca' del Bosco**, Brut Nuova Cuvee	64	
	Franciacorta (chardonnay, pinot bianco, pinot nero)		
005	nv **Bele Casel**, Prosecco di Valdobbiadene	25	
	Valdobbiadene (prosecco valdobbiadene)		
	ESPANA		
006	nv **Cristalino**, Rose Brut	29	10
	Cava, España (macabeo, xarel.lo, parellada, trepat)		
007	nv **Acabat de Degollar**, "Privat", Reserva Brut Nature	55	
	Cava, España (chardonnay)		

	white	bottle	250 ml
	FRANCE		
102	01 **Domaine de l'Arjolle**, "Equinoxe"	32	11
	Cotes du Thongue (viognier, sauvignon, muscat)		
103	02 **Hugues Beaulieu**, "Caves de Pomerol"	25	9
	Picpoul de Pinet (picpoul)		
105	01 **Cuvee de Palmier**, Sauvignon Blanc	21	
	Vin de Pays de L'Herault (sauvignon)		
106	02 **Michel Laroche**, Chardonnay	35	12
	South of France (chardonnay)		
107	01 **Domaine de Triennes**, "Sainte Fleur"	31	11
	Provence (viognier)		
108	02 **Colombelle**, Blanc	17	
	Cotes de Gascogne (colombard, ugni blanc)		
109	02 **Les Vignes Retrouvees**, Blanc	26	9
	Cotes de Saint Mont (gros manseng, petit corbu, aruflac)		
110	02 **J.F. Lurton**, "Terra Sana"	25	
	Vin de Pays Charentais (ugni blanc, colombard, sauvignon)		
112	00 **Coste Rousse**, "Font de Lautre"	18	
	Cotes de Thongue, Languedoc (chardonnay, sauvignon)		
113	01 **Domaine de Grangeneuve**, "Les Dames Blanches"	34	12
	Coteaux du Tricastin (viognier, marsanne, roussanne)		
	ITALIA		
104	02 **Casale Mattia**, 'I Vigneti Del Casale' Superiore	25	
	Frascati (malvasia, trebbiano, bombino, bello)		
114	00 **Terre di Ginestra**, Catarratto	34	
	Sicilia (catarratto)		
115	02 **Gianni Gagliardo**, Falegro	38	13
	Roero (favorita)		
116	00 **Borgo San Daniele**, Arbis Blanc	59	
	Friuli Isonzo (tocai, sauvignon, chardonnay, pinot bianco)		
117	01 **Furlan Castelcosa**, "Cuvee Tai"	46	
	Friuli Venezia Giulia (tocai, sauvignon, traminer, riesling)		
118	02 **Villa Giorgia**, Pinot Grigio	26	9
	Sicilia (pinot grigio)		
120	02 **Cusumano**, "Angimbe"	36	
	Sicilia (inzolia, chardonnay)		
121	01 **Lungarotti**, "Torre di Giano"	35	
	Bianco di Torgiano (trebbiano, grechetto)		
122	03 **Argiolas**, Vermentino	24	
	Costamolina, Sardinia (vermentino)		
123	02 **Antinori**, "Castello della Sala" Chardonnay	32	
	Umbria (chardonnay)		

continued on back

	white	bottle	250 ml
101	03 **Pipoli**, Chiaro	23	8
	Basilicata (aglianico)		
124	02 **Abbazia Di Novacella**, "Kerner"	38	
	Valle Isarco (kerner)		
125	01 **Vignalta**, "Sirio", Muscat Veneto	23	
	Veneto (muscat veneto)		
126	00 **Venica e Venica**, Tocai Friulano	36	
	Collio (tocai friulano)		
127	00 **Isole e Olena**, Chardonnay	55	
	Barberino Val D'Elsa (chardonnay)		
	ESPANA		
128	02 **Bodegas Castelo de Medina**, Vegadeo Verdejo	23	
	Rueda (verdejo, sauvignon)		
129	02 **Bodegas Penascal**, Blanco	18	
	Castilla y Leon (sauvignon)		
130	02 **Lagar de Cervera**, Albarino	42	
	Rias Baixas (albarino)		
131	00 **Belorande y Lurton**, Blanco	62	
	Rueda Superior (verdejo)		
132	02 **Can Feixes**, Blanc Seleccio	28	10
	Penedes (parellada, macabeo, chardonnay)		
134	01 **Torres**, "Viña Esmeralda"	33	
	Penedes (moscatel, gewurztraminer)		
119	02 **Roig Olle**, Blanc	32	11
	Penedes (xarel.lo)		
135	01 **Santiago Ruiz**, Blanco	43	
	Rias Baixas (albarino)		
136	02 **Bodegas Cerrosol**, Rueda Verdejo	20	
	Rueda (verdejo)		
140	02 **Zaleo**, Gran Seleccion	27	10
	Ribera del Guadiana (macabeo)		
	PORTUGAL		
137	02 **Joao Pires**, Muscat	29	
	Terras do Sado (muscat of Alexandria)		
138	03 **Morgado da Andorinha**, Vinho Verde	29	10
	Lima (loureiro, paderna)		
139	01 **Dorado**, Vinho Verde	41	
	Moncao (alvarinho)		
133	02 **Quinta das Maias**, Malvasia-Fina	38	13
	Dao (malvasia-fina)		

beer

Estrella Galicia, "Lager Especial"	5	
Galicia, España		
Cruzcampo Cerveza	5	
Sevilla, España		
Le Baladin, "Nora", organic, 750ml	27	
Piozzo, Italia		
Moretti, "La Rossa"	4	
Puglia, Italia		
De Regenboog, "Vuuve", ale	8	
Brugge, Belgium		
De Regenboog, "Wostyntje", mustard ale	9	
Brugge, Belgium		
Delirium Tremens, ale	10	
Huyghe, Belgium		
Lindemans, "Kriek", lambic ale,	7	
Vlezenbeek, Belgium		
Brasserie Dupont, "Foret", saison ale, 750ml	18	
Tourpes, Belgium		
Brasserie de Saverne, "Boris", ale, 8.5oz	4	
Saverne, France		

glassware provided by riedel

06.12.04

JUTTA DREWES / KAKAO / GERMANY

ON THESE PAGES / Images from Kakao, 'a mixture of neighbourhood café, lounge, tourist attraction and nice hangout'. The floral logo refers to the blossom of the cacao tree, while much of the imagery derives from classic reggae album covers.

Berlin's Kakao is a reggae-influenced hot-chocolate bar containing an eclectic mix of ideas and imagery. Owned by Holger in't Veld and located next door to her chocolate shop (called, appropriately enough, in't Veld) the cafe's aim, according to graphic designer Jutta Drewes, is to provide 'maximum quality and taste with a down-to-earth attitude'.

Kakao, explains the Hamburg-based Drewes, is 'a mixture of neighbourhood café, lounge, tourist attraction, and nice hangout for the early evening'. Serving a combination of hot chocolate, cakes, juice, wine and cocktails, it also selects the music it plays very carefully – a fact that is reflected in some of the imagery adorning both the interior and exterior. Having already worked on the neighbouring chocolate shop, Drewes' brief was straightforward: give the café/bar the same classic-modern feeling with a bit more freedom and music.

Working closely with interior designer Kumpanin+, Drewes selected imagery from classic reggae covers ('Something that is warm and cool at the same time – Kakao music') while sticking to the limited colour range of dark brown, red, gold and off-white. On the ceiling is an abstract version of a world map, with all the cocoa-producing countries highlighted in red, and cocoa manufacturers represented by red dots.

The café's rather curious signature image of a black-and-white ship, set against a block of colour, used in much of in't Veld's packaging and reflected in the interior, was created for very personal reasons. Holger in't Veld's father was a sailor, and it was felt the image also captured the café's laid-back feel – or as Drewes puts it, 'slow in travel and taste'. It also refers to an era of classic design and rams home the point that cocoa comes from overseas. The café's florid logo, with its Eureka typeface, harks back to the blossom of the cocoa tree: 'the beginning of the long journey for the chocolate'.

THE ULTIMATE TRIUMPH OF POWER IS TO CONQUER LOVE.
THE ULTIMATE TRIUMPH OF LOVE IS TO KILL THAT WHICH GIVES THE MOST POWER.

kakao

DER NACHKRIEGSGENERATION HABEN WIR ZU VERDANKEN,
DASS SCHOKOLADE ALS LEBENSMITTEL EINGESTUFT WIRD.
WIE ZUCKER UND MILCH. DIE BOHNE, DIE DABEI VERGESSEN
WURDE, IST NACH IHRER BEHANDLUNG EINES DER LETZTEN
GROSSEN GESCHMACKS-ABENTEUER DER ÜBERWASSERWELT.
URALT, DABEI ABER VON ANBEGINN NATUR, KULTUR UND TECHNIK.
WIE WEIN. NUR ANSPRUCHSVOLLER. WILDER. POTENTER.
JETZT ENDLICH LERNEN SIE SICH KENNEN, DIE EWIGEN
GENUSSMITTEL AUS DEM ALTEN EUROPA UND DEM NOCH ETWAS
ÄLTEREN MITTELAMERIKA.
VIELLEICHT SIND SIE ZU KAUZIG UND EIGEN, UM WIRKLICH
FREUNDE ZU WERDEN.
EIN PAAR IHRER MULTIPLEN PERSÖNLICHKEITEN ABER VERSTEHEN
SICH BESTIMMT BLENDEND.
FÜR SIE (UND EUCH) IST DIESER LADEN GEMACHT
– DAS PASSENDE UMFELD, SICH ANGENEHM BEKANNT ZU MACHEN.

* KAKAO, MILCH, SÄFTE UND BACKWAREN STAMMEN AUS BIOLOGISCHER LANDWIRTSCHAFT.
 ALLE ANDEREN PRODUKTE SIND TROTZDEM GUT. PROBIERT DIE SÜßWEINE! UND, ACH JA...SCHOKOLADE...

ON THESE PAGES / The bar's external signage. The ship was chosen for nostalgic reasons. Owner Holger in't Veld's father was a sailor.

KARIM RASHID /
SEMIRAMIS HOTEL / GREECE

According to the official version, the Semiramis Hotel, owned by one-time civil engineer and architect-turned-contemporary art dealer Dakis Joannou, is 'design-led'. Maybe. To my mind, Semiramis is very much a *designer*-led hotel and it only takes a glance at the images on this page to work out that the designer in question is Karim Rashid. Situated in the affluent suburb of Kifissia, about 30 minutes from the centre of Athens, the 52-bedroom hotel contains a restaurant split over two floors serving a modern Mediterranean cuisine. However, this project is very much about the personalities involved. Like Philippe Starck, Rashid is more than merely a designer – he's a lifestyle choice. And at Semiramis, he has designed everything from the slippers under the beds to the reserved signs on the restaurant tables. For this reason, the interiors and graphics are virtually indivisible.

Rarely a man given to understatement, Rashid explains his design aims thusly: 'In this digital age of information, I want the hotel to embrace the global village and to create a cosmic sense of well-being in this millennium. Design and architecture will play an important role in intensifying this reality. They can provide and maintain our enjoyment of living and nurture a direct experience with the energy and *modus* of the time.'

For the hotel and restaurant graphics, he picked out and repeated shapes that occur in the hotel's interior. While Semiramis is loaded with contemporary furniture and high-tech features, the graphics have a retro, sixties/seventies feel about them, using pinks, limes, oranges and light yellows in an attempt to 'bring energy and positive emotions' to the visitors.

SEMIRAMIS

appetizers

gazpacho	7.50
mixed green salad with asparagus, tomato, avocado and lemon-truffle dressing	4.40
house marinated salmon gravlox style with honey and mustard	5.60
slow roasted summer vegetables with warm herbed goat cheese	4.60
lobster salad with mango, papaya and citrus-mint vinaigrette	4.40

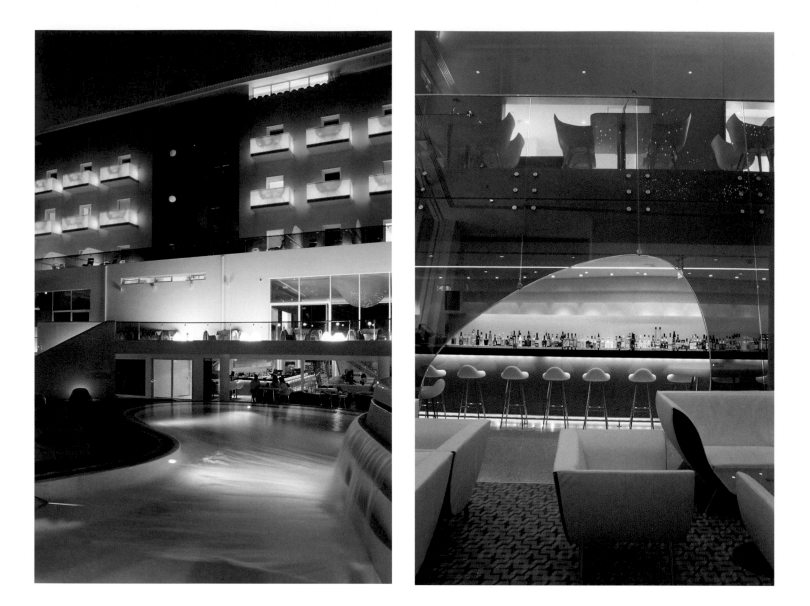

Meanwhile, for the pool-side menu, the designer elected to use blue. According to Rashid: 'The entire communication programme of the Semiramis hotel was designed to have a contemporary, fluid sensibility. The font used [Metro DF in the main titles] is my favourite: an updated version of the fonts from the seventies when the radius was so prominent in late modernism. The new font is sensual, friendly and flows. The whole hotel had to flow together to create a positive memorable experience.'

The hotel and restaurant's logo consists of two superimposed blobs, a shape favoured by the designer. 'The figure-of-eight means *soul*,' he says. 'Overlapping it into another blob form implies a certain relaxed, fluid condition. Making it translucent so that the pastel colours cross over each other implies a certain lightness and calmness.' Originally, Rashid had wanted to design the whole building in this form, but the local planning authority intervened, so only the windows in the back façade, the pool and public areas relate directly to the logo.

While Rashid likes to deny heritage (describing it to one interviewer as 'nostaligia'), Semiramis, with its love of technology and lively graphic palette, owes more than a small debt to the work of the James Bond film production designer, Ken Adam.

ABOVE / Rashid wanted to repeat his overlapping, translucent, figure-of-eight concept over the entire hotel exterior, but planning consent was given only to windows in the back façade, the pool and public areas.

FACING PAGE, ABOVE / Details of some of the shapes repeated throughout the Seriramis graphic scheme. Even the laundry tags (BELOW) haven't been left out.

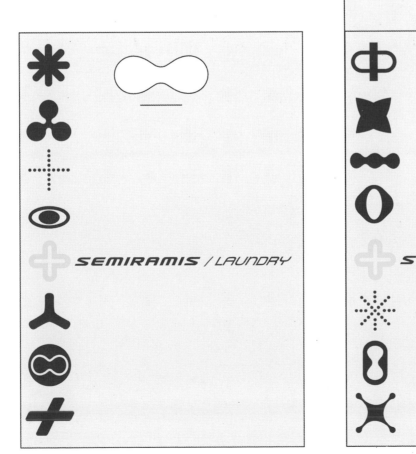

SEMIRAMIS / LAUNDRY

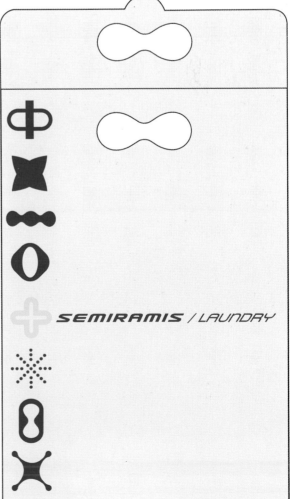

SEMIRAMIS / LAUNDRY

LESLEY MOORE / MARCEL WANDERS STUDIO / BLITS / THE NETHERLANDS

Designers have known for years that, for a high-end eatery to be successful, food must become theatre. However, at Blits, the Rotterdam restaurant owned by the New York Group, Marcel Wanders has taken this edict to an entirely new level. Waxing lyrical (and not a little biblical) about the space, he writes in the practice's official statement:

> As evening falls, it's time for the audience to take the stage. Spectators and theatre merge, and it becomes impossible to tell the actors from the onlookers. The Rotterdam audience is the star of the evening; bottles are poured with charisma and bravado, bread and fish are miraculously multiplied all around. The stage is scattered with props, and the formalities of the performance make way for chance encounters and unwritten romances.

In terms of an interior, this translates into a restaurant that contains a 'love suite', walls decorated in a wild florid print and a bar embellished with theatre-style curtains. There's more than a whiff of the baroque about the entire exercise, and it was inevitable that the scheme's graphic design, by Dutch practice Lesley Moore, is heavily influenced by the interior. Indeed, the firm's Alex Clay is happy to admit that it was Wanders who conceived the logo. However, he's quick to add that, 'Because they don't really do graphic design themselves, they asked us to take over from there. So what we got was the logo and the plans for the interior. What we tried to do was combine the logo, which we felt had an almost old-fashioned look to it, with certain elements to make it feel contemporary.' The challenge, he concedes, was to make it organic and warm, while at the same time ensuring it would be functional and of its time.

To do this, the designers combined the Party font that comes free with Windows with the more formal VAG Rounded, which, as Clay says, means 'you can have quite elegant stuff without making it too swirly'. The colour palette was tweaked from the interior, while the menu looks like a scroll with patterned printing on the back and the Blits logo as a seal. According to Clay, the client would rather have an extreme solution than a safe one – in which case it would have gone home very happy.

Incidentally, with all the surrounding theatre, it could be easy to forget the tapas-style food altogether, but Clay assures us that it's 'quite nice'.

ABOVE / The Blits logo was designed by Marcel Wanders.

FACING PAGE / A detail from the restaurant's interior.

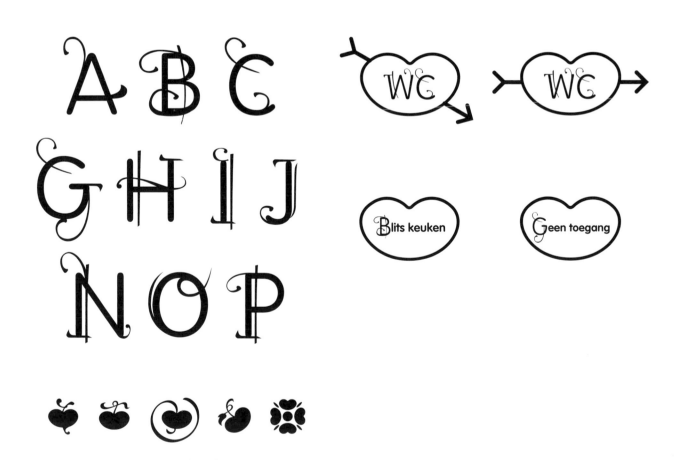

FACING PAGE ABOVE / The restaurant's 'Love Suite'.
BELOW / An example of how the Blits signage is used.

TOP / Another view of this theatrical Rotterdam restaurant.

ABOVE / The Blits typeface was a combination of Party font and VAG Rounded.

LEWIS MOBERLY /
GRAND HYATT / DUBAI

One would expect that designing various different restaurant identities for a global hotel chain could be tricky. After all, organizations like Grand Hyatt tend to have exacting brand guidelines. Then there's the difficulty of attempting to create a brand within a brand, and questions about how distinct each restaurant should feel. For example, do they all have to share a strand of Grand Hyatt DNA, must they conform to a brand colour palette, and what elements of the brand essence need to be evoked?

In the case of Grand Hyatt Dubai, where Lewis Moberly created 15 restaurant identities, the consultancy was given a very specific and different kind of brief: 'To design brand identities for individual cafés, bars and restaurants, which should all feel as if they were owned by independent proprietors. They all needed to project authenticity and be appropriately premium to sit comfortably within the Hyatt portfolio and a five-star hotel.' They were not to carry any corporate stamp.

Working closely with the hotel's general manager in Dubai as well as the vice-president for food and beverages at Hyatt International, Lewis Moberly devised a number of brand names, propositions and design concepts that responded to the brief. Following the Grand Hyatt team's selection of one or two preferred routes, the designs were developed and refined in line with their feedback. This collaborative, rigorous approach reaped its rewards.

Lewis Moberly created 15 brand experiences within the hotel, and to give some sense of the sheer eclecticism, we've picked out four very different examples here. In Panini, the consultancy was asked to create a vibrant Italian café and bakery. Panini's packaging was designed to reflect the fun but sophisticated nature of café culture. The free-style illustration reflects and extends the logo running across the extensive range, from baguettes to cakes.

ABOVE / The Grand Hyatt's Manhattan Grill used the photography of Berenice Abbott to create an American brasserie-style restaurant.

FACING PAGE ABOVE / In Panini, the brief was to create a fun but sophisticated café, while Tea House was given a calm, refined graphic palette.

FACING PAGE BELOW / Detail from the Indochine menu showing 'the noodle dance'.

Meanwhile, with Manhattan Grill, the brand name was a given, as was the restaurant's American brasserie style. The result is a sophisticated urban experience, with the strong, graphic black-and-white identity supported by the evocative imagery of American photographer Berenice Abbott.

Tea House was a softer experience, and as such its graphics and brand palette are calmer and more refined, with tea-leaves representing the roof of the house. And finally, Indochine offers a broad, southeast Asian menu. The favoured brand positioning and subsequent identity was 'the noodle dance', in which different Asian nationalities are united in light-hearted illustration.

Interestingly, when considered as a collection, all identities echo the Grand Hyatt Dubai's five-star brand credentials and engage the consumer with the promise of an authentic dining experience.

LIPPA PEARCE /
DANA CENTRE RESTAURANT / UK

How do you make complex scientific issues accessible to the wider public? It's a deceptively difficult question that London's Science Museum has attempted to answer by creating a new café-cum-bar-cum-discussion hothouse around the back of the main museum. At the Dana Centre, named after the research organization that occupies the rest of the building, people are encouraged 'to talk, to argue, to experiment with ideas, to be provocative, radical and even playful'. And it's a scheme where the graphics, by the London-based firm Lippa Pearce, play a hugely significant role.

'The idea is that it's dusting off all these old ideas of what science is about,' explains the company's Harry Pearce. 'It's putting scientists face to face with the public in an arena that isn't scientific: it's a café and a bar.' According to the designer, 'The whole thing had to feel like it's alive and vibrant. The identity is the whole building – not just the logo.' The Dana Centre is awash with messages. The reception walls, for example, are plastered with bizarre, tongue-in-cheek, rhetorical questions created by the centre's copywriter, Oliver Wingate. In the café itself, the tabletops are loaded with what Pearce describes as 'invented philosophies of the future', while the centre's glazing is covered in bits of copy picked up from internet chat rooms. This is a building that's eager to engage.

With so much text to play with, Pearce was keen to employ a simple palette of fonts. The window installation, therefore, has been done in News Gothic, while a combination of Gothic 13 and Rockwell was specified for both the tables and the reception walls. 'All the [type]faces have been around a long time and they're classics in their own right,' he explains. 'We didn't do anything funky with the text because there was so much going on in the nature of the words. It didn't need lots of different types; it just needed lots of different ideas.'

For the logo, Pearce drew inspiration from the centre itself. The marque mimics the building's plan, with the orange block representing the café/bar, while the yellow denotes the rest of the Dana Foundation. The typeface, meanwhile, is a redrawn version of Futura. The logo makes a cameo appearance in the interior itself on a concrete column that runs through the entire building. Pearce describes it as an act of architectural cannibalism, saying it has been 'chopped up and fed back to the building'.

ABOVE / The Dana Centre's glazing is loaded with text.

FACING PAGE / The centre's logo mimics the building's architecturual style.

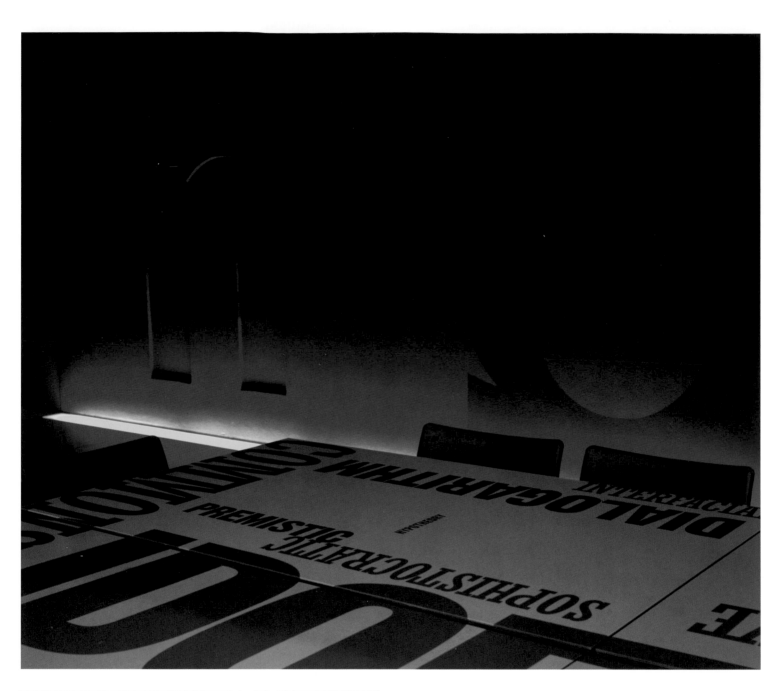

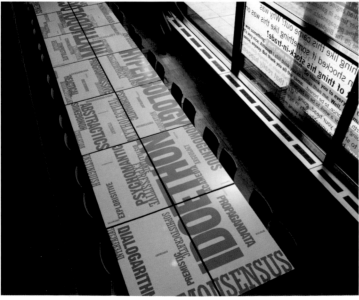

ON THIS PAGE / The tabletops in the café are covered with 'invented philosophies of the future'.

FACING PAGE / Meanwhile, the reception walls are plastered with tongue-in-cheek, rhetorical questions. Even the signage has something to say.

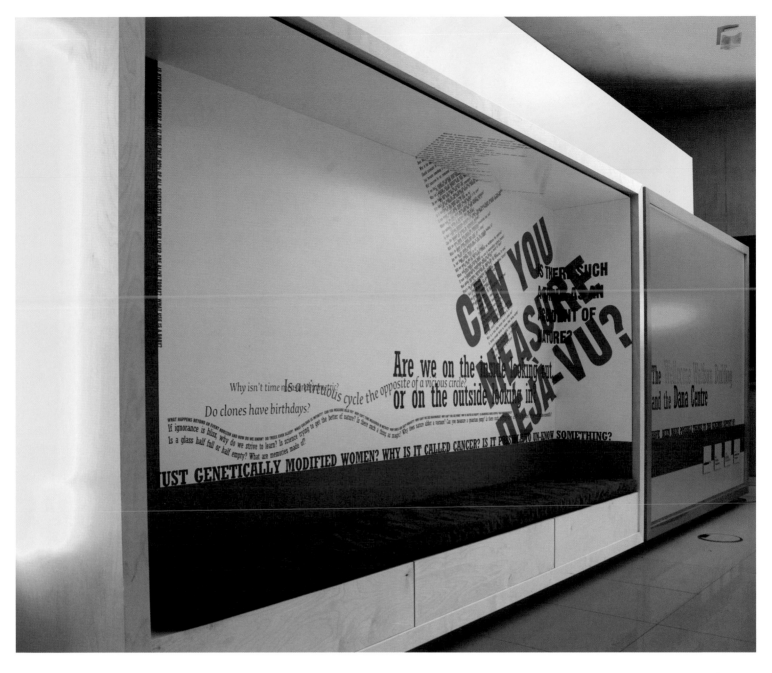

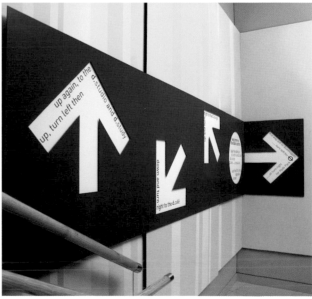

la gastronomie à petits prix

MANO / FOUDE / FRANCE

Le Mans is a French town with more of a reputation for fast cars rather than for fast food. However, for a time, the now sadly defunct Foude tried to change that perception. It was certainly ambitious. As the restaurant's official press release said: *Foude is a place where creativity is leading the idea. In every field it has been transformed into reality: commercial design, packaging, recipes, customer service.*

Opened in May 2005 and designed by Le Mans-based practice Mano, Foude fell somewhere in between fast food and traditional catering. It served local produce in dishes that were individually (and extremely colourfully) wrapped, and customers had the option of either eating in or taking out. The food, rather like the restaurant, was incredibly eclectic, giving diners the choice of five different menu options to fit any budget – so one dish and a drink would cost €6.95 ($8.88) while two dishes with a drink would set you back €8.95 ($11.43).

However, perhaps its most intriguing aspect was the conveyor-belt system. Once customers had placed their order at either the counter or automated machine, they received an invoice. They could then find their table and swipe the invoice's bar-code across a 'label lector'. This automatically let the conveyor belt know where to send the order.

Meanwhile, the restaurant's interiors were split into different sections: quiet and intimate if you were by yourself; louder and more brash if you arrived with a large group. Describing the graphics, Mano's Anne-Hélène Foret says they were designed to be 'serious but fun, colourful and simple'. Certainly, colour was everywhere in this project: on the product labels, the waitresses' outfits, on the bowls and even in the recipes themselves. Rather like the UK's Yo! Sushi chain, there was a retro-futuristic feel to the two-dimensional design that was presumably meant to soften a service system which could otherwise disorient customers. By the same token, it made Foude feel friendly, lively and, above all, fast. Sadly, by 2006 it was closed: a fascinating experiment that was possibly conducted in the wrong location.

ON THESE PAGES / Foude's graphics were designed to be 'serious but fun' and 'colourful and simple'. This is evident in the restaurant's logo ABOVE…

…and, on the FACING PAGE, in some of its packaging.

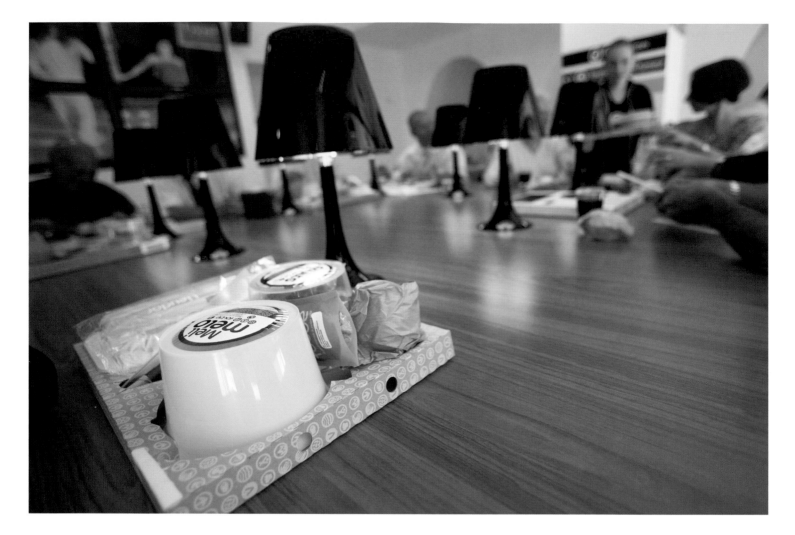

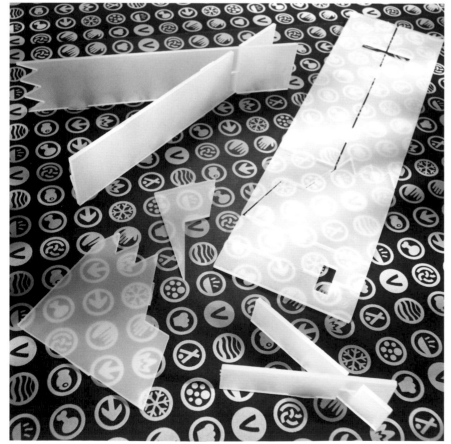

ABOVE / More examples of Foude's packaging.

LEFT / The recycled cutlery. The icons on the table underneath are all used in the restaurant's interior – as the image on the FACING PAGE shows.

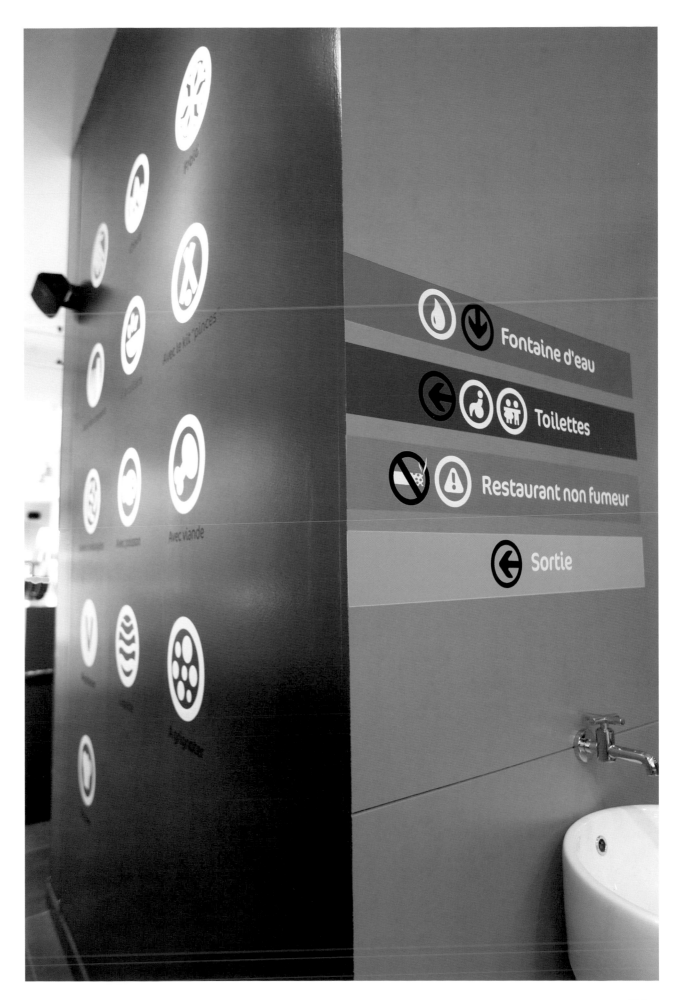

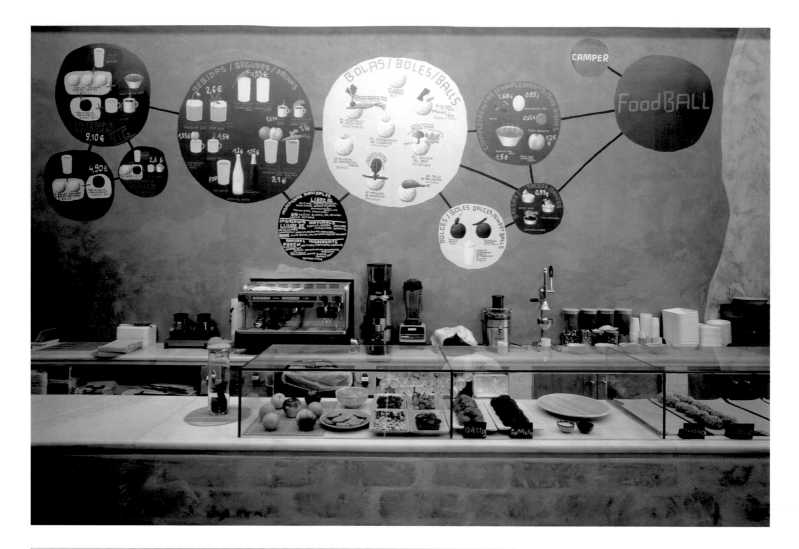

MARTÍ GUIXÉ /
CAMPER FOODBALL / SPAIN

It's not the most obvious brand extension – Spanish shoemaker turns restaurateur – but then Camper has always been a company that likes to do things a little bit differently. 'We didn't want to diversify in the usual way,' says Head of Business Development Miguel Flux. 'While I am sure we could successfully put the Camper name on watches and sunglasses, we wanted to do something that we, and our customers, would appreciate as useful. Food and shelter, like shoes, are basic needs.'

The result of this logic is Camper FoodBall, which is something of a hybrid. The Barcelona-based restaurant's name is derived from the food it serves: balls of wholegrain rice filled with various locally sourced ingredients such as mushrooms, tofu, chicken and beetroot. Split into three sections – the entrance with a counter; the kitchen; and an eating area that is notably devoid of tables and chairs and instead contains a huge set of concrete steps on which people sit and eat – the restaurant has been designed by Martí Guixé and contains some of his trademark flourishes.

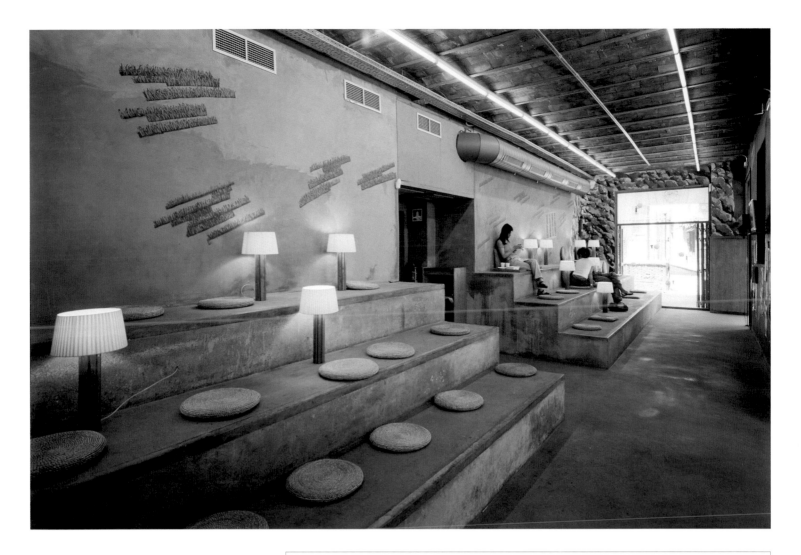

As Guixé sees it, FoodBall is a health-food store. 'For lack of definition,' he says, 'it is a restaurant, a bar, a fast-food restaurant, a take-away [take-out], and possibly a point of encounter or a reference point in the context of the neighbourhood.'

Whichever way you cut it, though, the designer has created some fascinating graphics for the walls which he describes as 'something like a stage set painted with figures in axonometric perspective, representing an idealization of a rural world that is at once naïve and electronic – like with computer games'. He continues: 'This set stretches out in its context as a medium for communication, to which information concerning themes related to health food could be added in a controlled fashion. The mural refers to politically engaged painting as well as aerial perspectives like in SimCity: spaces of representation and action in a visual context.'

They also give a space that could otherwise be rather stark a warm, quirky feel. Guixé uses the same style to paint the menu on the wall behind the service counter – meaning there's no need for either traditional menus or McDonald's-style signage. And like Camper's shoes, the whole thing is as ecologically sound as it can be, using non-contaminating materials and renewable energy sources; even the plates and cups are biodegradable. Perhaps it isn't a brand extension too far after all.

FACING PAGE / Customers at Foodball choose from a menu that's painted directly on the wall.

ABOVE / Rather than boring, traditional tables and chairs, the restaurant employs steps for seating.

RIGHT / A closer view of the Camper Foodball's mural-cum-menu.

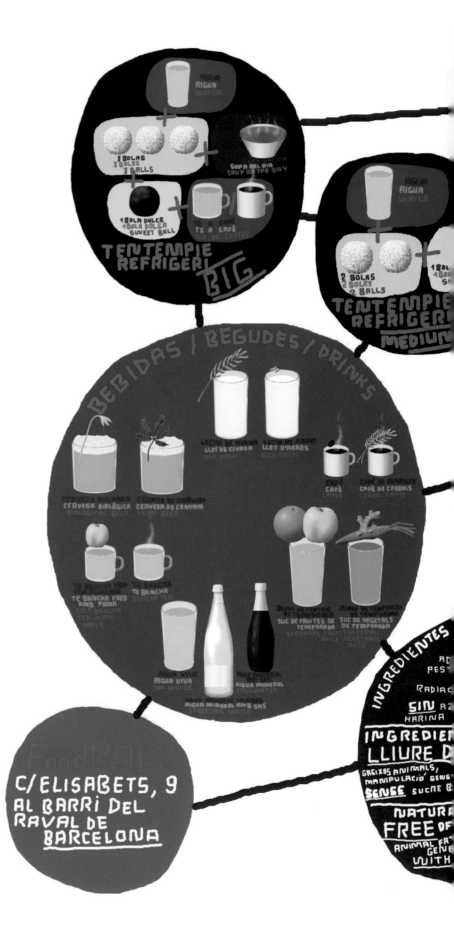

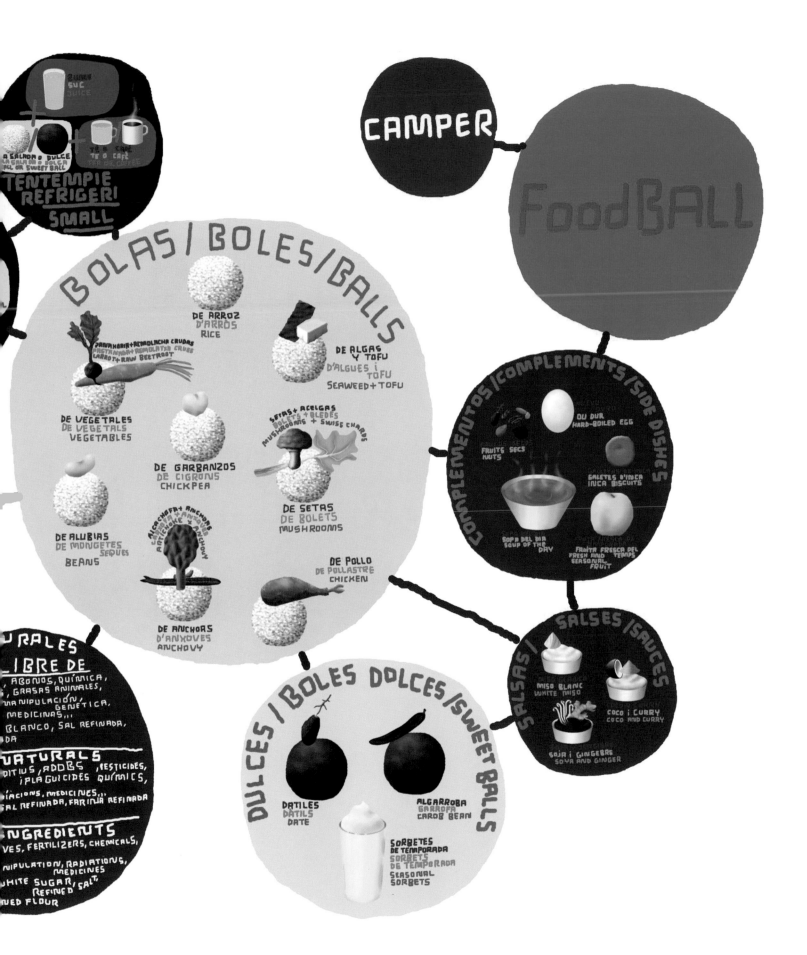

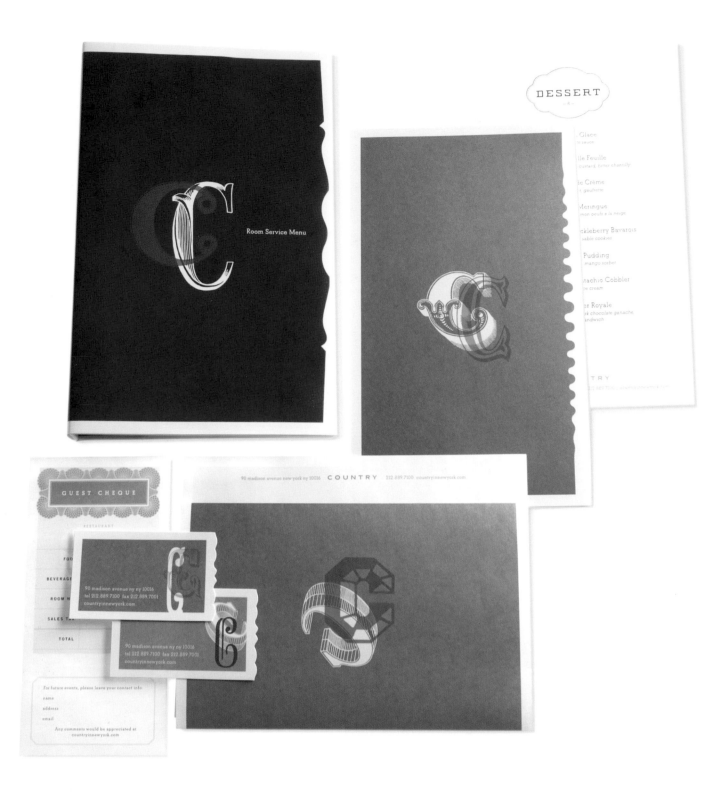

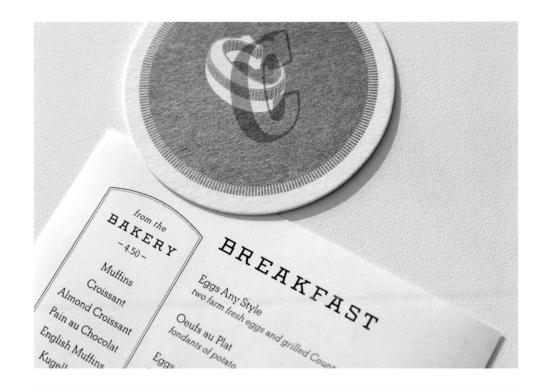

MUCCA DESIGN / COUNTRY / USA

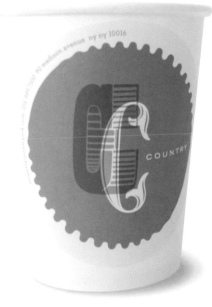

Part of the Carlton Hotel on Madison Avenue, which was originally designed by Harry Allen Jacobs in 1904 and more recently restored by David Rockwell, New York's Country serves contemporary dishes featuring locally grown and organic vegetables. Owned by chef Geoffrey Zakarian, its graphics come courtesy of Mucca Design.

'The client didn't really have a clear idea in mind,' recalls the project's art director, Andrea Brown. '[He] wanted something sophisticated but not too serious – something that had an edge to it, but not too much. The other thing the owner wanted to do was use the letter "C" as in "Country", but he wanted something sort of subtle.' Mucca's solution was to come up with different variations around the all-important letter 'C'. 'We experimented with a few "Cs" and we thought it would be interesting to use them differently each time,' says Brown. 'Also, we didn't want it to be from any specific time period. We thought it would be interesting to combine and overprint them. It just made it a little more ambiguous.'

By creating a huge number of variations, the logo can be used throughout the restaurant without verging on overkill. Indeed, it's almost an 'anti-logo' logo. 'When you're in a restaurant, you already know where you are (hopefully!), and seeing a logo at every turn can become tedious – so we aimed for a more unexpected solution,' Brown explains. The majority of the restaurant's literature is in silver, giving the work a sense of fun but making sure that it retains a suitable level of sophistication – the exception being the room-service menu that comes in a vibrant pink. The menu itself uses a Beton font, largely, says Brown, because 'We liked it. It was not so cold and had a bit of personality.'

Interestingly, Mucca had no knowledge of what the Rockwell scheme would look like; however, the results fit together surprisingly snugly.

ON THESE PAGES / Material for Country. Each piece contains a slightly different variation of the letter 'c', creating something that's almost an anti-logo.

NENDO / KEMURI / JAPAN

The idea behind this restaurant, a charcoal grill in Tokyo designed by Nendo, was to keep things as simple and as casual as possible. Appropriately enough, given the cuisine it serves, *kemuri* means 'smoke' in Japanese; however, in this environment it also has another more subtle inference: the name is supposed to represent something ordinary or everyday. According to Nendo's communications director, Takahiro Matsumura: 'During some meetings with the owner, he said the point of the restaurant was that the service would be casual but full of hospitality. He felt it would make the dishes more delicious.'

This notion can be seen in the interiors that are pared down without being intimidating and include piles of straws in the restaurant's screens. 'We used straws as a design concept to represent something that wasn't special,' Takahiro explains. 'The piles also represent a repetition of service.' Elsewhere, the company elected to employ natural materials and bench-type seating along the walls.

BELOW LEFT / Kemuri has a pared-down but not intimidating interior. While the bench seating is very simple, the walls and screens contain piles of straws which are designed to represent 'repetition of service'.

BOTH PAGES, BELOW / Examples of Kemuri direct-mail material. The symbols wittily play around with the restaurant's name as well as the cuisine it serves.

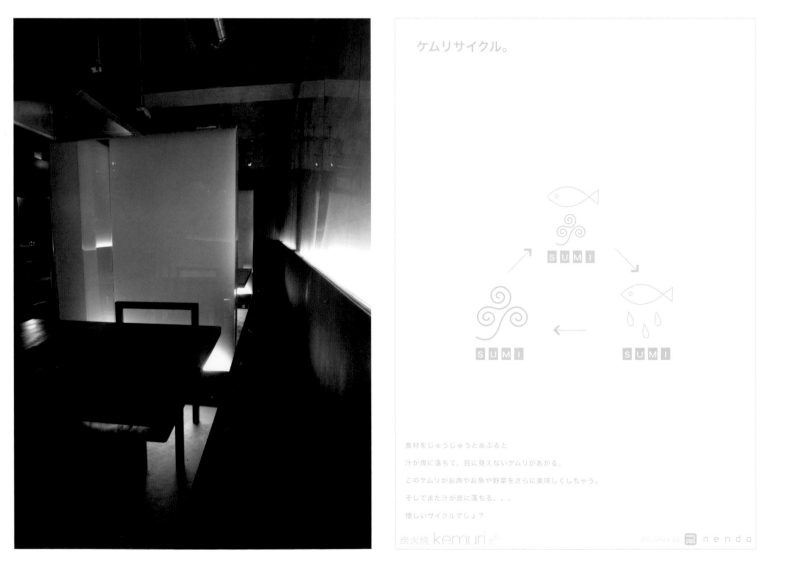

ケムリサイクル。

食材をじゅうじゅうとあぶると
汁が炭に落ちて、目に見えないケムリがあがる。
このケムリがお肉やお魚や野菜をさらに美味しくしちゃう。
そしてまた汁が炭に落ちる、、、
嬉しいサイクルでしょ？

炭火焼 kemuri

nendo

Meanwhile, its graphics are notable for juxtaposing the Kemuri logo, which represents rising smoke, with symbols of fishes as well as a happy, beaming sun. They also allowed the designer a chance to play with words. For instance, on one of the three direct-mail designs, Nendo has placed the Kemuri logo with an arrow pointing to the sun. But here the logo is supposed to represent a cloud (or *kumori* in Japanese), providing diners with a mini-weather forecast of their experience in the restaurant and saying, in Takahiro's words, 'You will be happy after having a dinner with the smoke grills.' Meanwhile, on another design, the restaurant's logo rises from the street map like a plume of smoke, proving that, while the concept may be simple, that doesn't mean it precludes a hint of humour.

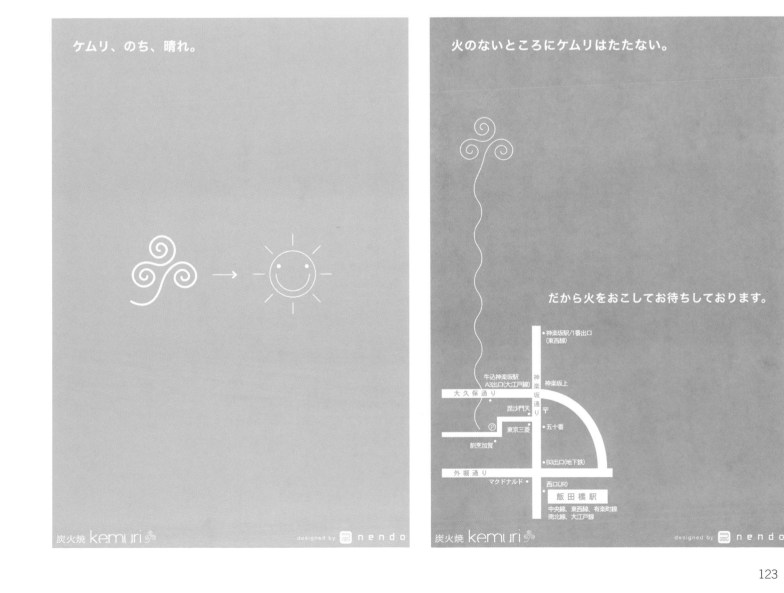

NORTH / YAUATCHA /
BUSABA EATHAI /
HAKKASAN / LING LING / UK

Yauatcha, another London restaurant from the prolific Alan Yau, is a Chinese eaterie of two distinct halves. At ground level is a tea bar, serving over 150 different infusions, while downstairs in the basement is a restaurant serving dim sum. Like a number of Yau's other establishments (think Hakkasan, below), Yauatcha combines a traditional sense of the Far East with elements expected by a twenty-first-century urbanite. As North Project Designer Jeremy Coysten puts it, 'The client wanted it to be distinctive but he also wanted it to speak to a London audience.'

To achieve this, Coysten spent two weeks researching in China and Taiwan, 'purely so that we could pull out any visual references that we could find'. 'We went to tea plantations, museums and the like,' he says. Some initial ideas, such as sourcing materials from the area, had to be shelved because of time and budget restrictions. 'In the end,' Coysten explains, 'we were working on replicating materials by embossing paper – particularly for the cake boxes. We also ran into quite a few problems with what materials you have to use for the Food Standards Agency.' It meant that, ultimately, most of the stuff was made in the UK and France.

The design of the cake boxes that dominate the upstairs tearoom came out of North's initial research. Inspired by a combination of the indigenous embroidery and the view of the local tea plantations from the sky, Coysten, while openly admitting that it's quite an abstract concept, says: 'It was all about the idea of water and steam and infusion. So we were trying to find some kind of graphic vocabulary that could give a visual identity but was also rooted in some kind of graphic concept.' However, he makes no bones about the rather excitable green and pink colour palette. Having considered using the traditional gold and red, North instead elected to use colours that would purposely give the restaurant a contemporary edge. 'We just wanted something really unusual,' he says. 'We did a lot of research on Japanese packaging, and there were just a lot of similar colours coming through.'

Once in place, nothing was allowed to compete with the restaurant's packaging, not even the logo. 'We kind of felt that the illustrations were more of a logo than the logo itself. They were the expression of the brand, really. The logo was more of a non-logo – it was just purely to say "This is Yauatcha".' Likewise, the menu uses a Futura font that sits unobtrusively next to the abstracted plantations. 'It had to be sensitive to the illustration,' muses Coysten. 'At the end of the day, the menu is there to be read – not for the designer to have fun with.'

ON THESE PAGES / Cake boxes dominate Yauatcha's tearoom, just as the design of these dominated North's concept for the restaurant. Their patterns and colours were inspired by embroidery, aerial views of tea plantations and current trends in Japanese packaging. The result was so popular that people began buying cakes just so they could take the boxes home.

Yauatcha is just one of four projects that North has done with Alan Yau. At Busaba Eathai, a Thai take on fast food, the brief was that the restaurant should be 'modern, healthy and communal'. Importantly, it was also planned as a chain. Located on the UK capital's busy Wardour Street, Busaba doesn't take bookings, so waiting to get in was expected, and entertaining customers was vital. This led to the development of a touch-screen menu outside the restaurant's door, and the insertion of large windows in the exterior which add to a sense of street theatre. According to Coysten, the Busaba logo is 'ethnic and futuristic, reading from top to bottom (as you would in Thai); it has a friendly, "noodle" quality'. The wood-on-wood pattern was introduced for the second and third restaurants.

While the logo font was hand-drawn, North elected to use VAG Rounded for the secondary font, which appears to have become something of an industry standard for all noodle and Thai restaurants since. On the menu covers and the stationery, the traditional wood-on-wood effect was combined with the silver-foil logo, giving more than a subtle hint that this is a fusion restaurant.

ON THESE PAGES / Busaba Eathai's logo was hand-drawn, but it mixes well with VAG Rounded, the secondary font. Together with the wood-on-wood effect of the menus and stationery, the fonts help reinforce the idea of the London eatery as a fusion restaurant.

busaba eathai
gan gin gan yuu

busaba eathai

**106–110 Wardour Street
London W1F 0TF**

Phone
020 7255 8686

Fax
020 7255 8688

Email
mail@busaba.com

hakkasan

ON THESE PAGES / The back-to-back 'K', a Chinese symbol of prosperity, features on all stationery at Hakkasan. This was partnered by the Rotis typeface to give a modern twist to a traditional Chinese feel.

It may not have been his first restaurant and it certainly hasn't been his last, but Hakkasan is undoubtedly Yau's best-known and most respected. Hidden on a back street behind London's Tottenham Court Road, the restaurant has a nightclub, rather salacious feel that North's graphics also had to convey. Coysten confirms that the brief was 'modern, classy, upmarket'. It was to be authentic Chinese with a very modern intervention. This meant that the identity had to be whispered rather than shouted, and, in Coysten's words, was basically invisible. In its place, he says, 'There was more of a reliance on quality of materials and finishes to express Chinese luxury.'

The identity itself was a back-to-back 'K' – the Chinese symbol of prosperity. This was used as a repeat pattern throughout all the stationery, creating numerous different textures. 'The K pattern could be used functionally for information like forms and playfully as with the toilet signs. It could also be used to draw objects and shapes,' Coysten explains. Meanwhile, the rule with the colour palette was that there wasn't one. Every item played around with different, vibrant colour combinations. The core typeface was Rotis.

Hakkasan invites you for an evening of drinks and Christmas menu tasting
Sunday 15 September 2002 6.00pm—9.00pm Hakkasan 8 Hanway Place London W1P 9DH
RSVP Jayne Carolan +44 20 7927 7010

haⱢkasan

hakkasan Launch Party 8 Hanway Place, London W1 Thursday March 22 6.30pm to 10pm Designer Christian Liaigre
Executive Architects Jestico + Whiles · Contractor Pat Carter · Lighting Arnold Chan · Graphics North · Uniforms Hussein
Chalayan / Timothy Everest / Chester Barrie / William Chang · Accessories Bill Amberg / Michael Young · Music Frederic
Sanchez / Claude Challe · Feng Shui Patrick Wong · Kitchen Tong Chee · Bar Dick Bradsell · Special thanks Marion,
Charlotte and Guillaume at Christian Liaigre · Jim, Jenny and all at PC Shopfitters · Eoin, Jeff, David and everyone else at
Jestico + Whiles · Bill and Antonius at Kaizen · Peter and Richard at Beechers · Grégoire at Sigébene · Mason, Sean,
Simon and Stephen and everyone at North · Peter Veale · Opas and Anurak · Willie Renner · Nick and Muniza at Chester
Barrie · Josh White · Steve and Brendon at Keogh Edwards · Ken Winch · Mick and Chris at Berkeley Projects · Kevin and
Peter at ACE · Myles and Stewart at BSG · Kevin Morton · Alan Carter · Andy Cleland · Peter Pendleton · Annabel and Dan
at Coexistence · Carol Bishop · Jeremy Newman · Ron Arad · Malcolm and Martin at MCE · Jonathan Turk and Don Mackin ·
Robbie Bargh · Grace, Diane, Richard and Jane at Olswang · Michael Israel · NG · Willy at Saunders Madewell ·
Rebecca Owen · Simon Maynard · Kathy Carruth · Jonathan Moore · Stephen Marks · Rainer Becker · Harnett Koopman ·
Suzie Houghton · Guillaume Rochette · Jean Michel · Jeff Yap · Gary Wong · Divesh and Amin · Michael Siefert ·
David Thompson · Peter Saville · Eric Parry and Nick Jackson · Laurence, Linda, Paul and Jonny · Kenny Yang · Six Wu ·
Simon and Debbie Chai · Tina Yau · Wendy Man · Wong Wai Hung · Romy · Terry Chung · Bal Thind · Sami Wasif ·
Christine Parkinson · Anand · Elizabeth and Harnett · Andre Fu RSVP Elizabeth Crompton-Batt PR +44 20 7436 0313
email ecb@ecbpr.co.uk haⱢkasan

Ling Ling was initially Hakkasan's adjoining bar before becoming a nightclub-style noodle and dim sum restaurant in its own right. Here, the brief for North was to create a graphic look that was very sensual and just a little bit erotic. The logotype is a modern interpretation of a 'seventies soft-disco vibe' while the rest of the identity is made up of a combination of photography and illustration created by Marcus James, showing a man and a woman disrobing for sex. There were ten key illustrations that were used across various menus, the matchboxes and the chopstick holders.

'In all four projects, we found that the graphic material was continually being stolen by the customers,' Coysten says. 'People wanted to keep the menus, chopsticks and the matches – basically anything designed and printed was taken. At Yauatcha, people could not get the packaging without buying a cake – so we found that people were buying just one cake purely to get the boxes!'

LEFT AND FACING PAGE / The brief for the graphics at Ling Ling was to create a sensual look – on everything from matchboxes to chopsticks holders.

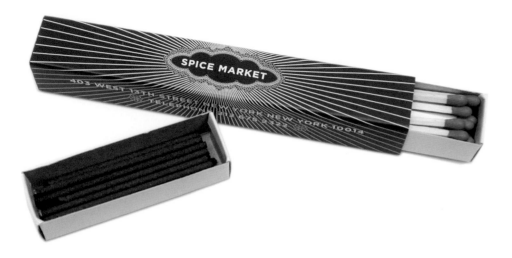

NUMBER SEVENTEEN /
THE SPICE MARKET / MERCER KITCHEN / JOJO / VONG / V / USA

In modern parlance, The Spice Market is probably best described as a fusion restaurant. Serving food inspired by Malayan street vendors, it's owned by French chef Jean-Georges Vongerichten and has an interior that has been largely imported from India. Yet at the same time it has a very particular New York feel. While the restaurant was designed by French architect Jacques Garcia, who elected to transport the inside of a Buddist Temple and adapt it to its new city's Meatpacking District, the graphics came courtesy of Number Seventeen.

According to Emily Oberman, who founded the firm along with Bonnie Siegler, the brief was simple. 'It was pretty much an explanation of what the food was going to be,' she says. 'They described it as Malaysian street food. Then they described this temple they'd found in India and had shipped over and rebuilt and reconfigured to fit in this space.' The practice took its cues from the interior. 'It had a very carved and detailed feel about it,' explains Oberman. 'They also showed us what they were thinking about for the plates and chopsticks, and that's pretty much the inspiration for what we did.'

The logo and patterns on the restaurant's literature are a mixture of Thai and Malaysian artwork which Number Seventeen customized for the New York market, while for the fonts, the practice decided to employ two old favourites: Gotham and Clarendon. 'The nice thing about Gotham is that it's very New York,' says Oberman. 'I know Jean-Georges is French, but his restaurants feel distinctly at home in the city. And so we used a font that feels New Yorky but is still modern and clean and kind of timeless. Combining that with the intricate pattern that we used on the menu and matches just felt like the right combination.' Clarendon is simply described as 'a go to' font. 'It's just beautiful,' Oberman says. 'It's a serif that holds its own. It's chunky and it sort of stands up nicely against the lightness and detail of the pattern; it doesn't compete with it at all.'

The choice of brown colourway that predominates in the graphics becomes startlingly obvious when you see the interior, but Number Seventeen chose an orange for the dessert menu to add what the pair describe as 'a brightness and a hotness'. Another neat detail can be found in the matchboxes, as Oberman points out. 'In New York, you can't really smoke in restaurants any more or bars or anywhere else. But matches are a really nice thing – you know you leave a restaurant and there's a box of matches? So we decided to take the matches and turn them into something less about smoking and more about the restaurant.' The long Spice Market matchboxes are split into two compartments: one, naturally enough, contains matches, but in the other is incense. It's a nice touch.

ON THESE PAGES / Various examples of the graphic design. The patterns that run across much of the material come from a mixture of Thai and Malaysian artwork that has been customized for the New York market.

FACING PAGE FAR RIGHT / The interior of The Spice Market was originally a Buddhist temple.

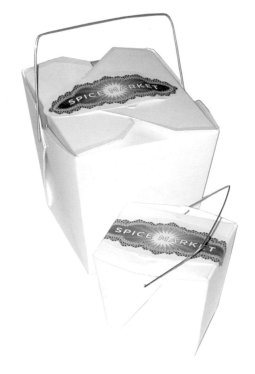

ABOVE / Menus and matchboxes from the Mercer Kitchen. The chipboard matches the hotel's natural feel, while the orange stemmed from the kitchen's open hearth.

FACING PAGE ABOVE / A business card and mint packet from V.

FACING PAGE BELOW / The menu from Jojo. The menu was designed to make the place look 'brotherly'.

Number Seventeen's relationship with Jean-Georges Vongerichten started in the nineties when they worked on the Mercer Kitchen, part of the Mercer Hotel. 'We designed everything for the Mercer Hotel, and Jean-Georges had seen what we had done and really liked it, so that was our introduction to him,' explains Siegler. 'He asked if we'd do something for the Kitchen but in keeping with the overall theme.' So, like the hotel, the restaurant had a natural feel. The menus were made from chipboard ('It's a natural, unadorned material') with a brown-leather lining on the inside. 'The hotel had secondary colours that were very muted, but because the Kitchen, which is underground, had an open hearth, we thought of the idea of fire,' says Oberman. Thus, the Kitchen's accent colour is orange. Likewise the fonts used on the menu, Metro and Tray Gothic, were lifted directly from the hotel. 'Metro has a timeless, yet quirky quality,' Oberman says, while adding that 'Tray Gothic is just an incredibly beautiful, not ostentatious font.'

The work obviously impressed, because Siegler and Oberman then went on to revamp JoJo. Located in an old townhouse, the theme for the redesigned restaurant was, according to Number Seventeen, 'brotherly': 'The waitresses were wearing lingerie and there was a lot of velvet.' Taking this theme, the designers created a business card that was soft, fuzzy and black on one side with the JoJo logo stamped in gold foil. Likewise, the menus were in black printed with a gold silk screen, while the JoJo logo itself, which Oberman says is 'like a flower', is deliberately hidden in the cracks of the gold leaf.

On a roll, the duo's next project with Vongerichten was Vong. According to Siegler, the restaurant, designed by The Rockwell Group, was a tactile delight. 'There was a lot of gold leaf on the walls,' she remembers, 'and there were tiles everywhere. You could touch everything, and everything had a texture to it. It was overwhelming.' Apart, that is, from the menu, which was a photograph of a tile. 'It seemed the antithesis of the restaurant itself because it was a representation of something rather than being something itself,' she continues. The designers decided to pick up two colours, green and gold, from the restaurant and added their own swirl patterns that were inspired by the copper shades of the interior. The results, says Siegler, are magical.

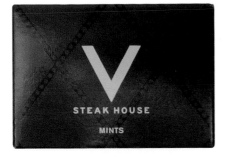

Number Seventeen's final project for the bulging Jean-Georges empire was for V, his take on the traditional steak house. The idea for the interior was what filmmakers would describe as 'high-concept'. It was designed as an extension of Central Park – leaves decorated the ceiling and columns are made to look like trees. 'It was all very rich in texture,' Oberman recalls. 'We didn't really want to add to that. We didn't want to go over-the-top with more leaves and more park and more flowers.' So the pair decorated the menu and stationary with a detail from a pattern that's on the chairs and walls, in purple – one of the interior's accent colours. To emphasize this perhaps rather unexpected sense of restraint, the logo doesn't even appear on the front of the menu.

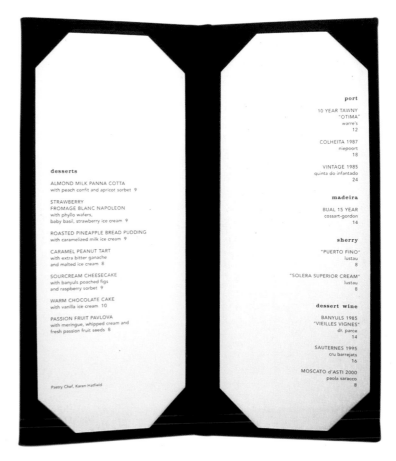

ON THESE PAGES / Menus, matchboxes and letterheads
from Vong. The gold and green was picked up from the
existing interiors designed by the Rockwell Group.

VONG

200 EAST 54TH STREET NEW YORK, NY 10022 ✳ 212) 486 9592 ✳ FAX 212) 980 3745

DON'T FORGET
MASSIVE
SOUP
SM 3 E
LG 4 E
SALAD BAR

Sun. MARCH 30
ALL AGES
4.00 €

MASSIVE SALATE BUFFET KLEIN E 3 GROSS E 4

NICHT VERGESSEN! SUPPE! E 4,-

COMBO
SOUP
SALAD
5 EURO WITH BREAD
ALL YOU CAN EAT!
EXTRA BIG FOR 6 EURO

SUPPE & SALAT & BROT 5,- GROSSE PORTION 6,-

DAILY SPECIAL
PLAT DU JOUR
SOUP OR SALAD +
MAIN COURSE
SELECTION OF THE DAY
6.-

PLAT DU JOUR - SUPPE ODER SALAT - HAUPTGERICHT DES TAGES 6,-

TEA
ESPRESSO

TASSE TEE
PFEFFERMINZ
KAMILLE
SCHWARZ
GRÜN
1,50

1,50

JUiCES:
APPLE, ORANGE, CHERRY,
BANANENNEKTAR,
TOMATO
GINGER ALE* TONIC*
BITTER LEMON* + CHININHALTIG
*FARBSTOFF

0.2 1 EURO 50

A Cola contains coloring & caffeine 1,50
 Fanta contains coloring 1,50
 Sprite
B Mineral Water carbonated 1,50
 Club Mate contains caffeine 2,00

SÄFTE: APFEL, ORANGE, KIRSCH, TOMATE - BANANENNEKTAR

COLA FARBSTOFF-, KOFFEINHALTIG / FANTA FARBSTOFFHALTIG
MINERALWASSER MIT KOHLENSÄURE / CLUB MATE - KOFFEINHALTIG

WINE
RED AND WHITE
TABLEWINE
GERMAN
FRENCH
ITALIAN
SPANISCH
3,-

absinth

4cl 4.-

IOLA'S BALLROOM 6130 PACIFIC BLVD. HUNTINGTON PA

TAFELWEIN - RÖT & WEISS - DEUTSCH, FRÄNZÖSISCH, ITALIANISCH, SPANISCH

CLUB
HANNA
3 YEAR 4CL 3,50
7 YEAR 4CL 4,00

RAMAZOTTI 4CL 3.-
103 NEGRO 4CL 4.-
RICARD 4CL 3.50

PAUL SNOWDEN /
WHITE TRASH FAST FOOD / GERMANY

Berlin's White Trash Fast Food is a fast-food joint serving salads, soups, steaks and fish that has an unusual set of influences: Chinese food and punk rock. In the words of its graphic designer, Paul Snowden, it's a brand that has become 'pretty much an institution for general insanity and good food'. Discussing the fanzine-style menu that he designed for the restaurant in 2002, Snowden explains: 'The first White Trash was in a squat in Berlin's Mitte area. When I heard they were opening, I approached them wanting to help out with the menu and came up with this. Because everyone needs to eat, I saw the menu as a great (and cheap) way for design to reach a lot of people fast. I've always loved the do-it-yourself thing and I think I had a burning urge to get away from the computer and do something handmade. My brother was into US hardcore and he read the legendary hardcore punkzine *Maximum Rock & Roll*, so I was very familiar with some of the images, a lot of the music and most of the attitude.'

Once Snowden had persuaded the client to let him do the work, he was left to his own devices. 'There was no briefing,' he admits. 'I just thought about what would be cool. The fanzine reflects the whole punk-rock, do-it-yourself concept of White Trash. As well as the food, music plays a very important role in the restaurant. so they had a good appreciation of the concept.'

He then scoured the internet for old punk, new-wave and American hardcore record covers which were adapted for the menu. 'All the images are pumped-up jpegs and gifs, which are whipped into the fabulous bitmap format,' he tells me. The fonts used are largely true to the original designs, although Snowden has, he confesses, added 'Helvetica here and Futura there'. 'After being schooled on Designers Republic and Helvetica,' he says, 'I turned to Futura because "Futura is the new Helvetica". And uppercase Futura has been my font since.'

In true fanzine spirit, it's all photocopied in black and white on standard A4, which is designed, stapled, cut and delivered by the designer himself. As well as feeling authentically punk, it makes the menu easy to change and incredibly cheap to produce. Yet it still remains an object of desire. 'The menu was an instant success, was very popular and always got stolen,' says Snowden. 'But then, that was part of the idea, too.'

In 2005, the restaurant closed down briefly, only to re-open across the city in an old Irish pub.

ON THESE PAGES / Matching the fast, punky ethos of White Trash, Paul Snowden's menus appropriate images and the do-it-yourself feel of the era to glorious effect. The result is a menu that resembles a fanzine.

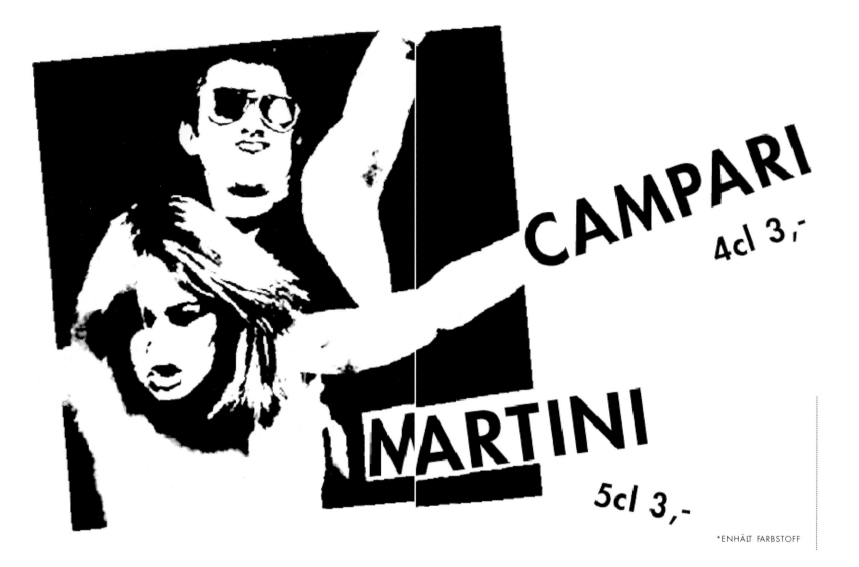

ON THESE PAGES / More from White Trash. All the menus
were photocopied in black and white on A4, which
were designed, stapled, cut and delivered by the
designer himself.

champagne Piccolo
12,-

PROSECCO 0,1 L 3.00

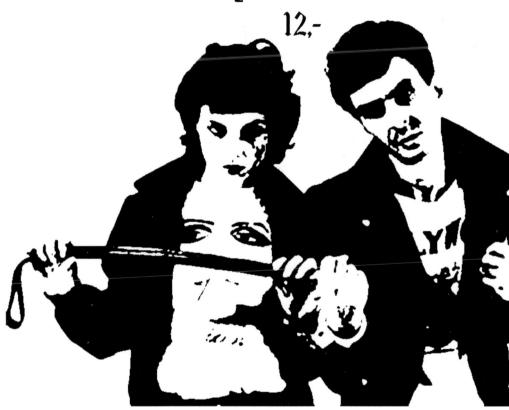

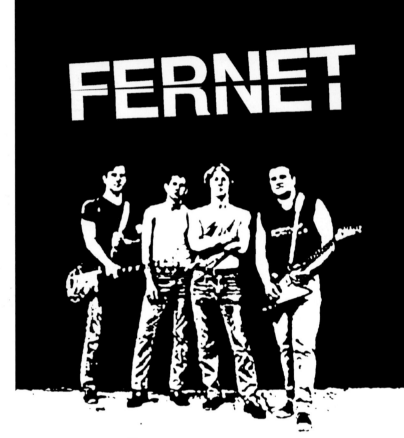

FERNET

branca

2cl 2,-

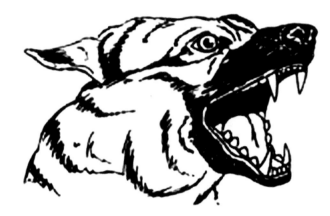

WARNING!

JÄGERMEISTER
2CL 2EURO

ON THESE PAGES / More images from White Trash
Fast Food, where the ever changing menus and flyers
quickly became collector's items.

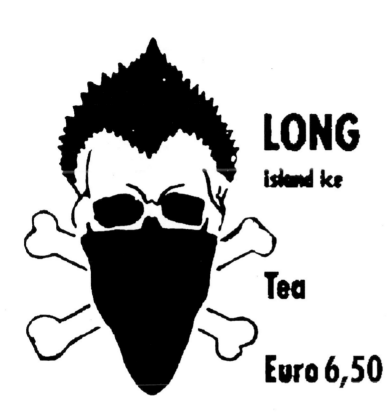

LONG island ice

Tea

Euro 6,50

4CL GIN 1CL MARTINI ROSSO 1CL NOILY PRAT ORANGE JUICE

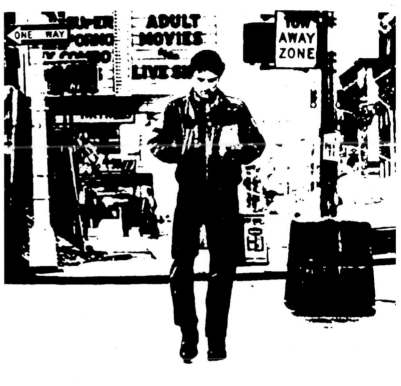

BRONX

5E

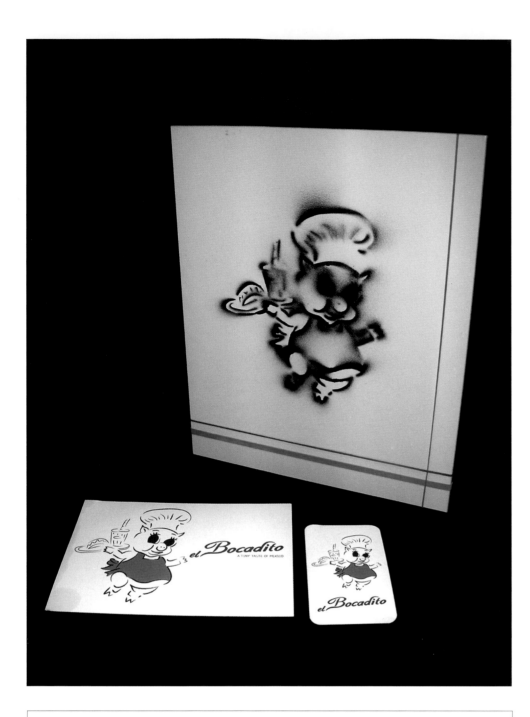

PAULA BOLLA SORRENTINO /
EL BOCADITO / USA

El Bocadito, which apparently means 'tiny morsel' in Spanish, is a small Mexican restaurant on New York's Lower East Side. With the vast array of eateries to choose from in that city, what really sets this restaurant apart is its charmingly naïve graphic design by Paula Bolla Sorrentino. According to the designer, the brief for the restaurant came after the owner, Holly Grabelle, visited an exhibition about Mexican street art curated by Deborah Holtz at The Amory Centre for Arts in Los Angeles. 'She was very much inspired by the art, by its cheerful imagery and its hand-quality typography, and wanted to bring the same characteristics to her restaurant,' says Sorrentino.

With interiors by architect Aaron McDonald, the idea behind the scheme was to 'convey the human side of her business with not-so-perfect imagery which communicated directly with the consumer'. In the process, she sketched over 50 characters that she thought

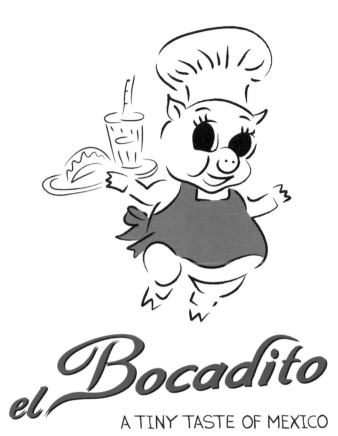

el Bocadito
A TINY TASTE OF MEXICO

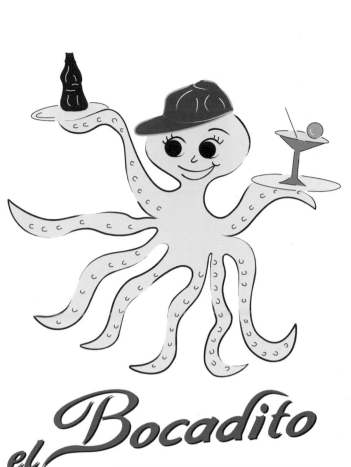

el Bocadito
A TINY TASTE OF MEXICO

represented the restaurant, before selecting the pig, octopus, bull, bunny and dog that adorn El Bocadito's walls and menus. 'For me, it was the perfect time to incorporate hand-quality elements into a project,' explains Sorrentino. 'The use of collages, stencil and handmade typography are components that make graphic design more human. It has more of a soul than a perfect, computer-generated line, and it is where art meets communication.'

All the stationary was printed on recycled paper, while the paintings were created using acrylic and crayons on wood and cardboard. Meanwhile, the menus were made using a combination of stencils and hand-painting, with rubber bands rather than glue or tape keeping the pages together. On the inside, the text itself is in Gill Sans Light which, says Sorrentino, creates 'a precise contrast with the hand-drawn overall design; an area where the reader can abstract from the actual design style, rest their [sic] eyes for a minute and focus on the items in the menu'. In other words, it's easy to read.

ON THESE PAGES / Menus and logos from the Mexican-inspired El Bocadito. The characters, which were inspired by an exhibition of Mexican art, were hand-drawn, while the menus are held together by rubber bands.

PENTAGRAM / EAT. / UK

The past decade has seen the inexorable rise of the coffee bar across the UK. No street in the nation, it seems, is complete without a Starbucks or a Costa Coffee. However, since it launched on Villiers Street in London during 1996, EAT. has stood out defiantly, creating well-crafted sandwiches and, perhaps as importantly, an identity that has brought clarity to the visual clutter of the contemporary high street.

Owned by Faith and Niall MacArthur, the brand has 53 outlets at the time of writing, making a range of soups, pies, salads, wraps, sushi, desserts and baked goods (as well as coffee) in kitchens on each premises. Laudable as this is, there can be little doubt that it owes much of its success to Angus Hyalnd's graphics, which are as strong as a cup of espresso. Appointed in 2002, the Pentagram partner was asked to evolve the existing identity and 'redefine the EAT. brand experience'. According to the practice, this prompted what it describes as 'a thorough investigation of the market and the credible points of differentiation between EAT. and its competitors'.

The conclusions Pentagram reached focused on 'the honesty at the heart of EAT.'s business – a business that is owned by real people (rather than a corporation) who have a genuine passion for real food and drink' – and led to a new logo-type and design language with guidelines for its correct and consistent usage across all the brand's elements. One of the most important of these was the new strapline, THE REAL FOOD COMPANY, which immediately suggests the firm's values (while at the same time, perhaps, being a subtle put-down to some of its rivals).

From there, Hyland and his team created 'an all-encompassing brand identity'. For the new logo, he chose the bold sans-serif Akzidenz Grotesk, on the basis that it 'communicates the warmth and quality of the brand with clarity and a distinct, contemporary tone', while the colour palette used warm, natural brown tones with a selection of more lively minor colours for typography and detailing across food packaging, menu boards and other accessories.

Graphic implementation was rolled out across EAT.'s outlets by Jules Bigg at Fresh Produce, who further developed the language of the Pentagram scheme and applied it to a wide range of packaging, print and marketing materials. Meanwhile, the architectural elements of the revamp were handled by David Collins Architecture & Design, and the entire project was overseen from start to finish by EAT. Food and Brand Director Faith MacArthur.

HOT DRINKS

CAPPUCCINO			1.95
LATTE	1.35	1.65	1.95
MOCHA	1.60	1.90	2.20
ESPRESSO	1.10	1.40	
MACCHIATO	1.10	1.40	
BREWED COFFEE	1.20	1.40	1.60
HOT CHOCOLATE	1.40	1.65	1.95
STEAMED MILK	1.10	1.35	1.60
TEAS/TISANES	1.00	1.10	1.20
CHAI LATTE	1.40	1.65	1.95

COLD DRINKS

	TALL	GRANDE
LATTE CHILLER	2.20	2.40
MOCHA CHILLER	2.40	2.60
ICED LATTE	1.60	2.00
ICED MOCHA	1.80	2.20
ICED TEA	1.20	1.35
MANGO BLAST	2.45	2.65
STRAWBERRY BLAST	2.45	2.65
PEACH BLAST	2.45	

EXTRAS

EXTRA ESPRESSO
SYRUP SHOT
WHIPPED CREAM
WHOLE, SKIMMED OR SOYA MILK

TODAYS SOUPS

SIMPLE

SWEET RED PEPPER

SMALL	1.95
BIG	2.35

BOLD

INDIAN POTATO & ALMOND

SMALL	2.55
BIG	2.95

SANDWICHES OF THE WEEK

BRIE & BACON — 2.70

SPECIALS

AVOCADO HUMUS & RED PEPPER — 2.50

BREAKFAST

HOT
AVAILABLE UNTIL 11.30AM

EGGS BENEDICT (HAM)	1.75
BACON BUTTY	1.75
EGGS FLORENTINE (SPINACH)	1.75
EGGS ROYALE (SALMON)	1.95

COLD
AVAILABLE ALL DAY

HAM & CHEESE CROISSANT	2.10
SMOKED SALMON & CREAM CHEESE BAGEL	2.70
EGG & BACON CROISSANT	1.70

PASTRIES FROM 0.65

CEREALS & YOGHURTS

FRUIT SALADS

ABOVE / A view of a typical EAT. interior, complete with menu board on the back wall.

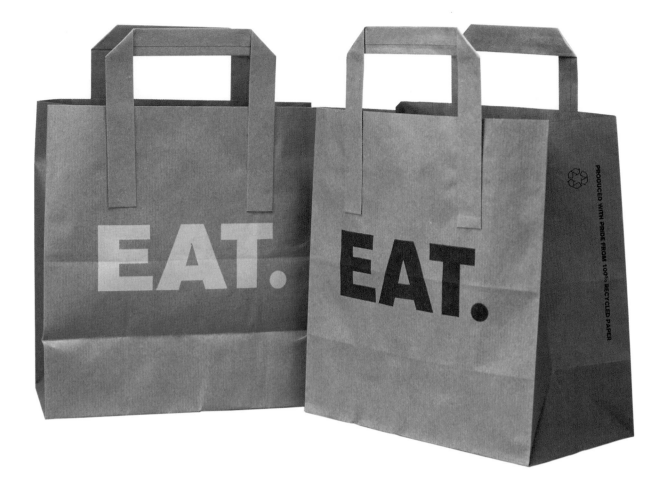

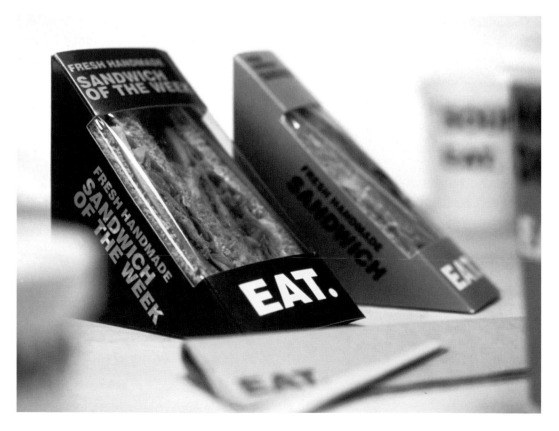

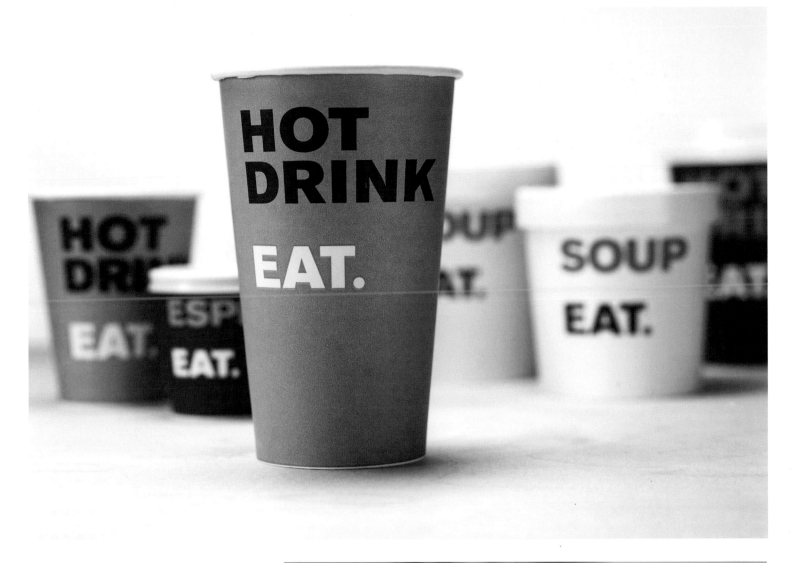

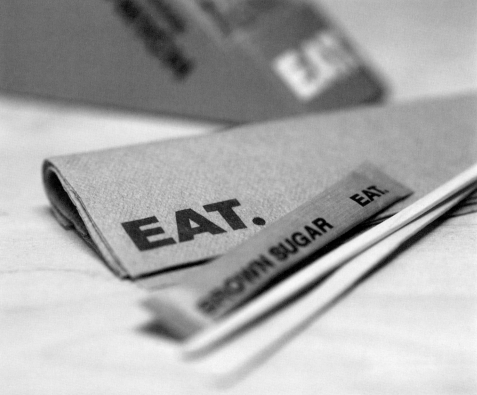

ON THESE PAGES / Packaging from the sandwich shop. The Akzidenz Grotesk font 'communicates the warmth and quality of the brand with clarity and a distinct contemporary tone', while the colours were chosen because they were warm and inviting.

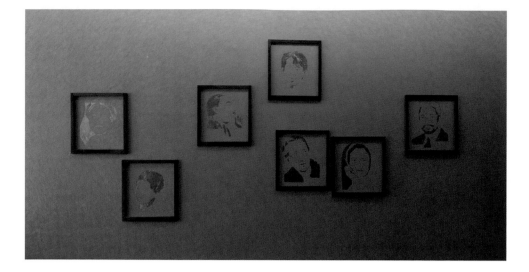

REVORM /
PRINZ MYSHKIN / GERMANY

If you had to open a vegetarian restaurant anywhere on the globe, it's highly unlikely that Munich would be the first choice. Bavaria, after all, is traditionally known as an old-fashioned, beer-and-sausage region. However, over the past 20 years Prinz Myshkin has ploughed its own distinct furrow. And more recently it has been helped by a dramatic makeover, both in its interiors and graphics.

'It's the hippy stuff that people always think of when they talk about vegetarian restaurants,' says Claas Blüher of graphics firm REVORM. 'Our aim was to get rid of those thoughts. You can sell vegetarian food with a contemporary touch and modern appeal.' One of the most important elements of the redesign was the restaurant's logo. 'We tried to give the identity a new cosmopolitan feel,' Blüher explains. 'Before our design, the restaurant had a hand-drawn type of logo; it looked very old-fashioned. We just tried to give the identity a clean and very light touch.' He succeeded. Using Foundary Sans, it's impossible to detect a whiff of incense around the new marque.

REVORM's work is also notable for its witty use of imagery. When designing postcards for the restaurant, for example, Blüher elected to subvert the famous image of a St. Bernard with a barrel of brandy around its neck. 'You get postcards everywhere, so we wanted to come up with something new. Munich is close to the Alps – lots of people go skiing and stuff – so the winter topic was a good one for us to use. That image of the dog carrying the brandy is very common in Germany, so we thought we'd play with it.' The barrel was replaced by a bunch of carrots.

'All the people who saw the image smiled,' Blüher adds. 'And that's a good thing when you're talking about vegetarian food. People think of it as something rather boring and just a health issue.' Indeed, the image is so popular that it was used again for Prinz Myshkin's website, where each section is like a page of a restaurant reservations book. Click on to a new area and the book flicks through its pages until it reaches the right one.

Yet despite the redesign, it is noticeable that the restaurant hasn't completely dug up its roots. *Love is all about* has been printed on one of the sofas in the more lounge-y area, while on the opposite wall are pictures of Nobel Peace Prize-winners.

ABOVE AND FACING PAGE, ABOVE / A view of the interior. Revorm's aim was to destroy the preconceptions of vegetarian restaurants, and the logo as well as the modern decor went some way towards achieving this.

RIGHT / Despite the contemporary feel, there is still room for some hippy sentiment. 'Love is all about' has been printed on this sofa, for example.

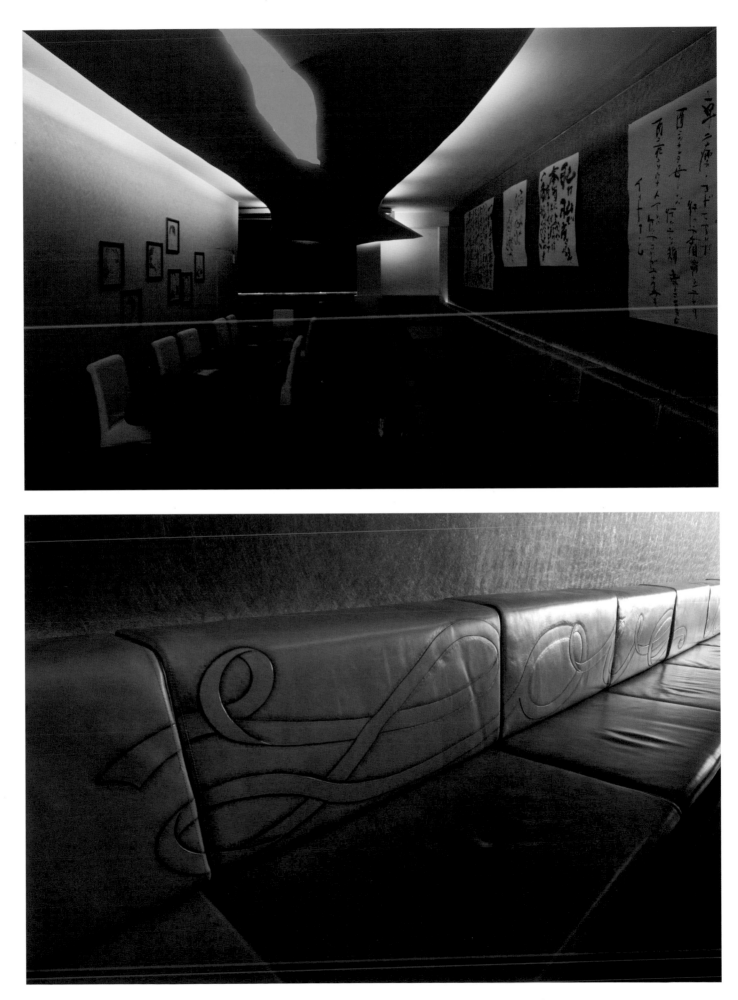

ON THESE PAGES / Advertising material for the restaurant, which plays on Prinz Myshikin's vegetarian roots, but with a very contemporary touch.

Wissen Sie, ich verstehe nicht, wie man an einem Baum vorbeigehen kann, ohne darüber glücklich zu sein, **dass man ihn sieht.**

Wie man mit einem Menschen reden und nicht darüber glücklich sein kann, **dass man ihn liebt.**

Oh, ich verstehe es nur nicht auszudrücken, **aber viele schöne Dinge** begegnen einem auf Schritt und Tritt.

Diese Worte des Dostojewskischen Helden Prinz Myshkin mögen als Inspiration und Einladung verstanden werden, sich dem Genuss der kulinarischen Köstlichkeiten hinzugeben, die wir Ihnen bieten.

PRINZ MYSHKIN

vegetarisches Restaurant Café Bar
Hackenstrasse 2 80331 München Fon 089/265596 Fax 089/264496
info@prinzmyshkin.com www.prinzmyshkin.com

SEA DESIGN / OQO / UK

London's OQO had an unusual birth. A collaboration between architect Hawkins Brown and graphic designer SEA Design, the pair's first meeting with the client, Mark Chan, didn't take place in a boardroom but in a local cinema called The Screen on the Green. In an unusual brief, Chan was keen that his chosen creatives watch his inspiration for the new Islington-based restaurant, the Japanese animated art-house favourite *Spirited Away*.

According to SEA's John Simpson, the detail came much later. 'The owner was undecided whether it was going to be a cocktail bar or a Chinese tapas restaurant,' he explains. The name itself, he says, was chosen because of its ambiguity. Yet, while SEA might have been keen to give OQO a slight air of mystery, its brand had to be readily identifiable.

It was only when Simpson took Chan to see photographer John Ross that things really began to drop into place. 'We made up 80 different cocktails and just photographed them from a bird's-eye view,' he recalls. 'We also did the food he was going to prepare and shot those on the same format, on this black background.' These images aren't just used on the restaurant-cum-bar's literature and menus; they also appear on the walls, providing an aesthetic that can easily be rolled out. They even turn up on the cigarette machine, although Simpson is keen to point out that it's branding, not overkill: 'It's not stamping it everywhere, but there's a definite look about it.'

And he's not wrong. The idea of the circular glass rim from the photography is mirrored in OQO's hand-drawn logo, while the menus use Helvetica Thin because, as Simpson says, 'It's a sans serif that just keeps everything really simple.'

Interestingly, Ross's photographs have also been used in a poster advertising campaign at the local London Underground station. Rolling up the escalator, travellers are shown three plain images, while the fourth contains the restaurant's details. 'It's a bar using branding as a way of attracting customers,' says Simpson. It's also a technique used widely in the fast-food business. As the market in the UK continues to expand, it seems that restaurants will no longer simply be able to rely on quality food or a dazzling interior; they'll have to think extremely carefully about their branding as well.

ON THESE PAGES / Exterior and logo of OQO. The restaurant's name came from a photograph of cocktail glasses' circular rims.

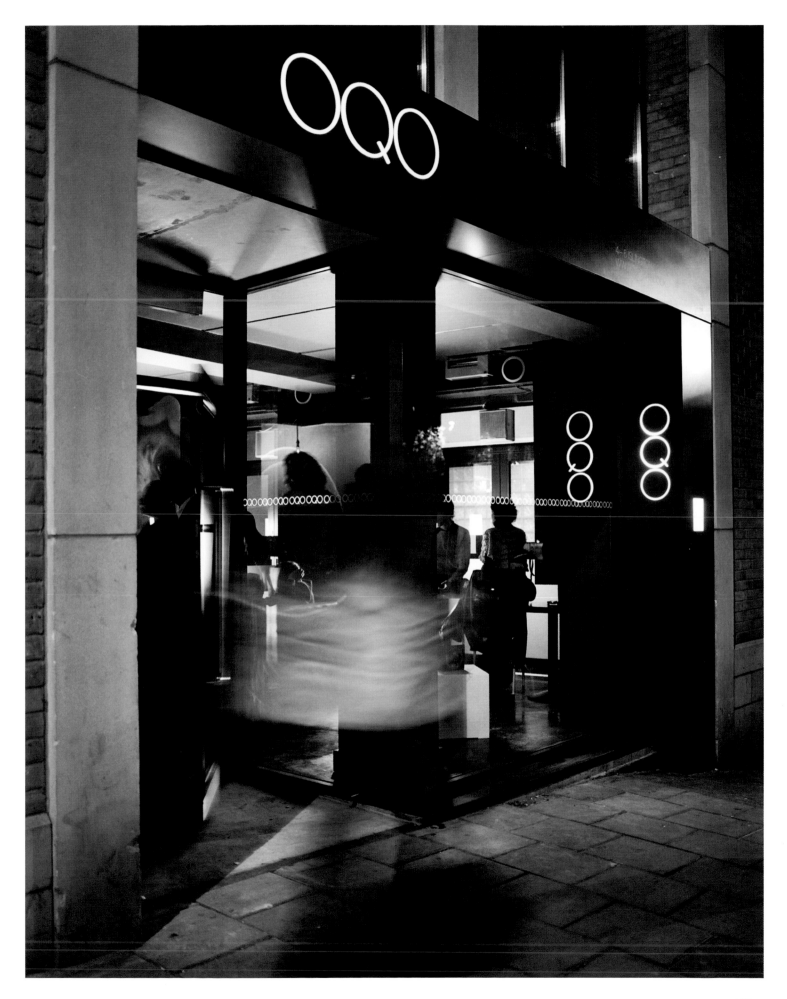

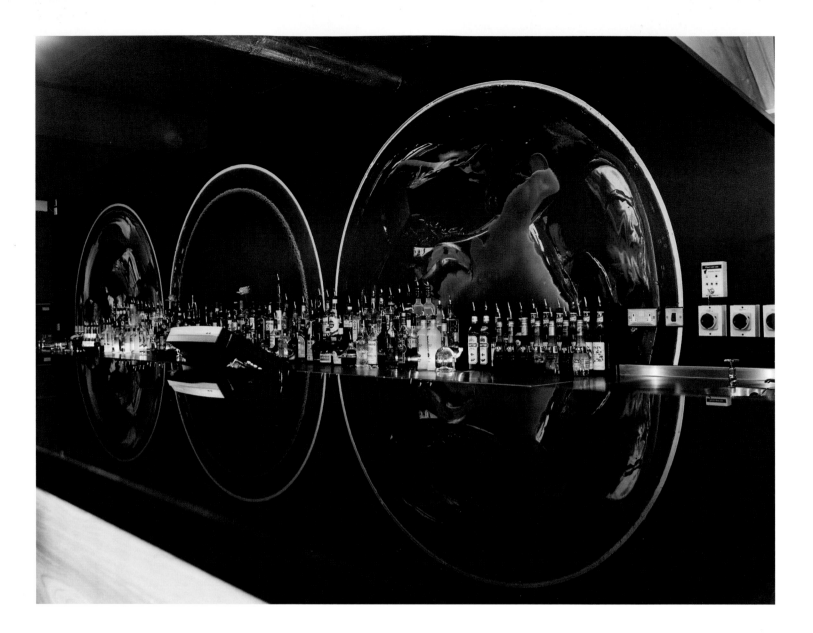

ABOVE / The restaurant's interior, which includes John Ross's striking photography behind the bar.

FACING PAGE / Just some of the cocktail images captured by John Ross.

ABOVE / The OQO logo on the restaurant's exterior. The name was chosen deliberately because of its ambiguity.

FACING PAGE / Even the toilet symbols contain the same clean, branded lines.

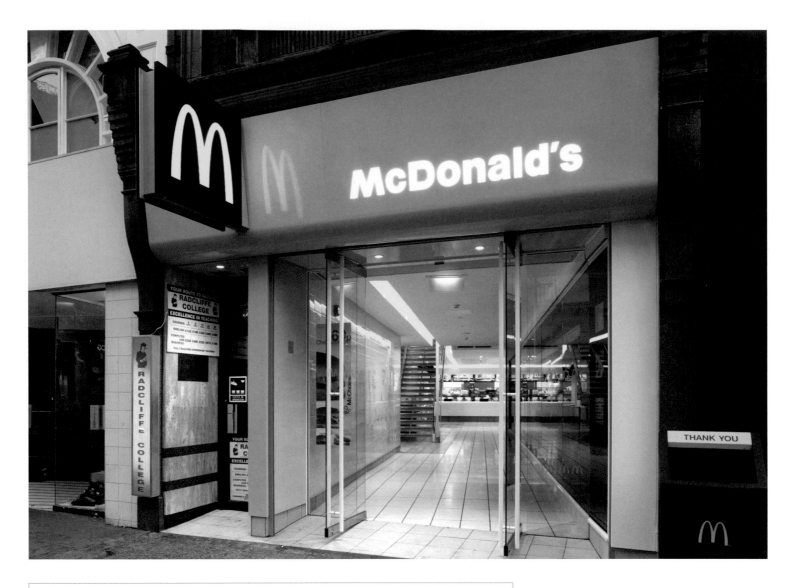

SHH / MCDONALD'S / UK

It is well documented that McDonald's, once the undoubted king of fast-food brands, has found the new millennium distinctly difficult. Taking the lion's share of the blame for the rise in obesity across the developed world, the brand has tried to reinvent both its menus and its design. There is no better example of this than its flagship restaurant on London's Oxford Street, designed by shh.

Of course, McDonald's is a brand that has always been keenly aware of the importance of graphics, as shh's director, Neil Hogan, is happy to admit. 'McDonald's has used graphics in its work before we got involved,' he says. 'And the use of large-format graphics has become a mainstay of commercial interiors, so in that sense it's nothing new.' However, even from the street, it's obvious that a dramatic change has taken place. For one thing, shh, along with the brand's guardian, The Marketing Store Worldwide, decided gently to subvert McDonald's traditional fascia. For Oxford Street, then, yellow is the dominant colour rather than red.

On the right-hand side of the entrance tunnel, a digital ticker-tape pumps out corporate messages, set against a red glass wall. Once inside, the restaurant is split into three distinct floors. Three signage screens at the beginning of the store make it clear that the upstairs is designated for teenagers, downstairs for lunchtime office workers, and the main floor for families.

ABOVE / The McDonald's entrance corridor includes a digital ticker-tape that pumps out corporate messages – in this case, 'I'm loving it'.

FACING PAGE / The rather more elegant than usual fascia, where yellow, not red, is the dominant colour.

And each different 'lounge' has a very specific graphic palette. Arguably the most dramatic is what Hogan describes as the 'digitized street theme' in the basement, which presents a distorted, three-quarter view of the British capital. 'The idea was that you could do one for [other UK cities such as] Manchester, or one for Leeds,' Hogan explains. 'You could effectively use a slight local influence, which is something they're very keen on.'

In fact, it's an idea that the designers took up in their reworking of another branch of McDonald's further along the same street. Working to a smaller budget, the firm used familiar London icons, such as the red Routemaster bus and the giant ferris wheel that is the London Eye, on the restaurant's walls. 'It took the essence of the other site and used even more graphics,' says Hogan. 'Because it was much cheaper, we used the graphics in a different way, experimenting at the time. What you see in Oxford Street was really a catalyst for change. It's not the end game, but at the time it was a major, major step.'

ABOVE / An example of the colour palette and the
'environmental' graphics.

FACING PAGE, TOP TO BOTTOM / Two views of the
lower ground floor, and the upstairs bar area, which
was designed with teenagers in mind.

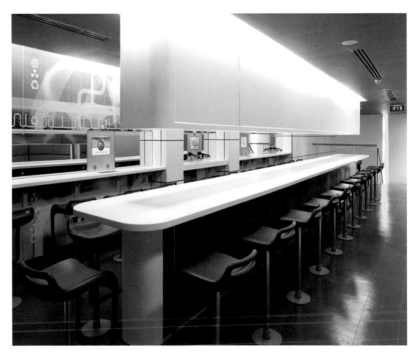

STUDIO MARISCAL / CALLE 54 / SPAIN

Madrid's Calle 54 is many things: part restaurant, part bar and part jazz club. However, it's very definitely all Javier Mariscal. Inspired by Fernando Trueba's film of the same name that pays tribute to the Latin jazz of the 1950s, the club was the idea of a group of friends which included film producers, directors, journalists and businessmen. Split over three floors, Calle 54 contains a bistro and bar on the ground level while above that is the restaurant, bar and stage; there's a cloakroom in the basement. From the entrance it's immediately clear who designed the space.

According to Studio Mariscal, the intention was to give the club a 'mean look', albeit in a sophisticated way. Certainly the interior and the graphics take their inspiration from the Jazz Age. 'It was created on the spirit that gives life to Latin Jazz, using its iconography and emphasizing the myths it generates,' says the practice. 'The objective was that the premises should be liked by all those who understand that leisure time is something very serious, and who wish to add the joy of listening to excellent music to the pleasure of eating well or having a nice drink.'

It's an effect that stretches from the façade (which carries a neon piano player drawn in typical Mariscal style) through to the interior. While the club is loaded with graphics – even the plates have been customized – the element that ties the entire space together is the type mural wall. Emblazoned with the names of jazz legends written in Franklyn Condensed type and embossed in three different widths on a black background, the mural passes through all three floors. According to the studio, the font was chosen because of its ties with the age and its use on classic jazz albums like those of the Blue Note label. Not surprisingly, the colour palette is immediately evocative of the same era.

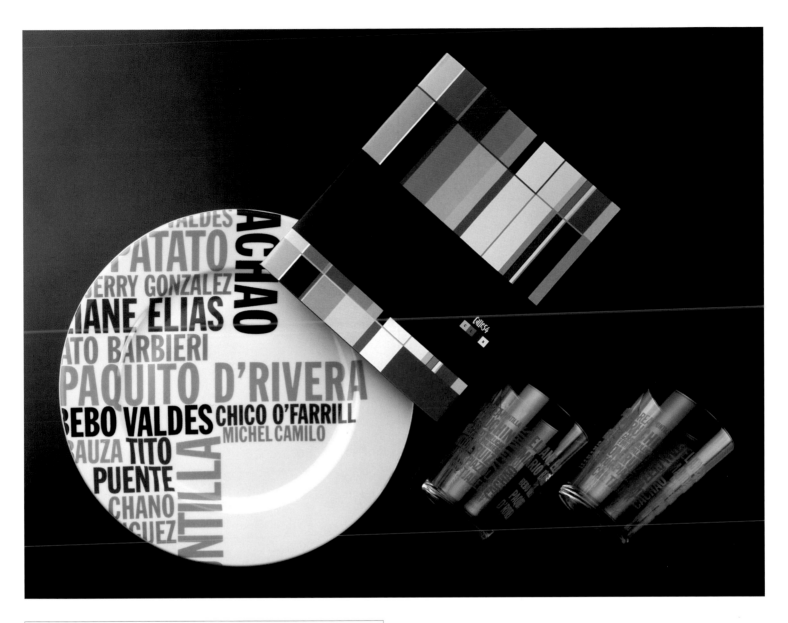

TOP / Everything in the restaurant – from the plates to the menus – features Studio Mariscal's distinctive graphics.

ABOVE / The Calle 54 logo was inspired by the jazz age.

FACING PAGE / Studio Mariscal's hand-drawn characters pop up repeatedly in the restaurant – including on the tops of the tables.

WATER'S EDGE /
CROSSROADS CAFÉ / SINGAPORE

Situated at the junction of Scotts Road and Orchard Road, Singapore's main retail drag, the Crossroads Café is an alfresco restaurant that forms part of the extraordinary-looking Marriott Hotel. According to the scheme's graphic designer, Kuan Tan of Water's Edge, the fact that the clientele comes from a mix of tourists as well as the city's four ethnic cultures literally makes the venue the crossroads of Asia. Hence the name – and the fusion-style food.

'We wanted a device like an arrow to pinpoint the significance of this location, using the credibility of the famous roads so that it is easy to find it on a tourist map,' Tan continues. He came up with the idea of the fork that holds the menu together on the front of a wooden board. While there is some philosophy behind the idea (the fork symbolizes the junction itself but also, of course, food), it is also highly practical. 'The location and open-air dining means customers sometimes experience some very strong winds, especially in the rainy, monsoon months,' explains Tan. 'Menus and napkins fly [off], which means they are kept away and are not in place prominently on the tables for would-be customers – [hence] the heavy board and the cast-iron fork fastener. It was billed in Singapore magazines as the heftiest menu ever seen.'

The designer is at pains to point out that the menu's sheer bulk has other advantages. 'Nice menus are often stolen or removed from the premises – tucked into handbags and such – costing the restaurant a small fortune in reprints,' he says. 'We report no stolen menus with ours, although some diners did inquire about purchasing them as mementos!'

To capture the essence of Singapore Asian heritage as well as its colonial past, Water's Edge took an existing Western font (which Tan is reluctant to name) and customized it to give it what he describes as 'Eastern promise'. He elected to keep the colours natural, using green and a yellowish off-white. To protect the menu from spills, the A4 covers were laminated.

DESIGNERS /
CONTACT DETAILS

AVROKO
210 Elizabeth Street
Floor 3
New York, NY 10012
USA
T +1 212 343 7024
www.avroko.com

Barkley Evergreen & Partners Inc
423 West 8th Street
Kansas City, MO 64105
USA
T +1 816 842 1500
F +1 816 222 9144
www.beap.com

Bob's Haus
3728 McKinley Blvd
Sacramento, CA
USA
T +1 916 736 9550

Brindfors Enterprise IG
Sveavägen 9-11
P.O. Box 7042
SE-103 86 Stockholm
Sweden
T +46 8 440 8000
www.enterpriseig.se

Bruce Mau Design Inc
197 Spadina Ave
Unit 501
Toronto, ON M5T 2C8
Canada
T +1 416 260 5777, ext. 226
www.brucemaudesign.com

cakedesign
18, rue du faubourg du temple
75011 Paris
France
T +33 01 40 21 39 95
www.cakedesign.fr

Coast Design & Art Direction
102 rue de la Victoire
B-1060 Bruxelles
Belgium
T +32 02 534 50 08
www.coastdesign.be

designrichtung gmbh
Luisenstraße 25
CH-8005 Zürich
Switzerland
T +41 44 422 53 20
www.designrichtung.ch

Edo
110, rue Réaumur
75002 Paris
France
T +33 01 53 00 95 25
F +33 01 53 00 95 72
www.agence-edo.com
info@agence-edo.com

Elena Barta
NOTI
Roger de Llúria, 35-37
08009 Barcelona
Spain
T +34 933 426 673
www.noti-universal.com

Frost Design
Level 1
15 Foster Street
Surry Hills
Sydney, NSW 2010
Australia
T +61 2 9280 4233
F +61 2 9280 4266
www.frostdesign.com.au

Grafica
Plaza Ramón Berenguer el Gran
08002 Barcelona
Spain
T +34 933 15 18 19
www.grafica-design.com

hgv
2-6 Northburgh Street
London EC1V 0AY
UK
T +44 (0)207 336 6336
www.hgv.co.uk

Hudson-Powell
3-4 Sunbury Workshops
25 Swanfield St
London E2 7LF
UK
T +44 (0)207 729 6788
www.hudson-powell.com

i_dbuero
GMBH für Grafik und Design
Bismarckstraße 67a
70197 Stuttgart
Germany
T + 49 711 636 8000
F + 49 711 636 8008
www.i-dbuero.de

Interfield Design/Peter Anderson/
8 Flitcroft Street
London WC2H
UK
T +44 (0)20 7836 5455

James Barondess
66 Beacon Street # 60
Boston, MA 02108
USA
T +1 617 367 1945
nijpe@yahoo.com

JNL Graphic Design
216 W. Chicago Avenue
Chicago, IL 60610
USA
T +1 312 640 1999
www.jnldesign.com

Jutta Drewes
Lippmannstrasse 53
D-22769 Hamburg
Germany
T + 49 2351 7642
info@seesaw.de
www.seesaw.de

Karim Rashid
357 West 17th Street
New York, NY 10011
USA
T +1 212 929 8657
www.karimrashid.com

Lesley Moore
Tweede Atjehstraat 60hs
1094 LK Amsterdam
The Netherlands
T +31 20 66 351 10
www.lesleymoore.nl

Lewis Moberly
33 Gresse Street
London W1T 1QU
UK
T +44 (0)207 580 9252
www.lewismoberly.com

Lippa Pearce Design Ltd
358a Richmond Road
Twickenham TW1 2DU
UK
T: +44 (0)208 744 2100
www.lippapearce.com

Marcel Wanders Studio
Jacob Catskade 35
1052 BT Amsterdam
The Netherlands
T +31 (0)20 422 1339
F +31 (0)20 681 5056
www.marcelwanders.com

agence mano
17, rue Montauban
72 000 Le Mans
France
T +33 02 43 82 99 99
www.mano-lemans.fr

Martí Guixé
info@guixe.com
www.guixe.com

Mucca Design Headquarters
568 Broadway
Suite 504
New York, NY 10012
USA
T +1 212 965 9821 x 102
info@muccadesign.com
www.muccadesign.com

Nendo
4-1-20-2A Mejiro Toshima-ku
Tokyo 171-0031
Japan
T +81-(0)3 3954 5554
F +81-(0)3 3954 5581
www.nendo.jp

North Design
Unit 2
The Glass House
3 Royal Oak Yard
Bermondsey Street
London SE1 3GD
UK
T +44 (0)207 357 0071
F +44 (0)207 490 4968
www.northdesign.co.uk

Number 17
285 West Broadway
Room 650
New York, NY 10013
USA
T +1 212 966 9395
www.numberseventeen.com

Paul Snowden
Skalitzerstrasse 138
10999 Berlin
Germany
T +49 164 6146445
www.paul-snowden.com

Paula Bolla Sorrentino
1235 Park Avenue
Number 9D
New York, NY 10128
USA
T +1 917 209 8005
pbsorrentino@aol.com

Pentagram Design Ltd
11 Needham Rd
London W11 2RP
UK
T +44 (0)207 229 3477
www.pentagram.com

REVORM
Königstraße 30
D-22767 Hamburg
Germany
T +49 40 23 84 35 30
F +49 40 23 84 35 37
www.revorm.com

Sea Design
70 St John Street
London EC1M 4DT
UK
T +44 (0)207 566 3100
www.seadesign.co.uk

shh
1 Vencourt Place
Ravenscourt Park
Hammersmith
London W6 9NU
UK
T +44 (0)208 600 4171
www.shh.co.uk

Estudio (Studio) Mariscal
Pellaires 30-38
08019 Barcelona
Spain
T +34 933 036 940
www.mariscal.com

Water's Edge
33 Liang Seah Street
02-01 Singapore 189054
www.watersedge.com.sg
info@watersedge.com.sg

PHOTOGRAPHERS /
PICTURE CREDITS

AVROKO
Photography: AvroKO

BARKLEY EVERGREEN & PARTNERS
Photography: Tim Pott Photography

BOB DAHLQUIST
All graphics and photogram images: Bob Dahlquist

BRINDFORS ENTERPRISE IG
Photography courtesy of Brindfors Enterprise IG (with the exception of the Gooh! interior, which is courtesy of Sweden Graphics/Gooh!)

BRUCE MAU DESIGN
Photography: Bruce Mau Design

CAKEDESIGN
Photography: Kong, page 30 and 33, Julien Oppenheim; Kong, page 31-2, Patricia Bailer; Lo-Sushi, page 34, Julien Oppenheim; Baccarat, page 35, Claude Weber

COAST
Photography of Pulp courtesy of Coast

DESIGNRICHTUNG
Photography: Tom Bisig, Basel (the total vista of the interior); all other pictures by designrichtung

FROST DESIGN
Photography: Anthony Donovan, Adrian Lander and Tracey Crerar

GRAFICA
Art direction: Pablo Martin; design: Pablo Martin, Xavier Roca, Javier Pereda; photography: Mauricio Salinas

HGV
Graphics photography of Roast courtesy of HGV

HUDSON POWELL
Graphics photography of Canteen courtesy of Hudson Powell and interiors courtesy of Meena Khera PR

I_DBUERO
Photography of Bravo Charlie and Rubirosa courtesy of I_DBuero

INTERFIELD DESIGN/PETER ANDERSON
Photography and images courtesy of Peter Anderson